Modernist Women Poets
An Anthology

Modernist Women Poets

AN ANTHOLOGY

Edited by
Robert Hass
and Paul Ebenkamp

COUNTERPOINT · BERKELEY, CALIFORNIA

Library of Congress Cataloging-in-Publication Data

Modernist Women Poets : an anthology / edited by
Robert Hass, Paul Ebenkamp.
 pages cm
1. American poetry—Women authors. 2. American poetry—20th century.
3. Modernism (Literature) 4. Women—United States--poetry. I. Hass, Robert,
editor of compilation. II. Ebenkamp, Paul, editor of compilation.
 PS589.M53 2014
 811'.50809287—dc23
2013047445

ISBN 978-1-61902-110-5

Cover and interior design by Gopa & Ted2, Inc.

Counterpoint Press
1919 Fifth Street
Berkeley, CA 94710
www.counterpointpress.com

Printed in the United States of America
Distributed by Publishers Group West

10 9 8 7 6 5 4 3 2 1

Contents

Preface: Sixteen Poets

C.D. Wright

Born near the end of the nineteenth century (with the exception of Laura Riding tipping a year into the twentieth), all sixteen of these poets, in one form or another, removed the stays from their corsets, as Gertrude Stein did immediately upon crossing the Atlantic, and emancipated their quick intelligences to make art. There is a defiant streak in all of them and they are as clear about what they oppose as they are that words are their weapons, utensils, and toys. Only one was born in the South and stayed rooted in her native state. Only three of them had children. Five of them preferred women to men. Most traveled extensively or relocated far from their origins. Many of them lived long and calamitously and struggled with poverty, disease, divorce, and, in one instance, rape and likely incest. Two died very prematurely, one of tuberculosis and one of scarlet fever. Some were educated at private colleges for women: Bryn Mawr, Vassar, Radcliffe, and Sweetbriar. There was a Berkeley and a Cornell graduate. Djuna Barnes barely attended school. Djuna Barnes was a prolific, free-ranging journalist. Marianne Moore taught Commercial English and law at a Native American school and was a part-time librarian; Anne Spencer was also a librarian. Hazel Hall labored at a sewing machine in the family attic. Within a wide span of intensity and yield, they all felt compelled to write poetry.

In order of their birth dates:
Lola Ridge's Hester Street (1910) in "The Ghetto" is as layered, vivid, and tense as Spike Lee's street in Bedford-Stuyvesant on the hottest day of the year in *Do the Right Thing* (1989). Nomadic and urban, Ridge

shifted often from country to country and early on from painting to poetry. Her political fire provided oxygen for her intellectual and creative expression.

Gertrude Stein broke all of the rules and they would never support their old armchair authority again. The first freedom comes with having an independent income. The second, with leaving your country behind. The next freedom comes with refusing to abide by the strictures of one's assigned gender. (It doesn't hurt to have an in-house amanuensis, reader, cook, host, and pillow partner.) The absence of children is further liberating. (It is more or less substantiated that offspring have been a contributing factor to many male artists' leaving their families—from Gauguin to Sherwood Anderson.) Mr. Anderson happens to have been Ms. Stein's unlikely, unwavering advocate. It was his astute observation that she "used words as if they had no experience":

Ex, ex, ex.
Bull it bull it bull it bull it.
Ex Ex Ex.

And amid many simple nouns, not a one stranger than, say, *cigarette*; amid much sibilance, rollicking repetition, reams of wittily coded sexual pleasure, and what John Ashbery has referred to as that "sudden inrush of clarity" that "is likely to be an aesthetic experience," Gertrude Stein reveals the true source of her optimistic output: "In the midst of writing there is merriment."

Amy Lowell took the imagist experiment to heart and found a way to compress much of what she experienced to color, liquid, light, and hard, smooth surfaces, only leaking her internal restlessness with an occasional disquietude, "I alone am out of keeping."

Dadaism offered a kind of haven for Elsa von Freytag-Loringhoven. It could not protect her from herself or the world's arbitrary cruelties, but it could allow her some fun with her tongue, and she used it to lick and to lash. The everyday inanities of commerce and the urban hubbub went into her rowdy mash-up:

Famous Fain reduces
Reg'lar fellows to the
Toughest Cory Chrome
Pancake apparel—kept
Antiseptic with gold dust
Rapid transit—
It has raised 3 generations
Of mince-piston-rings-pie.
Wake up your passengers—
Large and small—to ride
On pines—dirty erasers and
Knives

Adelaide Crapsey was not afforded a long lifeline. She went to college, studied in Rome and taught at Smith, but mostly she watched the world from her Brooklyn window and kept a bracing seasonal vigil over her own dying. She applied an economy of words uncommon for her time coupled with a stoic yet revealing level of restraint.

Like Stein, Angelina Weld Grimke was a lesbian, but she lived under her father's roof and sacrificed her desires to his rules. Her mother had evidently been committed to an institution early in Ms. Weld's life. Poems provided an outlet both for racial and sexual repression. On the unhassled page she could reject the constricted status of African Americans and assert her love for other women.

The child of former slaves, raised in foster care, Anne Spencer had a long, fruitful life as a teacher, wife and mother, librarian, vocal community activist, and prodigious gardener. Her home, garden, and the writing cottage her husband built for her in the garden are now a public museum in Lynchburg, Virginia. She wrote fearsome poems of protest such as "White Things" (unpublished in her lifetime), was much anthologized and had many literary friends in the center of the action of the Harlem Renaissance. However, it was the landscape of Virginia and the private world of her garden on which she lavished symbolic meaning and tilled a simple language of satisfaction.

In her mid-thirties by the time she moved to New York City from

Paris, Mina Loy had already dropped out of art school. Traveled. Married badly. Had affairs. Divorced. Lost a child. Left her two surviving children in someone else's care for a time. She had already been exposed to all of the currents of the art world and seemed to have some facility for everything that caught her attention. Her love poems ("Songs to Joannes") are described by her biographer Carolyn Burke as "a peculiar kind of war poetry," though critics tend to focus on the body as the centerfold of this sequence that is an audacious sendup of the romantic love poem. Bear in mind, this is writing that finds words delicious and will not have them chained to the wall of denotation. Being bourgeois was not her line of work. Her famous poem "Lunar Baedeker" is, for the traveling reader, a near hallucinatory trip: "Delirious Avenues / lit / with the chandelier souls / of infusoria / from Pharoah's tombstones, not to your next Best Western."

Hazel Hall never escaped her thirties, her wheelchair or sewing machine. Hazel Hall, poet. Hazel Hall, seamstress. She made an art out of her labor—sewing was one thing, writing about it another. And then there is death, the imminence of which she was well aware; that, too, became her art—dying was one thing, writing about it another:

Some who die escape
The rhythm of their death,
Some may die and know
Death as a broken song,
But a woman dies not so, not so;
A woman's death is long.

The elaborate embroidery at which she was adept is absent from the unadorned lines of her isolation. In the upper floor of her family home, like Adelaide Crapsey, she watched the world from her window. Adelaide Crapsey succumbed to tuberculosis and Hazel Hall to scarlet fever.

H.D.'s "Sea Rose"—the first poem in her first book, *Sea Garden*, along with other flowers from that garden—casts the emblems of love

in a whole new, salt-encrusted light, inaugurating a writing career that would take on the male preserve of the epic and refigure Greek mythos from the female's ground:

> I was not blind when I turned.
> I was not indifferent when I strayed aside
> or loitered as we threw went
> or seemed to turn a moment from the path
> for that same amaranth.

> I was not dull and dead when I fell
> back on our couch at night.
> I was not indifferent when I turned
> and lay quiet.
> I was not dead in my sleep.

No, H.D. was not blind. She contained multitudes and made radical choices for her era, including the perspective of the literary and idealized figure of the female as the author of her own life. The adrenalin rushes and risks of war and love stamped her early work. She and her long-term partner, Bryher (née Winifred Ellerman), were among the holdouts during the Blitz of London. The first section of H.D.'s *Trilogy*, "The Walls Do Not Fall," rolls out sequences of short couplets in which she makes her stand for the endurance of love, selfhood, and poetry—against the odds, beseeching, "Isis, the great enchantress, / in her attribute of Serqet, // the original great-mother, / who drove // harnessed scorpions / before her." There is both a layering of symbols and upending of their significance, a cutting to the cryptic bone, and a trove of biographical hints behind the persona of H.D.:

> be firm in your own small, static, limited

> orbit and the shark-jaws
> of outer circumstances

will spit you forth:
be indigestible, hard, ungiving.

so that, living within,
you beget, self-out-of-self . . .

And would proclaim poetry the redemptive successor to violence:

. . . O Sword,
you are the younger brother, the latter born,

your Triumph, however exultant
must one day be over,

in the beginning
was the Word.

Though H.D. did not stay at Bryn Mawr, she was there long enough to get wrapped up with Pound for a time, long enough to meet Marianne Moore (and would in fact publish Moore's poems in *The Egoist* when she was the editor).

Marianne Moore ended up in New York. After college she taught at a Native American school in Pennsylvania. She even taught the great footballer Jim Thorpe. In New York, she worked as a part-time librarian. There's something oddly fitting about her as a New York poet. She was both an anachronism and a modernist. Her use of syllabics was true to her sound and sense, and while other modernists experimented with syllabics, none were as committed as she; even she was not rigidly unwilling to break step with her count. Quotation and collage were a standard part of her toolbox. They are rife in the well-known poems "Marriage" and "An Octopus." She had a most particularizing sense of description, setting one thing utterly apart from anything else on earth or comparing one thing to another utterly dissimilar. More than anyone of her time, including the orchidaceous Mina Loy, the most unexpected, underused word was hers to deploy.

"Ecstasy affords / the occasion and expedience determines the form." There is no one else like her.

Djuna Barnes did not have a childhood anyone should endure or much of an education except in a very weird household. But she could read, draw, and write. She worked as a feature writer and illustrator. Her disposition ran to the strange and ornate and stylized. She was finally free of her horrid family in Greenwich Village and free of American constraints even more in Paris, where she lived with the love of her life, Thelma Wood. There seems to have been tremendous innate talent. She was a member of the Provincetown Players, wrote her own plays, wrote novels, stories, memoir, and poetry, and completed her opus with a bestiary. "Reading Djuna Barnes is like reading a foreign language, which you understand," wrote her friend Marianne Moore, with customary accuracy. Barnes's language never gives up that quality of the alien, but she is not opaque. Caustic, bitter, morbid, lonely, and true. Small wonder J.M. Synge was one of her favorites.

Hildegarde Flanner was born in Indianapolis and attended Sweetbriar before transferring to Berkeley. Her writer sister Janet Flanner aka "Genet" became a Parisian. Hildegarde converted to Californianism. Their father committed suicide when she was in her teens. When Hildegarde was a young married woman her house burned down in one of the major Southern California conflagrations. But by comparison to most of the poets of her generation, she had a comfortable and contented life, and the writings reflect a sense of well-being, generosity, and gratitude. The trees, plants, and animals were her teachers. She honored what she learned from them and sometimes time seemed to stop in her sights while everything extraneous fell away from what she was seeing.

Laura Riding was born in New York City of Austrian Jewish parents, went to Cornell, married her history professor, became affiliated with the Fugitives, went to Europe (at the invitation of Robert Graves), stayed, and helped dissolve his marriage. With Graves she cofounded Seizen Press. There is a kinship to Gertrude Stein in that Riding was intent on scrubbing words of their encrustations, but she was more of an ideologue than Stein, believing in the total purification of the

language. She returned to the States nearly fourteen years after expatting, married Schuyler Jackson, and moved to Florida, where she lived and wrote until her death in 1991. She formally renounced her art in the process of pursuing an intractable view of truth as poetry "failed her kind of seriousness."

The sixteen of them lived with a vengeance. They wrote out of necessity and aspiration. They set forth myriad options for successive writers. They extended the adventure to other women. In the indelible words of Gertrude Stein, "the difference is spreading."

Lola Ridge

from *The Ghetto*

I

Cool inaccessible air
Is floating in velvety blackness shot with steel-blue lights,
But no breath stirs the heat
Leaning its ponderous bulk upon the Ghetto
And most on Hester street . . .

The heat . . .
Nosing in the body's overflow,
Like a beast pressing its great steaming belly close,
Covering all avenues of air . . .

The heat in Hester street,
Heaped like a dray
With the garbage of the world.

Bodies dangle from the fire escapes
Or sprawl over the stoops . . .
Upturned faces glimmer pallidly—
Herring-yellow faces, spotted as with a mold,
And moist faces of girls
Like dank white lilies,
And infants' faces with open parched mouths that suck
 at the air as at empty teats.

Young women pass in groups,
Converging to the forums and meeting halls,
Surging indomitable, slow
Through the gross underbrush of heat.
Their heads are uncovered to the stars,
And they call to the young men and to one another
With a free camaraderie.
Only their eyes are ancient and alone . . .

The street crawls undulant,
Like a river addled
With its hot tide of flesh
That ever thickens.
Heavy surges of flesh
Break over the pavements,
Clavering like a surf—
Flesh of this abiding
Brood of those ancient mothers who saw the dawn
 break over Egypt . . .
And turned their cakes upon the dry hot stones
And went on
Till the gold of the Egyptians fell down off their arms . . .
Fasting and athirst . . .
And yet on . . .

Did they vision—with those eyes darkly clear,
That looked the sun in the face and were not blinded—
Across the centuries
The march of their enduring flesh?
Did they hear—
Under the molten silence
Of the desert like a stopped wheel—
(And the scorpions tick-ticking on the sand . . .)
The infinite procession of those feet?

.

IV

Calicoes and furs,
Pocket-books and scarfs,
Razor strops and knives
(Patterns in check . . .)

Olive hands and russet head,
Pickles red and coppery,
Green pickles, brown pickles,
(Patterns in tapestry . . .)

Coral beads, blue beads,
Beads of pearl and amber,
Gewgaws, beauty pins—
Bijoutry for chits—
Darting rays of violet,
Amethyst and jade . . .
All the colors out to play,
Jumbled iridescently . . .
(Patterns in stained glass
Shivered into bits!)

Nooses of gay ribbon
Tugging at one's sleeve,
Dainty little garters
Hanging out their sign . . .
Here a pout of frilly things—
There a sonsy feather . . .
(White beards, black beards
Like knots in the weave . . .)

And ah, the little babies—
Shiny black-eyed babies—

(Half a million pink toes
Wriggling altogether.)
Baskets full of babies
Like grapes on a vine.

Mothers waddling in and out,
Making all things right—
Picking up the slipped threads
In Grand street at night—
Grand street like a great bazaar,
Crowded like a float,
Bulging like a crazy quilt
Stretched on a line.

But nearer seen
This litter of the East
Takes on a garbled majesty.

The herded stalls
In dissolute array . . .
The glitter and the jumbled finery
And strangely juxtaposed
Cans, paper, rags
And colors decomposing,
Faded like old hair,
With flashes of barbaric hues
And eyes of mystery . . .
Flung
Like an ancient tapestry of motley weave
Upon the open wall of this new land.

Here, a tawny-headed girl . . .
Lemons in a greenish broth
And a huge earthen bowl
By a bronzed merchant

With a tall black lamb's wool cap upon his head . . .
He has no glance for her.
His thrifty eyes
Bend—glittering, intent
Their hoarded looks
Upon his merchandise,
As though it were some splendid cloth
Or sumptuous raiment
Stitched in gold and red . . .

He seldom talks
Save of the goods he spreads—
The meager cotton with its dismal flower—
But with his skinny hands
That hover like two hawks
Above some luscious meat,
He fingers lovingly each calico,
As though it were a gorgeous shawl,
Or costly vesture
Wrought in silken thread,
Or strange bright carpet
Made for sandaled feet . . .

Here an old grey scholar stands.
His brooding eyes—
That hold long vistas without end
Of caravans and trees and roads,
And cities dwindling in remembrance—
Bend mostly on his tapes and thread.

What if they tweak his beard—
These raw young seed of Israel
Who have no backward vision in their eyes—
And mock him as he sways
Above the sunken arches of his feet—

They find no peg to hang their taunts upon.
His soul is like a rock
That bears a front worn smooth
By the coarse fiction of the sea,
And, unperturbed, he keeps his bitter peace.

What if a rigid arm and stuffed blue shape,
Backed by a nickel star
Does prod him on,
Taking his proud patience for humility . . .
All gutters are as one
To that old race that has been thrust
From off the curbstones of the world . . .
And he smiles with the pale irony
Of one who holds
The wisdom of the Talmud stored away
In his mind's lavender.

But this young trader,
Born to trade as to a caul,
Peddles the notions of the hour.
The gestures of the craft are his
And all the lore
As when to hold, withdraw, persuade, advance . . .
And be it gum or flags,
Or clean-all or the newest thing in tags,
Demand goes to him as the bee to flower.
And he—appraising
All who come and go
With his amazing
Sleight-of-mind and glance
And nimble thought
And nature balanced like the scales at nought—
Looks Westward where the trade-lights glow,

And sees his vision rise—
A tape-ruled vision,
Circumscribed in stone—
Some fifty stories to the skies.

.

VI

In this dingy café
The old men sit muffled in woolens.
Everything is faded, shabby, colorless, old . . .
The chairs, loose-jointed,
Creaking like old bones—
The tables, the waiters, the walls,
Whose mottled plaster
Blends in one tone with the old flesh.

Young life and young thought are alike barred,
And no unheralded noises jolt old nerves,
And old wheezy breaths
Pass around old thoughts, dry as snuff,
And there is no divergence and no friction
Because life is flattened and ground as by many mills.

And it is here the Committee—
Sweet-breathed and smooth of skin
And supple of spine and knee,
With shining unpouched eyes
And the blood, high-powered,
Leaping in flexible arteries—
The insolent, young, enthusiastic, undiscriminating
 Committee,
Who would placard tombstones
And scatter leaflets even in graves,
Comes trampling with sacrilegious feet!

The old men turn stiffly,
Mumbling to each other.
They are gentle and torpid and busy with eating.
But one lifts a face of clayish pallor,
There is a dull fury in his eyes, like little rusty grates.
He rises slowly,
Trembling in his many swathings like an awakened mummy,
Ridiculous yet terrible.
—And the Committee flings him a waste glance,
Dropping a leaflet by his plate.

A lone fire flickers in the dusty eyes.
The lips chant inaudibly.
The warped shrunken body straightens like a tree.
And he curses . . .
With uplifted arms and perished fingers,
Claw-like, clutching . . .

So centuries ago
The old men cursed Acosta,
When they, prophetic, heard upon their sepulchres
Those feet that may not halt nor turn aside for ancient things.

VII

Here in this room, bare like a barn,
Egos gesture one to the other—
Naked, unformed, unwinged
Egos out of the shell,
Examining, searching, devouring—
Avid alike for the flower or the dung . . .
(Having no dainty antennae for the touch and withdrawal—
Only the open maw . . .)

Egos cawing,
Expanding in the mean egg . . .
Little squat tailors with unkempt faces,
Pale as lard,
Fur-makers, factory-hands, shop-workers,
News-boys with battling eyes
And bodies yet vibrant with the momentum of long runs,
Here and there a woman . . .

Words, words, words,
Pattering like hail,
Like hail falling without aim . . .
Egos rampant,
Screaming each other down.
One motions perpetually,
Waving arms like overgrowths.
He has burning eyes and a cough
And a thin voice piping
Like a flute among trombones.

One, red-bearded, rearing
A welter of maimed face bashed in from some old wound,
Garbles Max Stirner.
His words knock each other like little wooden blocks.
No one heeds him,
And a lank boy with hair over his eyes
Pounds upon the table.
—He is chairman.

Egos yet in the primer,
Hearing world-voices
Chanting grand arias . . .
Majors resonant,
Stunning with sound . . .
Baffling minors

Half-heard like rain on pools . . .
Majestic discordances
Greater than harmonies . . .
—Gleaning out of it all
Passion, bewilderment, pain. . .

Egos yearning with the world-old want in their eyes—
Hurt hot eyes that do not sleep enough . . .
Striving with infinite effort,
Frustrate yet ever pursuing
The great white Liberty,
Trailing her dissolving glory over each hard-won barricade—
Only to fade anew . . .

Egos crying out of unkempt deeps
And wavering their dreams like flags—
Multi-colored dreams,
Winged and glorious . . .

A gas jet throws a stunted flame,
Vaguely illumining the groping faces.
And through the uncurtained window
Falls the waste light of stars,
As cold as wise men's eyes . . .
Indifferent great stars,
Fortuitously glancing
At the secret meeting in this shut-in room,
Bare as a manger.

VIII

Lights go out
And the stark trunks of the factories
Melt into the drawn darkness,
Sheathing like a seamless garment.

And mothers take home their babies,
Waxen and delicately curled,
Like little potted flowers closed under the stars.

Lights go out
And the young men shut their eyes,
But life turns in them . . .

Life in the cramped ova
Tearing and rending asunder its living cells . . .
Wars, arts, discoveries, rebellions, travails, immolations, cataclysms,
 hates . . .
Pent in the shut flesh.
And the young men twist on their beds in languor and dizziness
 unsupportable . . .
Their eyes—heavy and dimmed
With dust of long oblivions in the gray pulp behind—
Staring as through choked glass.
And they gaze at the moon—throwing off a faint heat—
The moon, blond and burning, creeping to their cots
Softly, as on naked feet . . .
Lolling on the coverlet . . . like a woman offering her white body.

Nude glory of the moon!
That leaps like an athlete on the bosoms of the young girls stripped
 of their linens;
Stroking their breasts that are smooth and cool as mother-of-pearl
Till the nipples tingle and burn as though little lips plucked at them.
They shudder and grow faint.
And their ears are filled as with a delirious rhapsody,
That Life, like a drunken player,
Strikes out of their clear white bodies
As out of ivory keys.

Lights go out . . .
And the great lovers linger in little groups, still passionately
 debating,
Or one may walk in silence, listening only to the still summons
 of Life—
Life making the great Demand . . .
Calling its new Christs . . .
Till tears come, blurring the stars
That grow tender and comforting like the eyes of comrades;
And the moon rolls behind the Battery
Like a word molten out of the mouth of God.

Lights go out. . .
And colors rush together,
Fusing and floating away . . .
Pale worn gold like the settings of old jewels . . .
Mauves, exquisite, tremulous, and luminous purples
And burning spires in aureoles of light
Like shimmering auras.

They are covering up the pushcarts . . .
Now all have gone save an old man with mirrors—
Little oval mirrors like tiny pools.
He shuffles up a darkened street
And the moon burnishes his mirrors till they shine like
 phosphorus . . .
The moon like a skull,
Staring out of eyeless sockets at the old men trundling home
 the pushcarts.

IX

A sallow dawn is in the sky
As I enter my little green room.

Sadie's light is still burning . . .
Without, the frail moon
Worn to a silvery tissue,
Throws a faint glamour on the roofs,
And down the shadowy spires
Lights tip-toe out . . .
Softly as when lovers close street doors.

Out of the Battery
A little wind
Stirs idly—as an arm
Trails over a boat's side in dalliance—
Rippling the smooth dead surface of the heat,
And Hester street,
Like a forlorn woman over-born
By her babies at her teats,
Turns on her trampled bed to meet the day.

LIFE!
Startling, vigorous life,
That squirms under my touch,
And baffles me when I try to examine it,
Or hurls me back without apology.
Leaving my ego ruffled and preening itself.

LIFE!
Articulate, shrill,
Screaming in provocative assertion,
Or out of the black and clotted gutters,
Piping in silvery thin
Sweet staccato
Of children's laughter,

Or clinging over the pushcarts
Like a litter of tiny bells

Or the jingle of silver coins,
Perpetually changing hands,
Or like the Jordan somberly
Swirling in tumultuous uncharted tides,
Surface-calm.

Electric currents of life,
Throwing off thoughts like sparks,
Glittering, disappearing,
Making unknown circuits,
Or out of spent particles stirring
Feeble contortions in old faiths
Passing before the new.

Long nights argued away
In meeting halls
Back of interminable stairways—
In Roumanian wine-shops
And little Russian tea-rooms . . .

Feet echoing through deserted streets
In the soft darkness before dawn . . .
Brows aching, throbbing, burning—
Life leaping in the shaken flesh
Like flame at an asbestos curtain.

Life—
Pent, overflowing
Stoops and façades,
Jostling, pushing, contriving,
Seething as in a great vat . . .

Bartering, changing, extorting,
Dreaming, debating, aspiring,

Astounding, indestructible
Life of the Ghetto . . .

Strong flux of life,
Like a bitter wine
Out of the bloody stills of the world . . .
Out of the Passion eternal.

Flotsam

Crass rays streaming from the vestibules;
Cafes glittering like jeweled teeth;
High-flung signs
Blinking yellow phosphorescent eyes;
Girls in black
Circling monotonously
About the orange lights . . .

Nothing to guess at . . .
Save the darkness above
Crouching like a great cat.

In the dim-lit square,
Where disheveled trees
Tustle with the wind—the wind like a scythe
Mowing their last leaves
Arcs shimmering through a greenish haze—
Pale oval arcs
Like ailing virgins,
Each out of a halo circumscribed,
Pallidly staring . . .

Figures drift upon the benches
With no more rustle than a dropped leaf settling—
Slovenly figures like untied parcels,
And papers wrapped about their knees
Huddled one to the other,
Cringing to the wind—
The sided wind,
Leaving no breach untried . . .

So many and all so still . . .
The fountain slobbering its stone basin
Is louder than They—
Flotsam of the five oceans
Here on this raft of the world.

This old man's head
Has found a woman's shoulder.
The wind juggles with her shawl
That flaps about them like a sail,
And splashes her red faded hair
Over the salt stubble of his chin.
A light foam is on his lips,
As though dreams surged in him
Breaking and ebbing away . . .
And the bare boughs shuffle above him
And the twigs rattle like dice . . .

She—diffused like a broken beetle—
Sprawls without grace,
Her face gray as asphalt,
Her jaws sagging as on loosened hinges . . .
Shadows ply about her mouth—
Nimble shadows out of the jigging tree,
That dances above her its dance of dry bones.

II

A uniformed front,
Paunched;
A glance like a blow,
The swing of an arm,
Verved, vigorous;
Boot-heels clanking
In metallic rhythm;

The blows of a baton,
Quick, staccato . . .

—There is a rustling along the benches
As of dried leaves raked over . . .
And the old man lifts a shaking palsied hand,
Tucking the displaced paper about his knees.

Colder . . .
And a frost under foot,
Acid, corroding,
Eating through worn bootsoles.

Drab forms blur into greenish vapor.
Through boughs like cross-bones,
Pale arcs flare and shiver
Like lilies in a wind.

High over Broadway
A far-flung sign
Glitters in indigo darkness
And spurts again rhythmically,
Spraying great drops
Red as a hemorrhage.

Death Ray

I

There is that in the air, an imminence
Of things that hold the breath still and heart pale;
Nought that the mind affirms, but a fey sense
Illumines, and goes dark. Can it avail
For men to follow what but dreams have had
In high and secret places—the dim torch
That Zarathustra blew on and went mad.

Was this the gleam that Jesus sought by night,
When he walked, veiled . . . in glamorous dim light
Washed, as a white goat before the slaughter . . .
And heard no sound save the soft rhythmic beat
Upon the silken silence of his feet
Beautiful as gulls upon the water.

II

A joy is in the morning, veiled . . .
a light within a light . . .
now on the brick wall that burns to rose
and all but pulsates, now a gleam
as of a white soaring bird
that eyes strain for and lose sight . . .
now in a nimbus as of steam,
surrounding a clear flame,
invisible.

A joy floats in the morning, veiled . . .
a light within a light
that draws the trembling spirit like a seed . . .
a splendour in the morning, imminent,
a stirring at the quick
of some white palpitating core
of such intensity as might
burn up Manhattan like a reed.

III

Dawn is like a broken honeycomb
spilling over the waxen edges of the clouds
 that drip with light . . .
spires, swarming up the mauve mist,
reach those rosy tips
like little pointed tongues
first about a shining platter,
and every window is a brazier
that cups the living gold.

Even the squat chimneys,
rooting heaven,
catch the sun upon their snouts
 and keep it balancing.

Only my heart
like a splintered vase
is envious of the light
it cannot hold.

IV

Balance a sunbeam as you would a jar
Filled with clear water where no waters are . . .

Let not slip silently back in the sun,
There to be as in a field no more than one
Of many dandelions . . . this nuclear
Period set against the rushing hour
That holds there, motionless, the leaning sheer
Stalk of its unfathomable flower.

Let pass into the night its shining band,
So that they leave the covenant in your hand
Of lighted water, and the prideful calm
Of hilltops in most high untaken air:
Yet know that there shall cleave forever there
A golden nailhead, burning in your palm.

The Fifth-Floor Window

Walls . . . iridescent with eyes
that stare into the courtyard
at the still thing lying
in the turned-back snow . . .
stark precipice of walls
with a foam of white faces
lathering their stone lips . . .
faces of the shawled women
the walls pour forth without aim
under the vast pallor of the sky.

They point at the fifth-floor window
and whisper one to the other:
"It's hard on a man out of work
an' the mother gone out of his door
with a younger lover . . . "

The blanched morning stares
in like a face flattened against the pane
where the little girl used to cry all day
with a feeble and goading cry.
Her father, with his eyes at bay
before the vague question of the light,
says that she fell . . .
Between his twitching lips
a stump of cigarette
smolders, like a burning root.

Only the wind was abroad
in high cold hours

of the icy and sightless night
with back to the stars—
night growing white and still as a pillar of salt
and the snow mushing without sound—
when something hurtled through the night
and drifted like a larger snow-flake
in the trek of the blind snow
that stumbled over it in heaps—
only white-furred wind
pawed at the fifth-floor window
and nosed cigarette-butts on the sill . . .
till the window closed down softly
on the silvery fleece of wind
that tore and left behind its flying fringes.

Now the wind
down the valley of the tenements
sweeps in weakened rushes
and meddles with the clothes-lines
where little white pinafores sway stiffly
like dead geese.
Over the back-yards
that are laid out smooth and handsome as a corpse
under the seamless snow,
the sky is a vast ash-pit
where the buried sun
rankles in a livid spot.

Appulse

Light, drifting on still waters, like a gull
That floats asleep, make room upon that breast—
Too heavily jeweled for such sheer rest
As he, who entered quietly at lull
Of the tide, needs. Impinge on his deep calm,
Wherein lithe, avid, little bodies swarm . . .
Your cool flame, like a lily's, cannot warm,
Resuscitate, his chilled and needy palm.

Yet be a shining stillness in the world
That foams about his edges—a bright norm
Of light, encircled on all sides, a-spin,
Where thought at its own axis may be whorled
Motionless, as at the hollow of a storm
That twirls with the winged things it sucks therein.

Gertrude Stein

from *Tender Buttons: Objects*

A CARAFE, THAT IS A BLIND GLASS.

A kind in glass and a cousin, a spectacle and nothing strange a single hurt color and an arrangement in a system to pointing. All this and not ordinary, not unordered in not resembling. The difference is spreading.

GLAZED GLITTER.

Nickel, what is nickel, it is originally rid of a cover.

The change in that is that red weakens an hour. The change has come. There is no search. But there is, there is that hope and that interpretation and sometime, surely any is unwelcome, sometime there is breath and there will be a sinecure and charming very charming is that clean and cleansing. Certainly glittering is handsome and convincing.

There is no gratitude in mercy and in medicine. There can be breakages in Japanese. That is no programme. That is no color chosen. It was chosen yesterday, that showed spitting and perhaps washing and polishing. It certainly showed no obligation and perhaps if borrowing is not natural there is some use in giving.

A SUBSTANCE IN A CUSHION.

The change of color is likely and a difference a very little difference is prepared. Sugar is not a vegetable.

Callous is something that hardening leaves behind what will be soft if there is a genuine interest in there being present as many girls as men. Does this change. It shows that dirt is clean when there is a volume.

A cushion has that cover. Supposing you do not like to change, supposing it is very clear that there is no change in appearance, supposing that there is regularity and a costume is that any the worse than an oyster and an exchange. Come to season that is there any extreme use in feather and cotton. Is there not much more joy in a table and more chairs and very likely roundness and a place to put them.

A circle of fine card board and a chance to see a tassel.

What is the use of a violent kind of delightfulness if there is no pleasure in not getting tired of it. The question does not come before there is a quotation. In any kind of place there is a top to covering and it is a pleasure at any rate there is some venturing in refusing to believe nonsense. It shows what use there is in a whole piece if one uses it and it is extreme and very likely the little things could be dearer but in any case there is a bargain and if there is the best thing to do is to take it away and wear it and then be reckless be reckless and resolved on returning gratitude.

Light blue and the same red with purple makes a change. It shows that there is no mistake. Any pink shows that and very likely it is reasonable. Very likely there should not be a finer fancy present. Some increase means a calamity and this is the best preparation for three and more being together. A little calm is so ordinary and in any case there is sweetness and some of that.

A seal and matches and a swan and ivy and a suit.

A closet, a closet does not connect under the bed. The band if it is white and black, the band has a green string. A sight a whole sight and a little groan grinding makes a trimming such a sweet singing trimming and a red thing not a round thing but a white thing, a red thing and a white thing.

The disgrace is not in carelessness nor even in sewing it comes out out of the way.

What is the sash like. The sash is not like anything mustard it is not like a same thing that has stripes, it is not even more hurt than that, it has a little top.

A BOX.

Out of kindness comes redness and out of rudeness comes rapid same question, out of an eye comes research, out of selection comes painful cattle. So then the order is that a white way of being round is something suggesting a pin and is it disappointing, it is not, it is so rudimentary to be analysed and see a fine substance strangely, it is so earnest to have a green point not to red but to point again.

A PIECE OF COFFEE.

More of double.

A place in no new table.

A single image is not splendor. Dirty is yellow. A sign of more in not mentioned. A piece of coffee is not a detainer. The resemblance to yellow is dirtier and distincter. The clean mixture is whiter and not coal color, never more coal color than altogether.

The sight of a reason, the same sight slighter, the sight of a simpler negative answer, the same sore sounder, the intention to wishing, the same splendor, the same furniture.

The time to show a message is when too late and later there is no hanging in a blight.

A not torn rose-wood color. If it is not dangerous then a pleasure and more than any other if it is cheap is not cheaper. The amusing side is that the sooner there are no fewer the more certain is the necessity dwindled. Supposing that the case contained rose-wood and a color. Supposing that there was no reason for a distress and more likely for a number, supposing that there was no astonishment, it is not necessary to mingle astonishment.

The settling of stationing cleaning is one way not to shatter scatter and scattering. The one way to use custom is to use soap and silk for

cleaning. The one way to see cotton is to have a design concentrating the illusion and the illustration. The perfect way is to accustom the thing to have a lining and the shape of a ribbon and to be solid, quite solid in standing and to use heaviness in morning. It is light enough in that. It has that shape nicely. Very nicely may not be exaggerating. Very strongly may be sincerely fainting. May be strangely flattering. May not be strange in everything. May not be strange to.

DIRT AND NOT COPPER.

Dirt and not copper makes a color darker. It makes the shape so heavy and makes no melody harder.

It makes mercy and relaxation and even a strength to spread a table fuller. There are more places not empty. They see cover.

NOTHING ELEGANT.

A charm a single charm is doubtful. If the red is rose and there is a gate surrounding it, if inside is let in and there places change then certainly something is upright. It is earnest.

MILDRED'S UMBRELLA.

A cause and no curve, a cause and loud enough, a cause and extra a loud clash and an extra wagon, a sign of extra, a sac a small sac and an established color and cunning, a slender grey and no ribbon, this means a loss a great loss a restitution.

A METHOD OF A CLOAK.

A single climb to a line, a straight exchange to a cane, a desperate adventure and courage and a clock, all this which is a system, which has feeling, which has resignation and success, all makes an attractive black silver.

A RED STAMP.

If lilies are lily white if they exhaust noise and distance and even dust, if they dusty will dirt a surface that has no extreme grace, if they do this and it is not necessary it is not at all necessary if they do this they need a catalogue.

A BOX.

A large box is handily made of what is necessary to replace any substance. Suppose an example is necessary, the plainer it is made the more reason there is for some outward recognition that there is a result.

A box is made sometimes and them to see to see to it neatly and to have the holes stopped up makes it necessary to use paper.

A custom which is necessary when a box is used and taken is that a large part of the time there are three which have different connections. The one is on the table. The two are on the table. The three are on the table. The one, one is the same length as is shown by the cover being longer. The other is different there is more cover that shows it. The other is different and that makes the corners have the same shade the eight are in singular arrangement to make four necessary.

Lax, to have corners, to be lighter than some weight, to indicate a wedding journey, to last brown and not curious, to be wealthy, cigarettes are established by length and by doubling.

Left open, to be left pounded, to be left closed, to be circulating in summer and winter, and sick color that is grey that is not dusty and red shows, to be sure cigarettes do measure an empty length sooner than a choice in color.

Winged, to be winged means that white is yellow and pieces pieces that are brown are dust color if dust is washed off, then it is choice that is to say it is fitting cigarettes sooner than paper.

An increase why is an increase idle, why is silver cloister, why is

the spark brighter, if it is brighter is there any result, hardly more than ever.

A PLATE.

An occasion for a plate, an occasional resource is in buying and how soon does washing enable a selection of the same thing neater. If the party is small a clever song is in order.

Plates and a dinner set of colored china. Pack together a string and enough with it to protect the center, cause a considerable haste and gather more as it is cooling, collect more trembling and not any even trembling, cause a whole thing to be a church.

A sad size a size that is not sad is blue as every bit of blue is precocious. A kind of green a game in green and nothing flat nothing quite flat and more round, nothing a particular color strangely, nothing breaking the losing of no little piece.

A splendid address a really splendid address is not shown by giving a flower freely, it is not shown by a mark or by wetting.

Cut cut in white, cut in white so lately. Cut more than any other and show it. Show it in the stem and in starting and in evening coming complication.

A lamp is not the only sign of glass. The lamp and the cake are not the only sign of stone. The lamp and the cake and the cover are not the only necessity altogether.

A plan a hearty plan, a compressed disease and no coffee, not even a card or a change to incline each way, a plan that has that excess and that break is the one that shows filling.

A SELTZER BOTTLE.

Any neglect of many particles to a cracking, any neglect of this makes around it what is lead in color and certainly discolor in silver. The use of this is manifold. Supposing a certain time selected is assured, suppose it is even necessary, suppose no other extract is permitted and no more handling is needed, suppose the rest of

the message is mixed with a very long slender needle and even if it could be any black border, supposing all this altogether made a dress and suppose it was actual, suppose the mean way to state it was occasional, if you suppose this in August and even more melodiously, if you suppose this even in the necessary incident of there certainly being no middle in summer and winter, suppose this and an elegant settlement a very elegant settlement is more than of consequence, it is not final and sufficient and substituted. This which was so kindly a present was constant.

A LONG DRESS.

What is the current that makes machinery, that makes it crackle, what is the current that presents a long line and a necessary waist. What is this current.

What is the wind, what is it.

Where is the serene length, it is there and a dark place is not a dark place, only a white and red are black, only a yellow and green are blue, a pink is scarlet, a bow is every color. A line distinguishes it. A line just distinguishes it.

A RED HAT.

A dark grey, a very dark grey, a quite dark grey is monstrous ordinarily, it is so monstrous because there is no red in it. If red is in everything it is not necessary. Is that not an argument for any use of it and even so is there any place that is better, is there any place that has so much stretched out.

A BLUE COAT.

A blue coat is guided guided away, guided and guided away, that is the particular color that is used for that length and not any width not even more than a shadow.

A PIANO.

If the speed is open, if the color is careless, if the event is overtaken, if the selection of a strong scent is not awkward, if the button holder is held by all the waving color and there is no color, not any color. If there is no dirt in a pin and there can be none scarcely, if there is not then the place is the same as up standing.

This is no dark custom and it even is not acted in any such a way that a restraint is not spread. That is spread, it shuts and it lifts and awkwardly not awkwardly the center is in standing.

A CHAIR.

A widow in a wise veil and more garments shows that shadows are even. It addresses no more, it shadows the stage and learning. A regular arrangement, the severest and the most preserved is that which has the arrangement not more than always authorised.

A suitable establishment, well housed, practical, patient and staring, a suitable bedding, very suitable and not more particularly than complaining, anything suitable is so necessary.

A fact is that when the direction is just like that, no more, longer, sudden and at the same time not any sofa, the main action is that without a blaming there is no custody.

Practice measurement, practice the sign that means that really means a necessary betrayal, in showing that there is wearing.

Hope, what is a spectacle, a spectacle is the resemblance between the circular side place and nothing else, nothing else.

To choose it is ended, it is actual and more than that it has it certainly has the same treat, and a seat all that is practiced and more easily much more easily ordinary.

Pick a barn, a whole barn, and bend more slender accents than have ever been necessary, shine in the darkness necessarily.

Actually not aching, actually not aching, a stubborn bloom is so artificial and even more than that, it is a spectacle, it is a binding accident, it is animosity and accentuation.

If the chance to dirty diminishing is necessary, if it is why is there no complexion, why is there no rubbing, why is there no special protection.

A FRIGHTFUL RELEASE.

A bag which was left and not only taken but turned away was not found. The place was shown to be very like the last time. A piece was not exchanged, not a bit of it, a piece was left over. The rest was mismanaged.

A PURSE.

A purse was not green, it was not straw color, it was hardly seen and it had a use a long use and the chain, the chain was never missing, it was not misplaced, it showed that it was open, that is all that it showed.

A MOUNTED UMBRELLA.

What was the use of not leaving it there where it would hang what was the use if there was no chance of ever seeing it come there and show that it was handsome and right in the way it showed it. The lesson is to learn that it does show it, that it shows it and that nothing, that there is nothing, that there is no more to do about it and just so much more is there plenty of reason for making an exchange.

A CLOTH.

Enough cloth is plenty and more, more is almost enough for that and besides if there is no more spreading is there plenty of room for it. Any occasion shows the best way.

MORE.

An elegant use of foliage and grace and a little piece of white cloth and oil.

Wondering so winningly in several kinds of oceans is the reason that makes red so regular and enthusiastic. The reason that there is more snips are the same shining very colored rid of no round color.

A NEW CUP AND SAUCER.

Enthusiastically hurting a clouded yellow bud and saucer, enthusiastically so is the bite in the ribbon.

OBJECTS.

Within, within the cut and slender joint alone, with sudden equals and no more than three, two in the centre make two one side.

If the elbow is long and it is filled so then the best example is all together.

The kind of show is made by squeezing.

EYE GLASSES.

A color in shaving, a saloon is well placed in the centre of an alley.

A CUTLET.

A blind agitation is manly and uttermost.

CARELESS WATER.

No cup is broken in more places and mended, that is to say a plate is broken and mending does do that it shows that culture is Japanese. It shows the whole element of angels and orders. It does

more to choosing and it does more to that ministering counting. It does, it does change in more water.

Supposing a single piece is a hair supposing more of them are orderly, does that show that strength, does that show that joint, does that show that balloon famously. Does it.

A PAPER.

A courteous occasion makes a paper show no such occasion and this makes readiness and eyesight and likeness and a stool.

A DRAWING.

The meaning of this is entirely and best to say the mark, best to say it best to show sudden places, best to make bitter, best to make the length tall and nothing broader, anything between the half.

WATER RAINING.

Water astonishing and difficult altogether makes a meadow and a stroke.

COLD CLIMATE.

A season in yellow sold extra strings makes lying places.

MALACHITE.

The sudden spoon is the same in no size. The sudden spoon is the wound in the decision.

AN UMBRELLA.

Coloring high means that the strange reason is in front not more in front behind. Not more in front in peace of the dot.

A PETTICOAT.

A light white, a disgrace, an ink spot, a rosy charm.

A WAIST.

A star glide, a single frantic sullenness, a single financial grass greediness.

Object that is in wood. Hold the pine, hold the dark, hold in the rush, make the bottom.

A piece of crystal. A change, in a change that is remarkable there is no reason to say that there was a time.

A woolen object gilded. A country climb is the best disgrace, a couple of practices any of them in order is so left.

A TIME TO EAT.

A pleasant simple habitual and tyrannical and authorised and educated and resumed and articulate separation. This is not tardy.

A LITTLE BIT OF A TUMBLER.

A shining indication of yellow consists in there having been more of the same color than could have been expected when all four were bought. This was the hope which made the six and seven have no use for any more places and this necessarily spread into nothing. Spread into nothing.

A FIRE.

What was the use of a whole time to send and not send if there was to be the kind of thing that made that come in. A letter was nicely sent.

A HANDKERCHIEF.

A winning of all the blessings, a sample not a sample because there is no worry.

RED ROSES.

A cool red rose and a pink cut pink, a collapse and a sold hole, a little less hot.

IN BETWEEN.

In between a place and candy is a narrow foot-path that shows more mounting than anything, so much really that a calling meaning a bolster measured a whole thing with that. A virgin a whole virgin is judged made and so between curves and outlines and real seasons and more out glasses and a perfectly unprecedented arrangement between old ladies and mild colds there is no satin wood shining.

COLORED HATS.

Colored hats are necessary to show that curls are worn by an addition of blank spaces, this makes the difference between single lines and broad stomachs, the least thing is lightening, the least thing means a little flower and a big delay a big delay that makes more nurses than little women really little women. So clean is a light that nearly all of it shows pearls and little ways. A large hat is tall and me and all custard whole.

A FEATHER.

A feather is trimmed, it is trimmed by the light and the bug and the post, it is trimmed by little leaning and by all sorts of mounted reserves and loud volumes. It is surely cohesive.

A BROWN.

A brown which is not liquid not more so is relaxed and yet there is a change, a news is pressing.

A LITTLE CALLED PAULINE.

A little called anything shows shudders.

Come and say what prints all day. A whole few watermelon. There is no pope.

No cut pennies and little dressing and choose wide soles and little spats really little spices.

A little lace makes boils. This is not true.

Gracious of gracious and a stamp a blue green white bow a blue green lean, lean on the top.

If it is absurd then it is leadish and nearly set in where there is a tight head.

A peaceful life to arise her, noon and moon and moon. A letter a cold sleeve a blanket a shaving house and nearly the best and regular window.

Nearer in fairy sea, nearer and farther, show white has lime in sight, show a stitch of ten. Count, count more so that thicker and thicker is leaning.

I hope she has her cow. Bidding a wedding, widening received treading, little leading mention nothing.

Cough out cough out in the leather and really feather it is not for.

Please could, please could, jam it not plus more sit in when.

A SOUND.

Elephant beaten with candy and little pops and chews all bolts and reckless reckless rats, this is this.

A TABLE.

A table means does it not my dear it means a whole steadiness. Is it likely that a change.

A table means more than a glass even a looking glass is tall. A table means necessary places and a revision a revision of a little thing it means it does mean that there has been a stand, a stand where it did shake.

SHOES.

To be a wall with a damper a stream of pounding way and nearly enough choice makes a steady midnight. It is pus.

A shallow hole rose on red, a shallow hole in and in this makes ale less. It shows shine.

A DOG.

A little monkey goes like a donkey that means to say that means to say that more sighs last goes. Leave with it. A little monkey goes like a donkey.

A WHITE HUNTER.

A white hunter is nearly crazy.

A LEAVE.

In the middle of a tiny spot and nearly bare there is a nice thing to say that wrist is leading. Wrist is leading.

SUPPOSE AN EYES.

Suppose it is within a gate which open is open at the hour of closing summer that is to say it is so.

All the seats are needing blackening. A white dress is in sign.
A soldier a real soldier has a worn lace a worn lace of different
sizes that is to say if he can read, if he can read he is a size to show
shutting up twenty-four.

Go red go red, laugh white.

Suppose a collapse in rubbed purr, in rubbed purr get.

Little sales ladies little sales ladies little saddles of mutton.

Little sales of leather and such beautiful beautiful, beautiful
beautiful.

A SHAWL.

A shawl is a hat and hurt and a red balloon and an under coat and
a sizer a sizer of talks.

A shawl is a wedding, a piece of wax a little build. A shawl.

Pick a ticket, pick it in strange steps and with hollows. There is
hollow hollow belt, a belt is a shawl.

A plate that has a little bobble, all of them, any so.

Please a round it is ticket.

It was a mistake to state that a laugh and a lip and a laid climb and
a depot and a cultivator and little choosing is a point it.

BOOK.

Book was there, it was there. Book was there. Stop it, stop it, it
was a cleaner, a wet cleaner and it was not where it was wet, it was
not high, it was directly placed back, not back again, back it was
returned, it was needless, it put a bank, a bank when, a bank care.

Suppose a man a realistic expression of resolute reliability
suggests pleasing itself white all white and no head does that mean
soap. It does not so. It means kind wavers and little chance to beside
beside rest. A plain.

Suppose ear rings, that is one way to breed, breed that. Oh chance
to say, oh nice old pole. Next best and nearest a pillar. Chest not

valuable, be papered.

Cover up cover up the two with a little piece of string and hope rose and green, green.

Please a plate, put a match to the seam and really then really then, really then it is a remark that joins many many lead games. It is a sister and sister and a flower and a flower and a dog and a colored sky a sky colored grey and nearly that nearly that let.

PEELED PENCIL, CHOKE.

Rub her coke.

IT WAS BLACK, BLACK TOOK.

Black ink best wheel bale brown.

Excellent not a hull house, not a pea soup, no bill no care, no precise no past pearl pearl goat.

THIS IS THIS DRESS, AIDER.

Aider, why aider why whow, whow stop touch, aider whow, aider stop the muncher, muncher munchers.

A jack in kill her, a jack in, makes a meadowed king, makes a to let.

from *Tender Buttons*

ROASTBEEF.

In the inside there is sleeping, in the outside there is reddening, in the morning there is meaning, in the evening there is feeling. In the evening there is feeling. In feeling anything is resting, in feeling anything is mounting, in feeling there is resignation, in feeling there is recognition, in feeling there is recurrence and entirely mistaken there is pinching. All the standards have steamers and all the curtains have bed linen and all the yellow has discrimination and all the circle has circling. This makes sand.

Very well. Certainly the length is thinner and the rest, the round rest has a longer summer. To shine, why not shine, to shine, to station, to enlarge, to hurry the measure all this means nothing if there is singing, if there is singing then there is the resumption.

The change the dirt, not to change dirt means that there is no beefsteak and not to have that is no obstruction, it is so easy to exchange meaning, it is so easy to see the difference. The difference is that a plain resource is not entangled with thickness and it does not mean that thickness shows such cutting, it does mean that a meadow is useful and a cow absurd. It does not mean that there are tears, it does not mean that exudation is cumbersome, it means no more than a memory, a choice and a reestablishment, it means more than any escape from a surrounding extra. All the time that there is use there is use and any time there is a surface there is a surface, and every time there is an exception there is an exception and every time there is a division there is a dividing. Any time there is a surface there is a surface and every time there is a suggestion there is a suggestion and every time there is silence there is silence and every time that is languid there is that there then and not oftener, not always, not particular, tender and changing and external and

central and surrounded and singular and simple and the same and the surface and the circle and the shine and the succor and the white and the same and the better and the red and the same and the centre and the yellow and the tender and the better, and altogether.

Considering the circumstances there is no occasion for a reduction, considering that there is no pealing there is no occasion for an obligation, considering that there is no outrage there is no necessity for any reparation, considering that there is no particle sodden there is no occasion for deliberation. Considering everything and which way the turn is tending, considering everything why is there no restraint, considering everything what makes the place settle and the plate distinguish some specialties. The whole thing is not understood and this is not strange considering that there is no education, this is not strange because having that certainly does show the difference in cutting, it shows that when there is turning there is no distress.

In kind, in a control, in a period, in the alteration of pigeons, in kind cuts and thick and thin spaces, in kind ham and different colors, the length of leaning a strong thing outside not to make a sound but to suggest a crust, the principal taste is when there is a whole chance to be reasonable, this does not mean that there is overtaking, this means nothing precious, this means clearly that the chance to exercise is a social success. So then the sound is not obtrusive. Suppose it is obtrusive suppose it is. What is certainly the desertion is not a reduced description, a description is not a birthday.

Lovely snipe and tender turn, excellent vapor and slender butter, all the splinter and the trunk, all the poisonous darkening drunk, all the joy in weak success, all the joyful tenderness, all the section and the tea, all the stouter symmetry.

Around the size that is small, inside the stern that is the middle, besides the remains that are praying, inside the between that is turning, all the region is measuring and melting is exaggerating.

Rectangular ribbon does not mean that there is no eruption it means that if there is no place to hold there is no place to spread.

Kindness is not earnest, it is not assiduous it is not revered.

Room to comb chickens and feathers and ripe purple, room to curve single plates and large sets and second silver, room to send everything away, room to save heat and distemper, room to search a light that is simpler, all room has no shadow.

There is no use there is no use at all in smell, in taste, in teeth, in toast, in anything, there is no use at all and the respect is mutual.

Why should that which is uneven, that which is resumed, that which is tolerable why should all this resemble a smell, a thing is there, it whistles, it is not narrower, why is there no obligation to stay away and yet courage, courage is everywhere and the best remains to stay.

If there could be that which is contained in that which is felt there would be a chair where there are chairs and there would be no more denial about a clatter. A clatter is not a smell. All this is good.

The Saturday evening which is Sunday is every week day. What choice is there when there is a difference. A regulation is not active. Thirstiness is not equal division.

Anyway, to be older and ageder is not a surfeit nor a suction, it is not dated and careful, it is not dirty. Any little thing is clean, rubbing is black. Why should ancient lambs be goats and young colts and never beef, why should they, they should because there is so much difference in age.

A sound, a whole sound is not separation, a whole sound is in an order.

Suppose there is a pigeon, suppose there is.

Looseness, why is there a shadow in a kitchen, there is a shadow in a kitchen because every little thing is bigger.

The time when there are four choices and there are four choices in a difference, the time when there are four choices there is a kind and there is a kind. There is a kind. There is a kind. Supposing there is a bone, there is a bone. Supposing there are bones. There are bones. When there are bones there is no supposing there are bones. There are bones and there is that consuming. The kindly way to feel separating is to have a space between. This shows a likeness.

Hope in gates, hope in spoons, hope in doors, hope in tables, no hope in daintiness and determination. Hope in dates.

Tin is not a can and a stove is hardly. Tin is not necessary and neither is a stretcher. Tin is never narrow and thick.

Color is in coal. Coal is outlasting roasting and a spoonful, a whole spoon that is full is not spilling. Coal any coal is copper.

Claiming nothing, not claiming anything, not a claim in everything, collecting claiming, all this makes a harmony, it even makes a succession.

Sincerely gracious one morning, sincerely graciously trembling, sincere in gracious eloping, all this makes a furnace and a blanket. All this shows quantity.

Like an eye, not so much more, not any searching, no compliments.

Please be the beef, please beef, pleasure is not wailing. Please beef, please be carved clear, please be a case of consideration.

Search a neglect. A sale, any greatness is a stall and there is no memory, there is no clear collection.

A satin sight, what is a trick, no trick is mountainous and the color, all the rush is in the blood.

Bargaining for a little, bargain for a touch, a liberty, an estrangement, a characteristic turkey.

Please spice, please no name, place a whole weight, sink into a standard rising, raise a circle, choose a right around, make the resonance accounted and gather green any collar.

To bury a slender chicken, to raise an old feather, to surround a garland and to bake a pole splinter, to suggest a repose and to settle simply, to surrender one another, to succeed saving simpler, to satisfy a singularity and not to be blinder, to sugar nothing darker and to read redder, to have the color better, to sort out dinner, to remain together, to surprise no sinner, to curve nothing sweeter, to continue thinner, to increase in resting recreation to design string not dimmer.

Cloudiness what is cloudiness, is it a lining, is it a roll, is it melting.

The sooner there is jerking, the sooner freshness is tender, the sooner the round it is not round the sooner it is withdrawn in cutting, the sooner the measure means service, the sooner there is chinking, the sooner there is sadder than salad, the sooner there is none do her, the sooner there is no choice, the sooner there is a gloom freer, the same sooner and more sooner, this is no error in hurry and in pressure and in opposition to consideration.

A recital, what is a recital, it is an organ and use does not strengthen valor, it soothes medicine.

A transfer, a large transfer, a little transfer, some transfer, clouds and tracks do transfer, a transfer is not neglected.

Pride, when is there perfect pretence, there is no more than yesterday and ordinary.

A sentence of a vagueness that is violence is authority and a mission and stumbling and also certainly also a prison. Calmness, calm is beside the plate and in way in. There is no turn in terror. There is no volume in sound.

There is coagulation in cold and there is none in prudence. Something is preserved and the evening is long and the colder spring has sudden shadows in a sun. All the stain is tender and lilacs really lilacs are disturbed. Why is the perfect reestablishment practiced and prized, why is it composed. The result the pure result is juice and size and baking and exhibition and nonchalance and sacrifice and volume and a section in division and the surrounding recognition and horticulture and no murmur. This is a result. There is no superposition and circumstance, there is hardness and a reason and the rest and remainder. There is no delight and no mathematics.

Susie Asado

Sweet sweet sweet sweet sweet tea.
 Susie Asado.
Sweet sweet sweet sweet sweet tea.
 Susie Asado.
Susie Asado which is a told tray sure.
A lean on the shoe this means slips slips hers.
When the ancient light grey is clean it is yellow, it is a silver seller.
This is a please this is a please there are the saids to jelly. These are the wets these say the sets to leave a crown to Incy.
Incy is short for incubus.
A pot. A pot is a beginning of a rare bit of trees. Trees tremble, the old vats are in bobbles, bobbles which shade and shove and render clean, render clean must.
 Drink pups.
Drink pups drink pups lease a sash hold, see it shine and a bobolink has pins. It shows a nail.
What is a nail. A nail is unison.
Sweet sweet sweet sweet sweet tea.

Yet Dish

I

Put a sun in Sunday, Sunday.
Eleven please ten hoop. Hoop.
Cousin coarse in coarse in soap.
Cousin coarse in soap sew up. soap.
Cousin coarse in sew up soap.

II

A lea ender stow sole lightly.
Not a bet beggar.
Nearer a true set jump hum,
A lamp lander so seen poor lip.

III

Never so round.
A is a guess and a piece.
A is a sweet cent sender.
A is a kiss slow cheese.
A is for age jet.

IV

New deck stairs.
Little in den little in dear den.

V

Polar pole.
Dust winder.
Core see.
A bale a bale o a bale.

VI

Extravagant new or noise peal extravagant.

VII

S a glass.
Roll ups.

VIII

Powder in wails powder in sails, powder is all next to it is does wait
sack rate all goals like chain in clear.

IX

Negligible old star.
Pour even.
It was a sad per cent.
Does on sun day.
Watch or water.
So soon a moon or a old heavy press.

X

Pearl cat or cat or pill or pour check.
New sit or little.
New sat or little not a wad yet.
Heavy toe heavy sit on head.

XI

Ex, ex, ex.
Bull it bull it bull it bull it.
Ex Ex Ex.

XII

Cousin plates pour a y shawl hood hair.
No see eat.

XIII

They are getting bad left log lope, should a court say stream,
not a dare long beat a soon port.

XIV

Colored will he.
Calamity.
Colored will he
Is it a soon. Is it a soon. Is it a soon. soon. Is it a soon. soon.

XV

Nobody's ice.
Nobody's ice to be knuckles.
Nobody's nut soon.
Nobody's seven picks.
Picks soap stacks.
Six in set on seven in seven told, to top.

XVI

A spread chin shone.
A set spread chin shone.

XVII

No people so sat.
Not an eider.
Not either. Not either either.

XVIII

Neglect, neglect use such.
Use such a man.
Neglect use such a man.
Such some here.

XIX

Note tie a stem bone single pair so itching.

XX

Little lane in lay in a circular crest.

XXI

Peace while peace while toast.
Paper eight paper eight or, paper eight ore white.

XXII

Coop pour.
Never a single ham.
Charlie. Charlie.

XXIII

Neglect or.
A be wade.
Earnest care lease.
Least ball sup.

XXIV

Meal dread.
Meal dread so or.
Meal dread so or bounce.
Meal dread so or bounce two sales. Meal dread so or bounce two
sails. Not a rice. No nor a pray seat, not a little muscle, not a nor
noble, not a cool right more than a song in every period of nails
and pieces pieces places of places.

XXV

Neat know.
Play in horizontal pet soap.

XXVI

Nice pose.
Supper bell.
Pull a rope pressed.
Color glass.

XXVII

Nice oil pail.
No gold go at.
Nice oil pail.
Near a paper lag sought.
What is an astonishing won door. A please spoon.

XXVIII

Nice knee nick ear.
Not a well pair in day.
Nice knee neck core.
What is a skin pour in day.

XXIX

Climb climb max.
Hundred in wait.
Paper cat or deliver.

XXX

Little drawers of center.
Neighbor of dot light.
Shorter place to make a boom set.
Marches to be bright.

XXXI

Suppose a do sat.
Suppose a negligence.
Suppose a cold character.

XXXII

Suppose a negligence.
Suppose a sell.
Suppose a neck tie.

XXXIII

Suppose a cloth cape.
Suppose letter suppose let a paper.
Suppose soon.

XXXIV

A prim a prim prize.
A sea pin.
A prim a prim prize
A sea pin.

XXXV

Witness a way go.
Witness a way go. Witness a way go. Wetness.
Wetness.

XXXVI

Lessons lettuce.
Let us peer let us polite let us pour, let us polite. Let us polite.

XXXVII

Neither is blessings bean.

XXXVIII

Dew Dew Drops.
Leaves kindly Lasts.
Dew Dew Drops.

XXXIX
A R. nuisance.
Not a regular plate.
Are, not a regular plate.

XL
Lock out sandy.
Lock out sandy boot trees.
Lock out sandy boot trees knit glass.
Lock out sandy boot trees knit glass.

XLI
A R not new since.
New since.
Are new since bows less.

XLII
A jell cake.
A jelly cake.
A jelly cake.

XLIII
Peace say ray comb pomp
Peace say ray comb pump
Peace say ray comb pomp
Peace say ray comb pomp.

XLIV
Lean over not a coat low.
Lean over not a coat low by stand.
Lean over net. Lean over net a coat low hour stemmed
Lean over a coat low a great send. Lean over coat low extra extend.

XLV
Copying Copying it in.

XLVI

Never second scent never second scent in stand. Never second scent in stand box or show. Or show me sales. Or show me sales oak. Oak pet. Oak pet stall.

XLVII

Not a mixed stick or not a mixed stick or glass. Not a mend stone bender, not a mend stone bender or stain.

XLVIII

Polish polish is it a hand, polish is it a hand or all, or all poles sick, or all poles sick.

XLIX

Rush in rush in slice.

L

Little gem in little gem in an. Extra.

LI

In the between egg in, in the between egg or on.

LII

Leaves of gas, leaves of get a towel louder.

LIII

Not stretch.

LIV

Tea Fulls.
Pit it pit it little saddle pear say.

LV

Let me see wheat air blossom.
Let me see tea.

LVI

Nestle in glass, nestle in walk, nestle in fur a lining.

LVII

Pale eaten best seek.

Pale eaten best seek, neither has met is a glance.

LVIII

Suppose it is a s. Suppose it is a seal. Suppose it is a recognized opera.

LIX

Not a sell inch, not a boil not a never seeking cellar.

LX

Little gem in in little gem in an. Extra.

LXI

Catch as catch as coal up.

LXII

Necklaces, neck laces, necklaces neck laces.

LXIII

Little in in in in.

LXIV

Next or Sunday, next or sunday check.

LXV

Wide in swim, wide in swim pansy.

LXVI

Next to hear next to hear old boat seak, old boat seak next to hear.

LXVII

Ape pail ape pail to glow.

LXVIII

It was in on an each tuck. It was in on an each tuck.

LXIX

Wire lean string, wire lean string excellent miss on one pepper cute.
Open so mister soil in to close not a see wind not seat glass.

Idem The Same:
A Valentine To Sherwood Anderson

I knew too that through them I knew too that he was through,
I knew too that he threw them. I knew too that they were through,
I knew too I knew too, I knew I knew them.
I knew to them.
If they tear a hunter through, if they tear through a hunter, if
they tear through a hunt and a hunter, if they tear through the
different sizes of the six, the different sizes of the six which are these,
a woman with a white package under one arm and a black package
under the other arm and dressed in brown with a white blouse,
the second Saint Joseph the third a hunter in a blue coat and black
garters and a plaid cap, a fourth a knife grinder who is full faced
and a very little woman with black hair and a yellow hat and an
excellently smiling appropriate soldier. All these as you please.
In the meantime examples of the same lily. In this way please have
you rung.

WHAT DO I SEE.
A very little snail.
A medium sized turkey.
A small band of sheep.
A fair orange tree.
All nice wives are like that.
Listen to them from here.
Oh.
You did not have an answer.
Here.
Yes.

A VERY VALENTINE.

Very fine is my valentine.

Very fine and very mine.

Very mine is my valentine very mine and very fine.

Very fine is my valentine and mine, very fine very mine and mine is my valentine.

WHY DO YOU FEEL DIFFERENTLY.

Why do you feel differently about a very little snail and a big one.

Why do you feel differently about a medium sized turkey and a very large one.

Why do you feel differently about a small band of sheep and several sheep that are riding.

Why do you feel differently about a fair orange tree and one that has blossoms as well.

Oh very well.

All nice wives are like that.

To Be.

No Please.

To Be

They can please

Not to be

Do they please.

Not to be

Do they not please

Yes please.

Do they please

No please.

Do they not please

No please.

Do they please.

Please.

If you please.

And if you please.

And if they please.
And they please.
To be pleased.
Not to be pleased.
Not to be displeased.
To be pleased and to please.

KNEELING.

One two three four five six seven eight nine and ten.

The tenth is a little one kneeling and giving away a rooster with this feeling.

I have mentioned one, four five seven eight and nine.

Two is also giving away an animal.

Three is changed as to disposition.

Six is in question if we mean mother and daughter, black and black caught her, and she offers to be three she offers it to me.

That is very right and should come out below and just so.

BUNDLES FOR THEM.
A HISTORY OF GIVING BUNDLES.

We were able to notice that each one in a way carried a bundle, they were not a trouble to them nor were they all bundles as some of them were chickens some of them pheasants some of them sheep and some of them bundles, they were not a trouble to them and then indeed we learned that it was the principal recreation and they were so arranged that they were not given away, and to-day they were given away.

I will not look at them again.

They will not look for them again.

They have not seen them here again.

They are in there and we hear them again.

In which way are stars brighter than they are. When we have come to this decision. We mention many thousands of buds. And when I close my eyes I see them.

If you hear her snore

It is not before you love her
You love her so that to be her beau is very lovely
She is sweetly there and her curly hair is very lovely
She is sweetly here and I am very near and that is very lovely.
She is my tender sweet and her little feet are stretched out well
which is a treat and very lovely
Her little tender nose is between her little eyes which close and
are very lovely.
She is very lovely and mine which is very lovely.

ON HER WAY.

If you can see why she feels that she kneels if you can see why he
knows that he shows what he bestows, if you can see why they share
what they share, need we question that there is no doubt that by this
time if they had intended to come they would have sent some notice
of such intention. She and they and indeed the decision itself is not
early dissatisfaction.

IN THIS WAY.

Keys please, it is useless to alarm any one it is useless to alarm
some one it is useless to be alarming and to get fertility in gardens in
salads in heliotrope and in dishes. Dishes and wishes are mentioned
and dishes and wishes are not capable of darkness. We like sheep.
And so does he.

LET US DESCRIBE.

Let us describe how they went. It was a very windy night and the
road although in excellent condition and extremely well graded
has many turnings and although the curves are not sharp the rise
is considerable. It was a very windy night and some of the larger
vehicles found it more prudent not to venture. In consequence some
of those who had planned to go were unable to do so. Many others
did go and there was a sacrifice, of what shall we, a sheep, a hen, a
cock, a village, a ruin, and all that and then that having been blessed
let us bless it.

from *Lifting Belly*

III

Lifting belly in here.

Able to state whimsies.

Can you recollect mistakes.

I hope not.

Bless you.

Lifting belly the best and only seat.

Lifting belly the reminder of present duties.

Lifting belly the charm.

Lifting belly is easy to me.

Lifting belly naturally.

Of course you lift belly naturally.

I lift belly naturally together.

Lifting belly answers.

Can you think for me.

I can.

Lifting belly endears me.

Lifting belly cleanly. With a wood fire. With a good fire.

Say how do you do to the lady. Which lady. The jew lady. How do you do. She is my wife.

Can you accuse lifting belly of extras.

Salmon is salmon. Smoked and the most nourishing.

Pink salmon is my favorite color.

To be sure.

We are so necessary.

Can you wish for me.

I never mention it.

You need not resemble me.

But you do.

Of course you do.

That is very well said.
And meant.
And explained.
I explain too much.
And then I say.
She knows everything.
And she does.
Lifting belly beneficently.
I can go on with lifting belly forever. And you do.
I said it first. Lifting belly to engage. And then wishes. I wish to be whimsied. I do that.
A worldly system.
A humorous example.
Lindo see me.
Whimsy see me.
See me.
Lifting belly exaggerates. Lifting belly is reproachful.
Oh can you see.
Yes sir.
Lifting belly mentions the bee.
Can you imagine the noise.
Can you whisper to me.
Lifting belly pronouncedly.
Can you imagine me thinking lifting belly.
Safety first.
That's the trimming.
I hear her snore
On through the door.
I can say that it is my delight.
Lifting belly fairly well.
Lifting belly visibly.
Yes I say visibly.
Lifting belly behind me.
The room is so pretty and clean.
Do you know the rest.

Yes I know the rest.
She knows the rest and will do it.
Lifting belly in eclipse.
There is no such moon for me.
Eclipse indeed can lifting belly be methodical.
In lifting belly yes.
In lifting belly yes.
Can you think of me.
I can and do.
Lifting belly encourages plenty.
Do not speak of San Francisco he is a saint.
Lifting belly shines.
Lifting belly nattily.
Lifting belly to fly.
Not to-day.
Motor.
Lifting belly for wind.
We do not like wind.
We do not mind snow.
Lifting belly partially.
Can you spell for me.
Spell bottle.
Lifting belly remarks.
Can we have the hill.
Of course we can have the hill.
Lifting belly patiently.
Can you see me rise.
Lifting belly says she can.
Lifting belly soundly.
Here is a bun for my bunny.
Every little bun is of honey.
On the little bun is my oney.
My little bun is so funny.
Sweet little bun for my money.
Dear little bun I'm her sunny.

Sweet little bun dear little bun good little bun for my bunny.
Lifting belly merry Christmas.
Lifting belly has wishes.
And then we please her.
What is the name of that pin.
Not a hat pin.
We use elastic.
As garters.
We are never blamed.
Thank you and see me.
How can I swim.
By not being surprised.
Lifting belly is so kind.
Lifting belly is harmonious.
Can you smile to me.
Lifting belly is prepared.
Can you imagine what I say.
Lifting belly can.
To be remarkable.
To be remarkably so.
Lifting belly and emergencies.
Lifting belly in reading.
Can you say effectiveness.
Lifting belly in reserve.
Lifting belly marches.
There is no song.
Lifting belly marry.
Lifting belly can see the condition.
How do you spell Lindo.
Not to displease.
The dears.
When can I.
When can I.
To-morrow if you like.
Thank you so much.

See you.
We were pleased to receive notes.
In there.
To there.
Can you see spelling.
Anybody can see lines.
Lifting belly is arrogant.
Not with oranges.
Lifting belly inclines me.
To see clearly.
Lifting belly is for me.
I can say truthfully never better.
Believe me lifting belly is not nervous.
Lifting belly is a miracle.
I am with her.
Lifting belly to me.
Very nicely done.
Poetry is very nicely done.
Can you say pleasure.
I can easily say please me.
You do.
Lifting belly is precious.
Then you can sing.
We do not encourage a nightingale.
Do you really mean that.
We literally do.
Then it is an intention.
Not the smell.
Lifting belly is a chance.
Certainly sir.
I please myself.
Can we convince Morlet.
We can.
Then see the way.
We can have a pleasant ford.

And we do.

We will.

See my baby cheerily.

I am celebrated by the lady.

Indeed you are.

I can rhyme

In English.

In loving.

In preparing.

Do not be rough.

I can sustain conversation.

Do you like a title for you.

Do you like a title.

Do you like my title.

Can you agree.

We do.

In that way have candles.

And dirt.

Not dirt.

There are two Caesars and there are four Caesars.

Caesars do their duty.

I never make a mistake.

We will be very happy and boastful and we will celebrate Sunday.

How do you like your Aunt Pauline.

She is worthy of a queen.

Will she go as we do dream.

She will do satisfactorily.

And so will we.

Thank you so much.

Smiling to me.

Then we can see him.

Yes we can.

Can we always go.

I think so.

You will be secure.

We are secure.
Then we see.
We see the way.
This is very good for me.
In this way we play.
Then we are pleasing.
We are pleasing to him.
We have gone together.
We are in our Ford.
Please me please me.
We go then.
We go when.
In a minute.
Next week.
Yes indeed oh yes indeed.
I can tell you she is charming in a coat.
Yes and we are full of her praises.
Yes indeed.
This is the way to worry. Not it.
Can you smile.
Yes indeed oh yes indeed.
And so can I.
Can we think.
Wrist leading.
Wrist leading.
A kind of exercise.
A brilliant station.
Do you remember its name.
Yes Morlet.
Can you say wishes.
I can.
Winning baby.
Theoretically and practically.
Can we explain a season.
We can when we are right.

Two is too many.

To be right.

One is right and so we mount and have what we want.

We will remember.

Can you mix birthdays.

Certainly I can.

Then do so.

I do so.

Do I remember to write.

Can he paint.

Not after he has driven a car.

I can write.

There you are.

Lifting belly with me.

You inquire.

What you do then.

Pushing.

Thank you so much.

And lend a hand.

What is lifting belly now.

My baby.

Always sincerely.

Lifting belly says it there.

Thank you for the cream.

Lifting belly tenderly.

A remarkable piece of intuition.

I have forgotten all about it.

Have you forgotten all about it.

Little nature which is mine.

Fairy ham

Is a clam.

Of chowder

Kiss him Louder.

Can you be especially proud of me.

Lifting belly a queen.

In that way I can think.
Thank you so much.
I have,
Lifting belly for me.
I can not forget the name.
Lifting belly for me.
Lifting belly again.
Can you be proud of me.
I am.
Then we say it.
In miracles.
Can we say it and then sing. You mean drive.
I mean to drive.
We are full of pride.
Lifting belly is proud.
Lifting belly my queen.
Lifting belly happy.
Lifting belly see.
Lifting belly.
Lifting belly address.
Little washers.
Lifting belly how do you do.
Lifting belly is famous for recipes.
You mean Genevieve.
I mean I never ask for potatoes.
But you liked them then.
And now.
Now we know about water.
Lifting belly is a miracle.
And the Caesars.
The Caesars are docile.
Not more docile than is right.
No beautifully right.
And in relation to a cow.
And in relation to a cow.

Do believe me when I incline.
You mean obey.
I mean obey.
Obey me.
Husband obey your wife.
Lifting belly is so dear.
To me.
Lifting belly is smooth,
Tell lifting belly about matches.
Matches can be struck with the thumb.
Not by us.
No indeed.
What is it I say about letters.
Twenty six.
And counted.
And counted deliberately.
This is not as difficult as it seems.
Lifting belly is so strange
And quick.
Lifting belly in a minute.
Lifting belly in a minute now.
In a minute.
Not to-day.
No not to-day.
Can you swim.
Lifting belly can perform aquatics.
Lifting belly is astonishing.
Lifting belly for me.
Come together.
Lifting belly near.
I credit you with repetition.
Believe me I will not say it.
And retirement.
I celebrate something.
Do you.

Lifting belly extraordinarily in haste.
I am so sorry I said it.
Lifting belly is a credit. Do you care about poetry.
Lifting belly in spots.
Do you like ink.
Better than butter.
Better than anything.
Any letter is an alphabet.
When this you see you will kiss me.
Lifting belly is so generous.
Shoes.
Servant.
And Florence.
Then we can sing.
We do among.
I like among.
Lifting belly keeps.
Thank you in lifting belly.
Can you wonder that they don't make preserves.
We ask the question and they answer you give us help.
Lifting belly is so successful.
Is she indeed.
I wish you would not be disobliging.
In that way I am.
But in giving.
In giving you always win.
You mean in effect.
In mean in essence.
Thank you so much we are so much obliged.
This may be a case
Have no fear.
Then we can be indeed.
You are and you must.
Thank you so much.
In kindness you excel.

You have obliged me too.

I have done what is necessary.

Then can I say thank you may I say thank you very much.

Thank you again.

Because lifting belly is about baby.

Three eggs in lifting belly.

Éclair.

Think of it.

Think of that.

We think of that.

We produce music.

And in sleeping.

Noises.

Can that be she.

Lifting belly is so kind

Darling wifie is so good.

Little husband would.

Be as good.

If he could.

This was said.

Now we know how to differ.

From that.

Certainly.

Now we say.

Little hubbie is good.

Every Day.

She did want a photograph.

Lifting belly changed her mind.

Lifting belly changed her mind.

Do I look fat.

Do I look fat and thin.

Blue eyes and windows.

You mean Vera.

Lifting belly can guess.

Quickly.

Lifting belly is so pleased.
Lifting belly seeks pleasure.
And she finds it altogether.
Lifting belly is my love.
Can you say meritorious.
Yes camellia.
Why do you complain.
Postal cards.
And then.
The Louvre.
After that.
After that Francine.
You don't mean by that name.
What is Spain.
Listen lightly.
But you do.
Don't tell me what you call me.
But he is pleased.
But he is pleased.
That is the way it sounds.
In the morning.
By that bright light.
Will you exchange purses.
You know I like to please you.
Lifting belly is so kind.
Then sign.
I sign the bulletin.
Do the boys remember that nicely
To-morrow we go there.
And the photographs
The photographs will come.
When
You will see.
Will it please me.
Not suddenly

But soon
Very soon.
But you will hear first.
That will take some time.
Not very long.
What do you mean by long.
A few days.
How few days.
One or two days.
Thank you for saying so.
Thank you so much.
Lifting belly waits splendidly.
For essence.
For essence too.
Can you assure me.
I can and do.
Very well it will come
And I will be happy.
You are happy.
And I will be
You always will be.
Lifting belly sings nicely.
Not nervously.
No not nervously.
Nicely and forcefully.
Lifting belly is so sweet.
Can you say you say.
In this thought.
I do think lifting belly.
Little love lifting
Little love light.
Little love heavy.
Lifting belly tight.
Thank you.
Can you turn over.

Rapidly.
Lifting belly so meaningly.
Yes indeed the dog.
He watches.
The little boys.
They whistle on their legs,
Little boys have meadows,
Then they are well.
Very well.
Please be the man.
I am the man.
Lifting belly praises.
And she gives
Health.
And fragrance.
And words.
Lifting belly is in bed.
And the bed has been made comfortable.
Lifting belly knows this.
Spain and torn
Whistling.
Can she whistle to me.
Lifting belly in a flash.
You know the word.
Strawberries grown in Perpignan are not particularly good.
These are inferior kinds.
Kind are a kind.
Lifting belly is sugar.
Lifting belly to me.
In this way I can see.
What
Lifting belly dictate.
Daisy dear.
Lifting belly
Lifting belly carelessly.

I didn't.
I see why you are careful
Can you stick a stick. In what In the carpet.
Can you be careful of the corner.
Mrs. the Mrs. indeed yes.
Lifting belly is charming.
Often to-morrow
I'll try again.
This time I will sin
Not by a prophecy.
That is the truth.
Very well.
When will they change.
They have changed.
Then they are coming
Yes.
Soon.
On the way.
I like the smell of gloves.
Lifting belly has money.
Do you mean cuckoo.
A funny noise.
In the meantime there was lots of singing.
And then and then.
We have a new game
Can you fill it.
Alone.
And is it good
And useful
And has it a name
Lifting belly can change to filling petunia.
But not the same.
It is not the same.
It is the same.
Lifting belly.

So high.
And aiming.
Exactly.
And making
A cow
Come out.
Indeed I was not mistaken.
Come do not have a cow.
He has.
Well then.
Dear Daisy.
She is a dish.
A dish of good.
Perfect.
Pleasure.
In the way of dishes.
Willy.
And Milly.
In words.
So loud.
Lifting belly the dear.
Protection.
Protection
Protection
Speculation
Protection
Protection.
Can the furniture shine.
Ask me.
What is my answer.
Beautifully.
Is there a way of being careful
Of what.
Of the South.
By going to it.

We will go.

For them.

For them again.

And is there any likelihood of butter.

We do not need butter.

Lifting belly enormously and with song.

Can you sing about a cow.

Yes.

And about signs.

Yes.

And also about Aunt Pauline.

Yes.

Can you sing at your work.

Yes.

In the meantime listen to Miss Cheatham.

In the midst of writing.

In the midst of writing there is merriment.

If I Told Him:
A Completed Portrait of Picasso

If I told him would he like it. Would he like it if I told him.

Would he like it would Napoleon would Napoleon would would he like it.

If Napoleon if I told him if I told him if Napoleon. Would he like it if I told him if I told him if Napoleon. Would he like it if Napoleon if Napoleon if I told him. If I told him if Napoleon if Napoleon if I told him. If I told him would he like it would he like it if I told him.

Now.

Not now.

And now.

Now.

Exactly as as kings.

Feeling full for it.

Exactitude as kings.

So to beseech you as full as for it.

Exactly or as kings.

Shutters shut and open so do queens. Shutters shut and shutters and so shutters shut and shutters and so and so shutters and so shutters shut and so shutters shut and shutters and so. And so shutters shut and so and also. And also and so and so and also.

Exact resemblance to exact resemblance the exact resemblance as exact as a resemblance, exactly as resembling, exactly resembling, exactly in resemblance exactly a resemblance, exactly and resemblance. For this is so. Because.

Now actively repeat at all, now actively repeat at all, now actively repeat at all.

Have hold and hear, actively repeat at all.

I judge judge.

As a resemblance to him.

Who comes first. Napoleon the first.

Who comes too coming coming too, who goes there, as they go they share, who shares all, all is as all as as yet or as yet.

Now to date now to date. Now and now and date and the date.

Who came first Napoleon at first. Who came first Napoleon the first. Who came first, Napoleon first.

Presently.

Exactly do they do.

First exactly.

Exactly do they do too.

First exactly.

And first exactly.

Exactly do they do.

At first exactly and exactly.

And do they do.

At first exactly and first exactly and do they do.

The first exactly.

And do they do.

The first exactly.

At first exactly.

First as exactly.

At first as exactly.

Presently.

As presently.

As as presently.

He he he he and he and he and and he and he and he and and as and as he and as he and he. He is and as he is, and as he is and he is, he is and as he and he and as he is and he and he and and he and he.

Can curls rob can curls quote, quotable.

As presently.

As exactitude.

As trains.

Has trains.

Has trains.

As trains.

As trains.
Presently.
Proportions.
Presently.
As proportions as presently.
Father and farther.
Was the king or room.
Farther and whether.
Was there was there was there what was there was there what was there was there there was there.
Whether and in there.
As even say so.
One.
I land.
Two.
I land.
Three.
The land.
Three.
The land.
Three.
The land.
Two.
I land.
Two.
I land.
One.
I land.
Two.
I land.
As a so.
They cannot.
A note.
They cannot.
A float.

They cannot.
They dote.
They cannot.
They as denote.
Miracles play.
Play fairly.
Play fairly well.
A well.
As well.
As or as presently.
Let me recite what history teaches. History teaches.

from *Stanzas in Meditation*

PART I

STANZA I

I caught a bird which made a ball
And they thought better of it.
But it is all of which they taught
That they were in a hurry yet
In a kind of way they meant it best
That they should change in and on account
But they must not stare when they manage
Whatever they are occasionally liable to do
It is often easy to pursue them once in a while
And in a way there is no repose
They like it as well as they ever did
But it is very often just by the time
That they are able to separate
In which case in effect they could
Not only be very often present perfectly
In each way which ever they chose.
All of this never matters in authority
But this which they need as they are alike
Or in an especial case they will fulfill
Not only what they have at their instigation
Made for it as a decision in its entirety
Made that they minded as well as blinded
Lengthened for them welcome in repose
But which they open as a chance
But made it be perfectly their allowance

All which they antagonize as once for all
Kindly have joined it as they mind

[…]

PART II

STANZA I

Full well I know that she is there
Much as she will she can be there
But which I know which I know when
Which is my way to be there then
Which she will know as I know here
That it is now that it is there
That rain is there and it is here
That it is here that they are there
They have been here to leave it now
But how foolish to ask them if they like it
Most certainly they like it because they like what they have
But they might easily like something else
And very probably just as well they will have it
Which they like as they are very likely not to be
Reminded that it is more than ever necessary
That they should never be surprised at any one time
At just what they have been given by taking what they have
Which they are very careful not to add with
As they can easily indulge in the fragrance
Not only of which but by which they know
That they tell them so.

[…]

STANZA III

They can lightly send it away to say
That they will not change it if they can
Nor indeed by the time that it is made
They can indeed not be careful that they were thankful
That they should distinguish which and whenever
They were not unlikely to mean it more
Than enough not to decide that they would not
Or well indeed if it is not better
That they are not cautious if she is sleepy
And well prepared to be close to the fire
Where it is as if outside it did resemble
Or can be they will relinquish.
I think I know that they will send an answer.
It can be sensibly more than they could
That one sheep has one lamb and one sheep has two lambs
Or they can be caught as if when they had been
Not only as they like but she can say
He can say too two can be more that is to say
Three can be more than one more
And only after they have five nobody
Has quarreled not only for them but after a while
She knows that they know that they
Are not remarkable.
It is often more which they use that they
Knowing that there is a month to-day
In which often they use or can they use
Which they knew it could be in no venture
That they will use he will carefully await
And leave it like that to be carefully watching
Will we come and will we come then
They can to which can they be to which they use
Or not at all as in a fashion
More than kind.

It is often so that they will call them
Or can be there for which they will not see them
Nor can they us what they will like
In for instance will they change this for them.
Coming by themselves for them in no matter
Could one ask it is not usual
That if they are polite they are politer
Or either of them not to be one for them
Which they can call on their account for them.
It is all all of which they could be generous
If not one gave more to them
They could be with them all who are with them
For them can they be more than many
Not only but righteous and she would be
Not angry now not often for them
With not as told not by them
It is very well to have no thorough wishes
Wish well and they will call
That they were remarkable
And it is well to state that rain makes hills green
And the sky blue and the clouds dark
And the water water by them
As they will not like what they do not have
As nobody has been indifferent
Not only will she regret
But they will say one two three
Much as they use.
It is very well to know.
More than to know
What they make us of
Although it is cold in the evening
Even if a fire is burning and
Summer is of use to them

[...]

STANZA XI

I thought how could I very well think that
But which they were a choice that now they know
For which they could be always there and asking
But made not more than which than they can like
Not only why they came but which they knew
For their own sake by the time that it is there
They should be always rather liking it
To have not any one exclaim at last
It must be always just what they have done
By which they know they can feel more than so
As theirs they can recognise for which they place
And more and moreover which they do
It is not only to have all of it as more
Which they can piece and better more than which
They may remain all or in part
Some can think once and find it once
Others for which for which they will
It is at no time that they joined
For which they joined as only
Not for which it is in partly measure
Having alike be once more obtained
They made no trouble as they come again
All which they could
But they will care
All for which it is at once thought
Just when they can surprise
No one in what they could there
Make without any pause a rest.
They will think why they
And they will come
In response.
Should they be well enough.

Otherwise they can consider that
Whatever they have missed.
I think I know I like I mean to do
For which they could they will place
He will place there where
It is finally thought out best
No means no means in inquietude
Just when they give and claim a reward
Not for which they go and get this
They have been with the place their place
Why is there not why is there not with doubt.
Not able to be with mine.

STANZA XII

One fortunate with roses is fortunate with two
And she will be so nearly right
That they think it is right
That she is now well aware
That they would have been named
Had not their labels been taken away
To make room for placing there
The more it needs if not only it needs more so
Than which they came

STANZA XIII

But it was only which was all the same

[…]

PART III

STANZA II

It was not which they knew
But they think will it be though
The like of which they drew
Through.
It which may be that it is they did
For which they will be never be killed
By which they knew
And yet it is strange when they say
Who.
And so not only not here
May be they will be not in their place there
For which they will what will they may be there
For them for which not only very much
As is what they like there.
Now three things beside.
Add which not which to which
They wish which they divide.
If a fisherman fishes
Or else a well
Very well does an attack
Look back.
For that in use an extra make a moment
Further in use which they can be there when
In open use of which they like each one
Where they have been to have been come from.
It is often that they do regularly not having been
Before.
As much as and alike and because
Once before always before afraid in a dog fight
But not now.
Not at all now not when they not only wish to do

Can they be ours and very pretty too.
And you.
Once more I think about a lake for her
I do not think about a lake for them
And I can be not only there not in the rain
But when it is with them this it is soon seen
So much comes so many come.
Comfortably if they like what they come.
From.
Tables of tables and frames of frames.
For which they ask many permissions.
I do know that now I do know why they went
When they came
To be
And interested to be which name.
Who comes to easily not know
How many days they do know
Or whether better either and or
Before.
She can be eight in wishes
I said the difference is complicated
And she said yes is it it is
Or she said it is is it.
There seems so much to do
With one or two with six not seven
Either or.
Or believe.
That not only red at night can deceive.
Might they we hope better things of this.
Or of this.
Is.
When they are once or twice and deceive.
But leave
She can be called either or or before
Not only with but also with

With which they wish this
That they will like to give rain for rain
Or not.
It is just like it sounds.
I could not like it then nor now
Out now
Remained to how.
However they are careful.
Having forgotten it for them
Just how much they like
All potatoes are even when they have flowers
All adding is even
If they asked them
Would they ask them.
It would not be like alike for which
They did.
They had and did.
But which they had which they had which they is and did.
Gotten and gotten a row
Not to in did not and in said so
It is not only that I have not described
A lake in trees only there are no trees
Just not there where they do not like not having these
Trees.
It is a lake so and so or oh
Which if it is could it does it for it
Not make any do or do or it
By this it is a chance inclined.
They did not come from there to stay they were hired
They will originally will do
It is not only mine but also
They will three often do it.
Not now.
Do I mind

Went one.
I wish to remain to remember that stanzas go on

[…]

STANZA V

It is not a range of a mountain
Of average of a range of a average mountain
Nor can they of which of which of arrange
To have been not which they which
Can add a mountain to this.
Upper an add it then maintain
That if they were busy so to speak
Add it to and
If not only why they could not add ask
Or when just when more each other
There is no each other as they like
They add why then emerge an add in
It is of absolutely no importance how often they add it.

STANZA VI

By which are which add which a mounting
They need a leaf to leave a settling
They do not place a rein for resting
They do not all doubt can be a call
They can do which when ever they name
Their little hope of not knowing it.
Their little hope of not knowing it.

[…]

STANZA IX

Tell me darling tell me true
Am I all the world to you
And the world of what does it consist
Can they be a chance to can they be desist
This come to a difference in confusion
Or do they measure this with resist with
Not more which.
Than a conclusion.
Can they come with can they in with
For which they can need needing
It is often by the time that not only
Which waiting as an considerable
And not only is it in importance
That they could for an instance
Of made not engaged in rebound
They could indeed care
For which they can not only
Be very often rested in as much
Would they count when they do
Is which which when they do
Making it do.
For this all made because of near
No name is nearly here
Gathering it.
Or gathering it.
Might it in no way be a ruse
For it which in it they an obligation
Fell nearly well.

[...]

STANZA XII

Stanza ten make a hen
Stanza third make a bird
Stanza white make a dog
Stanza first make it heard
That I will not not only go there
But here

STANZA XIII

In changing it inside out nobody is stout
In changing it for them nobody went
In not changing it then.
They will gradually lengthen
It.

Amy Lowell

The Pike

In the brown water,
Thick and silver-sheened in the sunshine,
Liquid and cool in the shade of the reeds,
A pike dozed.
Lost among the shadows of stems
He lay unnoticed.
Suddenly he flicked his tail,
And a green-and-copper brightness
Ran under the water.

Out from under the reeds
Came the olive-green light,
And orange flashed up
Through the sun-thickened water.
So the fish passed across the pool,
Green and copper,
A darkness and a gleam,
And the blurred reflections of the willows on the opposite bank
Received it.

Patterns

I walk down the garden paths,
And all the daffodils
Are blowing, and the bright blue squills.
I walk down the patterned garden paths
In my stiff, brocaded gown.
With my powdered hair and jewelled fan,
I too am a rare
Pattern. As I wander down
The garden paths.
My dress is richly figured,
And the train
Makes a pink and silver stain
On the gravel, and the thrift
Of the borders.
Just a plate of current fashion,
Tripping by in high-heeled, ribboned shoes.
Not a softness anywhere about me,
Only whalebone and brocade.
And I sink on a seat in the shade
Of a lime tree. For my passion
Wars against the stiff brocade.
The daffodils and squills
Flutter in the breeze
As they please.
And I weep;
For the lime-tree is in blossom
And one small flower has dropped upon my bosom.

And the plashing of waterdrops
In the marble fountain

Comes down the garden paths.
The dripping never stops.
Underneath my stiffened gown
Is the softness of a woman bathing in a marble basin,
A basin in the midst of hedges grown
So thick, she cannot see her lover hiding,
But she guesses he is near,
And the sliding of the water
Seems the stroking of a dear
Hand upon her.
What is summer in a fine brocaded gown!
I should like to see it lying in a heap upon the ground.
All the pink and silver crumpled up on the ground.

I would be the pink and silver as I ran along the paths,
And he would stumble after,
Bewildered by my laughter.
I should see the sun flashing from his sword-hilt and the buckles
 on his shoes.
I would choose
To lead him in a maze along the patterned paths,
A bright and laughing maze for my heavy-booted lover.
Till he caught me in the shade,
And the buttons of his waistcoat bruised my body as he clasped me,
Aching, melting, unafraid.
With the shadows of the leaves and the sundrops,
And the plopping of the waterdrops,
All about us in the open afternoon—
I am very like to swoon
With the weight of this brocade,
For the sun sifts through the shade.

Underneath the fallen blossom
In my bosom,
Is a letter I have hid.

It was brought to me this morning by a rider from the Duke.
"Madam, we regret to inform you that Lord Hartwell
Died in action Thursday se'nnight."
As I read it in the white, morning sunlight,
 The letters squirmed like snakes.
"Any answer, Madam," said my footman.
"No," I told him.
"See that the messenger takes some refreshment.
No, no answer."
And I walked into the garden,
Up and down the patterned paths,
In my stiff, correct brocade.
The blue and yellow flowers stood up proudly in the sun,
Each one.
I stood upright too,
Held rigid to the pattern
By the stiffness of my gown.
Up and down I walked,
Up and down.

In a month he would have been my husband.
In a month, here, underneath this lime,
We would have broke the pattern;
He for me, and I for him,
He as Colonel, I as Lady,
On this shady seat.
He had a whim
That sunlight carried blessing.
And I answered, "It shall be as you have said."
Now he is dead.

In Summer and in Winter I shall walk
Up and down
The patterned garden-paths
In my stiff, brocaded gown.

The squills and daffodils
Will give place to pillared roses, and to asters, and to snow.
I shall go
Up and down,
In my gown.
Gorgeously arrayed,
Boned and stayed,
And the softness of my body will be guarded from embrace
By each button, hook, and lace.
For the man who should loose me is dead,
Fighting with the Duke in Flanders,
In a pattern called a war.
Christ! What are patterns for?

Thompson's Lunch Room—
Grand Central Station

Study in Whites

Wax-white—
Floor, ceiling, walls.
Ivory shadows
Over the pavement
Polished to cream surfaces
By constant sweeping.
The big room is colored like the petals
Of a great magnolia,
And has a patina
Of flower bloom
Which makes it shine dimly
Under the electric lamps.
Chairs are ranged in rows
Like sepia seeds
Waiting fulfilment.
The chalk-white spot of a cook's cap
Moves unglossily against the vaguely bright wall—
Dull chalk-white striking the retina like a blow
Through the wavering uncertainty of steam.
Vitreous-white of glasses with green reflections,
Ice-green carboys, shifting—greener, bluer—with the jar of moving
 water.
Jagged green-white bowls of pressed glass
Rearing snow-peaks of chipped sugar
Above the lighthouse-shaped castors
Of grey pepper and grey-white salt.
Grey-white placards: "Oyster Stew, Cornbeef Hash, Frankfurters":

Marble slabs veined with words in meandering lines.
Dropping on the white counter like horn notes
Through a web of violins,
The flat yellow lights of oranges,
The cube-red splashes of apples,
In high plated *épergnes*.
The electric clock jerks every half-minute:
"Coming—Past!"
"Three beef-steaks and a chicken pie,"
Bawled through a slide while the clock jerks heavily.
A man carries a china mug of coffee to a distant chair.
Two rice puddings and a salmon salad
Are pushed over the counter;
The unfulfilled chairs open to receive them.
A spoon falls upon the floor with the impact of metal striking stone,
And the sound throws across the room
Sharp, invisible zigzags
Of silver.

Spring Longing

The South wind blows open the folds of my dress,
My feet leave wet tracks in the earth of my garden,
The willows along the canal sing
 with new leaves turned upon the wind.

 I walk along the tow-path
 Gazing at the level water.
 Should I see a ribbed edge
 Running upon its clearness,
 I should know that this was caused
 By the prow of the boat
 In which you are to return.

Venus Transiens

Tell me,
Was Venus more beautiful
Than you are,
When she topped
The crinkled waves,
Drifting shoreward
On her plaited shell?
Was Botticelli's vision
Fairer than mine;
And were the painted rosebuds
He tossed his lady,
Of better worth
Than the words I blow about you
To cover your too great loveliness
As with a gauze
Of misted silver?
For me,
You stand poised
In the blue and buoyant air,
Cinctured by bright winds,
Treading the sunlight.
And the waves which precede you
Ripple and stir
The sands at my feet.

Bright Sunlight

The wind has blown a corner of your shawl
Into the fountain,
Where it floats and drifts
Among the lily-pads
Like a tissue of sapphires.
But you do not heed it,
Your fingers pick at the lichens
On the stone edge of the basin,
And your eyes follow the tall clouds
As they sail over the ilex-trees.

New Heavens for Old

I am useless.
What I do is nothing,
What I think has no savour.
There is an almanac between the windows:
It is of the year when I was born.

My fellows call to me to join them,
They shout for me,
Passing the house in a great wind of vermilion banners.
They are fresh and fulminant,
They are indecent and strut with the thought of it,
They laugh, and curse, and brawl,
And cheer a holocaust of "Who comes firsts!" at the iron fronts of
 the houses at the two edges of the street.
Young men with naked hearts jeering between iron house-fronts,
Young men with naked bodies beneath their clothes
Passionately conscious of them,
Ready to strip off their clothes,
Ready to strip off their customs, their usual routine,
Clamouring for the rawness of life,
In love with appetite,
Proclaiming it as a creed,
Worshipping youth,
Worshipping themselves.
They call for women and the women come,
They bare the whiteness of their lusts to the dead gaze of the old
 house-fronts,
They roar down the street like flame,
They explode upon the dead houses like new, sharp fire.

But I—
I arrange three roses in a Chinese vase:
A pink one,
A red one,
A yellow one.
I fuss over their arrangement.
Then I sit in a South window
And sip pale wine with a touch of hemlock in it,
And think of Winter nights,
And field-mice crossing and re-crossing
The spot which will be my grave.

Dissonance

From my window I can see the moonlight stroking the smooth
 surface of the river.
The trees are silent, there is no wind.
Admirable pre-Raphaelite landscape,
Light touched with ebony and silver.
I alone am out of keeping:
An angry red gash
Proclaiming restlessness
Of an incongruous century.

Elsa von Freytag-Loringhoven

Analytical Chemistry of Progeny

My bawdy spirit is innate —
A legacy from my Dada —
His crude jest bestowed on me
The sparkle of obscenity

My noble mother's legacy
Melancholy — passion — ardour —
Curbed by gentlewoman's reins
Exiled from castle — spoilt gentility

I am — gleaming fruit at the tree top
Fulfilment — brilliant design
Of a thousand-year-old marriage manure
Genius — idiocy — filth — purity

Whether you love it or turn up your nose
Whether it pleases you or not
It grows — develops — pops off the tree
Circling ball — nude in stockings

What is necessity — Lala! The world —
What Brooklyn Bridge —
Glass-blackened waves and foam.

A Dozen Cocktails Please

No spinsterlollypop for me — yes — we have
No bananas — I got lusting palate — I
Always eat them — — — —
They have dandy celluloid tubes — all sizes —
Tinted diabolically as a baboon's hind complexion.
A man's a —
Piffle! Will o' th' whisp! What is the dread
Matter with the up-to-date American-
Home-comforts? Bum insufficient for the
Should-be well groomed upsy.
That's the leading question.
There's the vibrator — — —
Coy flappertoy! I am adult citizen with
Vote — I demand my unstinted share
In roofeden — witchsabbath of our Baby-
Lonian obelisk.
What's radio for — if you please?
"Eve's dart pricks snookums upon
Wirefence"
An apple a day — — —
It'll come — — —
Ha! When? I am no tongueswallowing yogi.
Progress is ravishing —
It doesn't *me* —
Nudge it —
Kick it —
Prod it —
Push it —
Broadcast — — —
That's the lightning idea!

s.o.s. national shortage of — —
What?
How are we going to put it befitting
Lifted upsys?
Psh! Any sissypoet has sufficient freezing
Chemicals in his Freudian icechest to snuff all
Cockiness. We'll hire one.
Hell! Not that! That's the trouble — —
Cock*crow* — silly!
Oh — fine!
They're in France — the air on the line —
The Poles — — — — — —
Have them send waves — like candy —
Valentines — — —
Say it with — — —
Bolts!
Oh thunder!
Serpentine aircurrents — — —
Hhhhhphssssssss! The very word penetrates!
I feel whoozy!
I like that. I don't hanker after
Billy boys — but I am entitled
To be deeply shocked.
So are we — but you fill the hiatus.
Dear — I ain't queer — I need it straight — —
A dozen cocktails — please — — — —

Subjoyride

READY-TO-WEAR —
AMERICAN SOUL POETRY.
(THE RIGHT KIND)

It's popular — spitting Maillard's
Safety controller handle —
You like it!
They actually kill Paris
Garters dromedary fragrance
Of C.N. in a big Yuban!
Ah — madam —
That is a secret Pep-O-Mint —
Will you try it —
To the last drop?

Tootsie kisses Marshall's
Kippered health affinity
4 out of 5 — after 40 — many
Before your teeth full-o'
Pep with 10 nuggets products
Lighted Chiclets wheels and
Axels — carrying Royal
Lux Kamel hands off the
Better Bologna's beauty —
Get this straight — Wrigley's
Pinaud's heels for the wise —
Nothing so Pepsodent — soothing —
Pussy Willow — kept clean
With Philadelphia Cream

Cheese.
They satisfy the man of
Largest mustard underwear —
No dosing —
Just rub it on.

Weak — rundown man like
The growing miss as well —
Getting on and off unlawful
With jelly — jam — or Meyer's
Soap noodles
The Rubberset kind abounds —
The exact flavor lasts —
No metal can VapoRub
Oysterettes.

Wenatchee Barbasol peaks
Father John's patent — presentation —
Set — cold — gum's start
And finish.
18 years' electro-pneumatic
Operation Mary Garden cost
The golden key $1,500,000
Smile — see Lee Union — all
It's the grandest thing —
After every meal — no boiling
Required — keeps the
Doctor a day — just Musterole
Dear Mary — the mint with
The hole — oh Lifebuoy!
Adheres well — delights
Your taste — continuous
Germicidal action — it
Means a wealth of family

Vicks —
Our men know their
Combatant jobs since 1888 —
Quicker than Maxwell
Brakes.
You can teach a select
Seal packer parrol — Rinso —
Postum lister World-War
on Saxo Salve — —
Try a venotonic semi-
Soft of a stiff indigestion
Don't scratch!
Original sunshine makes
Tanlac children
Do you know that made
From rich pure shaving
Cream Jim Henry tired
Out?

Famous Fain reduces
Reg'lar fellows to the
Toughest Cory Chrome
Pancake apparel — kept
Antiseptic with gold dust
Rapid transit — —
It has raised 3 generations
Of mince-piston-rings-pie.
Wake up your passengers —
Large and small — to ride
On pins — dirty erasers and
Knives
These 3 Graces operate slot
For 5 cents.
Don't envy Aunt Jemima's

Self raising Cracker Jack
Laxative knitted chemise
With that chocolaty
Taste — use Pickles in Pattern
Follow Green Lions.

Ostentatious

Vivid fall's
Bugle sky —
Castle cloud's
Leafy limbswish —

> Westward:
> Saxophone day's
> Steelblast
> Galaxy —

Eastward:
Big she-moon's
Cheekflushed
Travesty

> Agog
> Ultramarine
> Avenues
> Limpid
> Thoroughfare.

Ohio—Indiansummer

Westgale ahonk
Past riverreeds
Dins poplars
Balalaika —

Sun's paradoxical caress —
Performance presently
Bedims —

Juxtaposed hemispheres azure
Concavity's
Chasmic zenith

Shocks
Brain —
Because
Night's
Death
Gibes —
Icenaked —
Tempestcrested —

All's Well

bloodsuckled
sucking
alive — —
money
breeds!

behold:
mammonmammoth!
scattered
motley
litter
spiritwhite
elephant!

it's
alright!

all
works well!
(though slow —)

to
an end —
(unknown —)

god's in his heaven —
(or ain't)

he
knows —
(or doesn't)

i
wonder?

— — —
— — —

don't mope!

what's —

the —

use?

Ultramundanity

earthcrucibles'
sunpestled
spirittesticle
lifeworks'
deathproduct:

compoundmetamorphosis'
loamfragrant
essence:

attar —
of —
souls:
 spirit

ashes
to
ashes:
 transmutation—
ego
to
supremeego's:
 ultrapool.

from
within
egoistplant's
accumulated
orgasmlitter
heatcolumned

electric
will
spirals
seamen exuberant
sexfestooned
bodyhumped
phallic
lords'
amatriculate
imagecirculate
spiritimmaculate
ultrasensed
egoidolatrous
selfabusive
incestuous
dynamoradiant
homosuicides'
perpetual
perpetrator:
testicle
brain
among
egoimagined
images
refleximaginative
imagery.

past
demons'
dim
memorymazed
tongues
invoke
by
grace

of
father
logos
pristine
in
hellmatterself
through
egomechanics'
immortal
systems'
calculated
reciprocity schemes'
infinite
thrift
of
allaround
alltogether
mutual
satisfactory
salvagecult
that:

redeemed
redeem
redeemer.

salto mortale

hip!
pal!
 this means *you!*
all's
sugar
in
christendom —

all's
christendom
too!

allaloooooooooooooh

Constitution

(INDESTRUCTIBILITY OF COSMOS — WHAT FATE!)

Still
Shape distinct —
Resist
I
Automatonguts
Rotating appetite —
Upbear against
Insensate systems
Systematical mechanism's
Selferecting — annihilating
Cutchew immortality's
Timeless digestive
Phallic act's
Vacuity —!

Cultivating
Primeval sense's
Instinctive caution
By:
"Keep smiling!"
Act — act — act — act —
Go on — on — on — onnnnnn—
Industry —
Uninvestigated!
Hush!
Bloodthrob!
Stiffle
Soulpant!

Dwindle
Spiritembryo!
Checked
By
Sense governing sense
To
Scirrhous dwarfiness —
Until
Principle of none-sense
Paramounts permanent
"Safety first" —

Unadmitting
Kissambushed demon's
Hideous apparition
To —
In —
Nervetransfixion
Fatally touch
Fibrous mould
By —
Sensible idiots
Scheme
Of:
Live soulless!
Train:
Callousness
To withstand —
Blindness
To unperceive —
Manikin:
To last
Forever —
Smile
For nothing. —

Soulhell —
Remorseless fate —
Inexhaustive well —
Nefarious hate
Indestructibility of cosmos —
Maniac ubiquity — — — —
From
Mortalitycast
I
Taunt
Thy
Teeth
Into —
Slashing
Me —
Ghoulpit —
Impotence
To
Shred
Pride:

Eternityshit!

Game Legend

Three
People
 Seated
In
Room —
Playing
 Game:
Boy —
Scientist —
Lady
Bare
Shame —
 Shameless
 In
 Love
 With
 Boy —
They
Made
Her
Toy —

Tore
Apart —

Swinging
Heart —
 She
 Laughed
 As

 Pain
 Came.
She
Was
Not
Young —

She
Was
Not
Old —
 Vibrant
 Was
 She —

Quiverbold!
Passionmad —
 She
 Leaped
 Bed —
 Of
 Love
 Dead — — —
At
Dawn — —

Heart
Shone
 Gold.

Florence Wheelock Ayscough and Amy Lowell

from *Fir-Flower Tablets*

Autumn River Song: On the Broad Reach

by Li T'ai-Po
Translated by Amy Lowell

In the clear green water—the shimmering moon.
In the moonlight—white herons flying.
A young man hears a girl plucking water-chestnuts;
They paddle home together through the night, singing.

The Heaven's Gate Mountains

By Li T'ai-Po
Translated by Amy Lowell

In the far distance, the mountains seem to rise out of the river;
Two peaks, standing opposite each other, make a natural gateway.
The cold color of the pines is reflected between the river-banks,
Stones divide the current and shiver the wave-flowers to fragments.
Far off, at the border of heaven, is the uneven line of
 mountain-pinnacles;
Beyond, the bright sky is a blur of rose-tinted clouds.
The sun sets, and the boat goes on and on—
As I turn my head, the mountains sink down into the brilliance of
 the cloud-covered sky.

The Retreat of Hsieh Kung

By Li T'ai-Po
Translated by Amy Lowell

The sun is setting—has set—on the Spring-green Mountain.
Hsieh Kung's retreat is solitary and still.
No sound of man in the bamboo grove.
The white moon shines in the center of the unused garden pool.
All round the ruined Summer-house is decaying grass,
Grey mosses choke the abandoned well.
There is only the free, clear wind
Again—again—passing over the stones of the spring.

On the Subject of Old Tai's Wine-Shop

By Li T'ai-Po
Translated by Amy Lowell

Old Tai is gone down to the Yellow Springs.
Yet he must still wish to make "Great Spring Wine."
There is no Li Po on the terrace of Eternal Darkness.
To whom, then, will he sell his wine?

In The Province of Lu, to the East of the Stone Gate Mountain, Taking Leave of Tu Fu

By Li T'ai-Po
Translated by Amy Lowell

When drunk, we were divided; but we have been together again for
 several days.
We have climbed everywhere, to every pool and ledge.
When, on the Stone Gate Road,
Shall we pour from the golden flagon again?
The Autumn leaves drop into the Four Waters,
The Ch'u Mountain is brightly reflected in the color of the lake.
We are flying like thistledown, each to a different distance;
Pending this, we drain the cups in our hands.

At the Edge Of Heaven, Thinking of Li Po

By Tu Fu
Translated by Amy Lowell

A cold wind blows up from the edge of Heaven.
The state of mind of the superior man is what?
When does the wild goose arrive?
Autumn water flows high in the rivers and lakes.

They hated your essay—yet your fate was to succeed.
The demons where you are rejoice to see men go by.
You should hold speech with the soul of Yuan,
And toss a poem into the Mi Lo River as a gift to him.

Adelaide Crapsey

November Night

Listen. .
With faint dry sound,
Like steps of passing ghosts,
The leaves, frost-crisp'd, break from the trees
And fall.

Release

With swift
Great sweep of her
Magnificent arm my pain
Clanged back the doors that shut my soul
From life.

Triad

These be
Three silent things:
The falling snow. . the hour
Before the dawn. . the mouth of one
Just dead.

Snow

Look up . .
From bleakening hills
Blows down the light, first breath
Of wintry wind. . look up, and scent
the snow!

Anguish

Keep thou
Thy tearless watch
All night but when the blue-dawn
Breathes on the silver moon, then weep!
Then weep!

Trapped

Well and
If day on day
Follows, and weary year
On year. . and ever days and years. .
Well?

Moon-Shadows

Still as
On windless nights
The moon-cast shadows are,
So still will be my heart when I
Am dead.

Languor After Pain

Pain ebbs,
And like cool balm,
An opiate weariness
Settles on eye-lids, on relaxed
Pale wrists.

The Guarded Wound

If it
Were lighter touch
Than petal of flower resting
On grass, oh still too heavy it were,
Too heavy!

Night Winds

The old
Old winds that blew
When chaos was, what do
They tell the clattered trees that I
Should weep?

Arbutus

Not Spring's
Thou art, but hers,
Most cool, most virginal,
Winter's, with thy faint breath, thy snows
Rose-tinged.

"He's killed the may and he's laid her by
To bear the red rose company."

Not thou,
White rose, but thy
Ensanguined sister is
The dear companion of my heart's
Shed blood.

Amaze

I know
Not these my hands
And yet I think there was
A woman like me once had hands
Like these.

The Warning

Just now,
Out of the strange
Still dusk. . as strange, as still. .
A white moth flew. Why am I grown
So cold?

Saying Of Il Haboul, Guardian Of The Treasure Of Solomon And Keeper Of The Prophet's Armor

My tent
A vapour that
The wind dispels and but
As dust before the wind am I
Myself.

Laurel in The Berkshires

Sea-foam
And coral! Oh, I'll
Climb the great pasture rocks
And dream me mermaid in the sun's
Gold flood.

Niagara—Seen on a Night in November

How frail
Above the bulk
Of crashing water hangs,
Autumnal, evanescent, wan,
The moon.

On Seeing Weather-Beaten Trees

Is it as plainly in our living shown,
By slant and twist, which way the wind hath blown?

Fragment

Nor moon,—
Nor stars. . the dark and in
The dark the grey
Ghost glimmer of the olive trees
The black straight rows
Of cypress.

Angelina Weld Grimke

Grass Fingers

Touch me, touch me,
Little cool grass fingers,
Elusive, delicate grass fingers.
With your shy brushings,
Touch my face—
My naked arms—
My thighs—
My feet.
Is there nothing that is kind?
You need not fear me.
Soon I shall be too far beneath you,
For you to reach me, even,
With your tiny, timorous toes.

Tenebris

There is a tree, by day,
That, at night,
Has a shadow,
A hand huge and black,
With fingers long and black.
 All through the dark,
Against the white man's house,
 In the little wind,
The black hand plucks and plucks
 At the bricks.
The bricks are the color of blood and very small.
 Is it a black hand,
 Or is it a shadow?

A Mona Lisa

I.

I should like to creep
Through the long brown grasses
 That are your lashes;
I should like to poise
 On the very brink
Of the leaf-brown pools
 That are your shadowed eyes;
I should like to cleave
 Without sound,
Their glimmering waters,
 Their unrippled waters,
I should like to sink down
 And down
 And down
 And deeply drown.

II.

Would I be more than a bubble breaking?
 Or an ever-widening circle
 Ceasing at the marge?
Would my white bones
 Be the only white bones
Wavering back and forth, back and forth
 In their depths?

The Black Finger

I have just seen a beautiful thing
 Slim and still,
Against a gold, gold sky,
 A straight cypress.
 Sensitive,
 Exquisite,
A black finger
Pointing upwards.
Why, beautiful still finger, are you black?
And why are you pointing upwards?

Under The Days

The days fall upon me;
One by one, they fall,
Like leaves
They are black,
They are grey.
They are white;
They are shot through with gold and fire.
They fall,
They fall
Ceaselessly.
They cover me,
They crush,
They smother.
Who will ever find me
Under the days?

Anne Spencer

At the Carnival

Gay little Girl-of-the-Diving-Tank,
I desire a name for you,
Nice, as a right glove fits;
For you—who amid the malodorous
Mechanics of this unlovely thing,
Are darling of spirit and form.
I know you—a glance, and what you are
Sits-by-the-fire in my heart.
My Limousine-Lady knows you, or
Why does the slant-envy of her eye mark
Your straight air and radiant inclusive smile?
Guilt pins a fig-leaf; Innocence is its own adorning.
The bull-necked man knows you—this first time
His itching flesh sees form divine and vibrant health,
And thinks not of his avocation.
I came incuriously—
Set on no diversion save that my mind
Might safely nurse its brood of misdeeds
In the presence of a blind crowd.
The color of life was gray.
Everywhere the setting seemed right
For my mood!
Here the sausage and garlic booth
Sent unholy incense skyward;
There a quivering female-thing
Gestured assignations, and lied

To call it dancing;
There, too, were games of chance
With chances for none;
But oh! Girl-of-the-Tank, at last!
Gleaming Girl, how intimately pure and free
The gaze you send the crowd,
As though you know the dearth of beauty
In its sordid life.
We need you—my Limousine-Lady,
The bull-necked man, and I.
Seeing you here brave and water-clean,
Leaven for the heavy ones of earth,
I am swift to feel that what makes
The plodder glad is good; and
Whatever is good is God.
The wonder is that you are here;
I have seen the queer in queer places,
But never before a heaven-fed
Naiad of the Carnival-Tank!
Little Diver, Destiny for you,
Like as for me, is shod in silence;
Years may seep into your soul
The bacilli of the usual and the expedient;
I implore Neptune to claim his child to-day!

Lines to a Nasturtium
(A lover muses)

Flame-flower, Day-torch, Mauna Loa,
I saw a daring bee, to-day, pause, and soar,
 Into your flaming heart;
Then did I hear crisp crinkled laughter
As the furies after tore him apart?
 A bird, next, small and humming,
Looked into your startled depths and fled. . . .
Surely, some dread sight, and dafter
 Than human eyes as mine can see,
Set the stricken air waves drumming
 In his flight.

 Day-torch, Flame-flower, cool-hot Beauty,
I cannot see, I cannot hear your flutey
Voice lure your loving swain,
But I know one other to whom you are in beauty
Born in vain:
Hair like the setting sun,
Her eyes a rising star,
Motions gracious as reeds by Babylon, bar
All your competing;
Hands like, how like, brown lilies sweet,
Cloth of gold were fair enough to touch her feet. . . .
Ah, how the senses flood at my repeating,
As once in her fire-lit heart I felt the furies
Beating, beating.

Translation

We trekked into a far country,
My friend and I.
Our deeper content was never spoken,
But each knew all the other said.
He told me how calm his soul was laid
By the lack of anvil and strife.
"The working kestrel," I said, "mutes his mating-note
To please the harmony of this sweet silence."
And when at the day's end
We laid tired bodies 'gainst
The loose warm sands,
And the air fleeced its particles for a coverlet;
When star after star came out
To guard their lovers in oblivion—
My soul so leapt that my evening prayer
Stole my morning song!

Mina Loy

Songs to Joannes

I

Spawn of Fantasies
Silting the appraisable
Pig Cupid his rosy snout
Rooting erotic garbage
"Once upon a time"
Pulls a weed white star-topped
Among wild oats sown in mucous-membrane

I would an eye in a Bengal light
Eternity in a sky-rocket
Constellations in an ocean
Whose rivers run no fresher
Than a trickle of saliva

These are suspect places

I must live in my lantern
Trimming subliminal flicker
Virginal to the bellows
Of Experience
 Coloured glass

II

 The skin-sack
In which a wanton duality
Packed
All the completion of my infructuous impulses
Something the shape of a man
To the casual vulgarity of the merely observant
More of a clock-work mechanism
Running down against time
To which I am not paced
 My finger-tips are numb from fretting your hair
A God's door-mat
 On the threshold of your mind

III

We might have coupled
In the bed-ridden monopoly of a moment
Or broken flesh with one another
At the profane communion table
Where wine is spill'd on promiscuous lips

We might have given birth to a butterfly
With the daily news
Printed in blood on its wings

IV

Once in a mezzanino
The starry ceiling
Vaulted an unimaginable family
Bird-like abortions
With human throats

And Wisdom's eyes
Who wore lamp-shade red dresses
And woolen hair

One bore a baby
In a padded porte-enfant
Tied with a sarsenet ribbon
To her goose's wings

But for the abominable shadows
I would have lived
Among their fearful furniture
To teach them to tell me their secrets
Before I guessed
—Sweeping the brood clean out

V

Midnight empties the street
Of all but us
Three
I am undecided which way back
 To the left a boy
—One wing has been washed in the rain
 The other will never be clean any more—
Pulling door-bells to remind
Those that are snug
 To the right a haloed ascetic
 Threading houses
Probes wounds for souls
—The poor can't wash in hot water—
And I don't know which turning to take
Since you got home to yourself—first

VI

I know the Wire-Puller intimately
And if it were not for the people
On whom you keep one eye
You could look straight at me
And Time would be set back

VII

My pair of feet
Smack the flag-stones
That are something left over from your walking
The wind stuffs the scum of the white street
Into my lungs and my nostrils
Exhilarated birds
Prolonging flight into the night
Never reaching— — — — — —

VIII

I am the jealous store-house of the candle-ends
That lit your adolescent learning
— — — — — — — — — —

Behind God's eyes
There might
Be other lights

IX

When we lifted
Our eye-lids on Love
A cosmos
Of colored voices
And laughing honey

And spermatozoa
At the core of Nothing
In the milk of the Moon

X

Shuttle-cock and battle-door
A little pink-love
And feathers are strewn

XI

Dear one at your mercy
Our Universe
Is only
A colorless onion
You derobe
Sheath by sheath
 Remaining
A disheartening odour
About your nervy hands

XII

Voices break on the confines of passion
Desire Suspicion Man Woman
Solve in the humid carnage

Flesh from flesh
Draws the inseparable delight
Kissing at gasps to catch it

Is it true
That I have set you apart
Inviolate in an utter crystallization

Of all the jolting of the crowd
Taught me willingly to live to share

Or are you
Only the other half
Of an ego's necessity
Scourging pride with compassion
To the shallow sound of dissonance
And boom of escaping breath

XIII

Come to me There is something
I have got to tell you and I can't tell
Something taking shape
Something that has a new name
A new dimension
A new use
A new illusion

It is ambient And it is in your eyes
Something shiny Something only for you
 Something that I must not see

It is in my ears Something very resonant
Something that you must not hear
 Something only for me

Let us be very jealous
Very suspicious
Very conservative
Very cruel
Or we might make an end of the jostling of aspirations
Disorb inviolate egos

Where two or three are welded together
They shall become god
— — — — — — —
Oh that's right
Keep away from me Please give me a push
Don't let me understand you Don't realise me
Or we might tumble together
Depersonalized
Identical
Into the terrific Nirvana
Me — you — me

XIV

Today
Everlasting passing apparent imperceptible
To you
I bring the nascent virginity of
—Myself for the moment

No love or the other thing
Only the impact of lighted bodies
Knocking sparks off each other
In chaos

XV

Seldom Trying for Love
Fantasy dealt them out as gods
Two or three men looked only human

But you alone
Superhuman apparently
I had to be caught in the weak eddy

Of your drivelling humanity
 To love you most

XVI

We might have lived together
In the lights of the Arno
Or gone apple stealing under the sea
Or played
Hide and seek in love and cob-webs
And a lullaby on a tin-pan

And talked till there were no more tongues
To talk with
And never have known any better

XVII

I don't care
Where the legs of the legs of the furniture are walking to
Or what is hidden in the shadows they stride
Or what would look at me
If the shutters were not shut

Red a warm colour on the battle-field
Heavy on my knees as a counterpane
Count counter
I counted the fringe of the towel
Till two tassels clinging together
Let the square room fall away
From a round vacuum
Dilating with my breath

XVIII

Out of the severing
Of hill from hill
The interim
Of star from star
The nascent
Static
Of night

XIX

Nothing so conserving
As cool cleaving
Note of the Q H U
Clear carving
Breath-giving
Pollen smelling
Space

White telling
Of slaking
Drinkable
Through fingers
Running water
Grass haulms
Grow to

Leading astray
Of fireflies
Aerial quadrille
Bouncing
Off one another
Again conjoining

In recaptured pulses
Of light

You too
Had something
At that time
Of a green-lit glow-worm
— — — — — — —
Yet slowly drenched
To raylessness
In rain

XX

Let Joy go solace-winged
To flutter whom she may concern

XXI

I store up nights against you
Heavy with shut-flower's nightmares
— — — — — — — — —
Stack noons
Curled to the solitaire
Core of the
Sun

XXII

Green things grow
Salads
For the cerebral
Forager's revival
Upon bossed bellies

Of mountains
Rolling in the sun
And flowered flummery
Breaks
To my silly shoes

In ways without you
I go
Gracelessly
As things go

XXIII

Laughter in solution
Stars in a stare
Irredeemable pledges
Of pubescent consummations
Rot
To the recurrent moon
Bleach
To the pure white
Wickedness of pain

XXIV

The procreative truth of Me
Petered out
In pestilent
Tear drops
Little lusts and lucidities
And prayerful lies
Muddled with the heinous acerbity
Of your street-corner smile

XXV

Licking the Arno
The little rosy
Tongue of Dawn
Interferes with our eyelashes
— — — — — — — —
We twiddle to it
Round and round
Faster
And turn into machines

Till the sun
Subsides in shining
Melts some of us
Into abysmal pigeon-holes
Passion has bored
In warmth

Some few of us
Grow to the level of cool plains
Cutting our foot-hold
With steel eyes

XXVI

Shedding our petty pruderies
From slit eyes

We sidle up
To Nature
— — — that irate pornographist

XXVII

Nucleus Nothing
Inconceivable concept
Insentient repose
The hands of races
Drop off from
Immodifiable plastic

The contents
Of our ephemeral conjunction
In aloofness from Much
Flowed to approachment of — — — —
NOTHING
There was a man and a woman
In the way
While the Irresolvable
Rubbed with our daily deaths
Impossible eyes

XXVIII

The steps go up for ever
And they are white
And the first step is the last white
Forever
Coloured conclusions
Smelt to synthetic
Whiteness
Of my
Emergence
And I am burnt quite white
In the climacteric
Withdrawal of your sun
And wills and words all white

Suffuse
Illimitable monotone

White where there is nothing to see
But a white towel
Wipes the cymophanous sweat
—Mist rise of living—
From your
Etiolate body
And the white dawn
Of your New Day
Shuts down on me

Unthinkable that white over there
—Is smoke from your house

XXIX

Evolution fall foul of
Sexual equality
Prettily miscalculate
Similitude

Unnatural selection
Breed such sons and daughters
As shall jibber at each other
Uninterpretable cryptonyms
Under the moon

Give them some way of braying brassily
For caressive calling
Or to homophonous hiccoughs
Transpose the laugh
Let them suppose that tears
Are snowdrops or molasses

Or anything
Than human insufficiencies
Begging dorsal vertebrae

Let meeting be the turning
To the antipodean
And Form a blurr
Anything
Than seduce them
To the one
As simple satisfaction
For the other

Let them clash together
From their incognitoes
In seismic orgasm

For far further
Differentiation
Rather than watch
Own-self distortion
Wince in the alien ego

XXX

In some
Prenatal plagiarism
Foetal buffoons
Caught tricks
— — — — —

From archetypal pantomime
Stringing emotions
Looped aloft
— — — —

For the blind eyes
That Nature knows us with
And the most of Nature is green

— — — — — — — — —

What guaranty
For the proto-form
We fumble
Our souvenir ethics to

— — — — — —

XXXI

Crucifixion
Of a busy-body
Longing to interfere so
With the intimacies
Of your insolent isolation

Crucifixion
Of an illegal ego's
Eclosion
On your equilibrium
Caryatid of an idea

Crucifixion
Wracked arms
Index extremities
In vacuum
To the unbroken fall

XXXII

The moon is cold
Joannes
Where the Mediterranean — — — — —

XXXIII

The prig of passion — — — —
To your professorial paucity

Proto-plasm was raving mad
Evolving us — — —

XXXIV

Love — — — the preeminent litterateur

Poe

a lyric elixir of death

 embalms
 the spindle spirits of your hour glass loves
 on moon spun nights

sets
 icicled canopy
 for corpses of poesy
 with roses and northern lights

 Where frozen nightingales in ilix aisles

 sing burial rites

Lunar Baedeker

A silver Lucifer
serves
cocaine in cornucopia

To some somnambulists
of adolescent thighs
draped
in satirical draperies

Peris in livery
prepare
Lethe
for posthumous parvenues

Delirious Avenues
lit
with the chandelier souls
of infusoria
from Pharoah's tombstones

lead
to mercurial doomsdays
Odious oasis
in furrowed phosphorous— — —

the eye-white sky-light
white-light district
of lunar lusts

— — — Stellectric signs
"Wing shows on Starway"
"Zodiac carrousel"

Cyclones
of ecstatic dust
and ashes whirl
crusaders
from hallucinatory citadels
of shattered glass
into evacuate craters

A flock of dreams
browse on Necropolis

From the shores
of oval oceans
in the oxidized Orient

Onyx-eyed Odalisques
and ornithologists
observe
the flight
of Eros obsolete

And "Immortality"
mildews . . .
in the museums of the moon

"Nocturnal cyclops"
"Crystal concubine"
— — — — — — —
Pocked with personification
the fossil virgin of the skies
waxes and wanes — — — —

Der Blinde Junge

The dam Bellona
littered
her eyeless offspring
Kriegsopfer
upon the pavements of Vienna

Sparkling precipitate
the spectral day
involves
the visionless obstacle

this slow blind face
pushing
its virginal nonentity
against the light

Pure purposeless eremite
of centripetal sentience

Upon the carnose horologe of the ego
the vibrant tendon index moves not

since the black lightning desecrated
the retinal altar

Void and extinct
this planet of the soul
strains from the craving throat
in static flight upslanting

A downy youth's snout
nozzling the sun
drowned in dumbfounded instinct

Listen!
illuminati of the colored earth
How this expressionless "thing"
blows out damnation and concussive dark

Upon a mouth-organ

Brancusi's Golden Bird

The toy
become the aesthetic archetype

As if
 some patient peasant God
 had rubbed and rubbed
 the Alpha and Omega
 of Form
 into a lump of metal

A naked orientation
unwinged unplumbed
—the ultimate rhythm
has lopped the extremities
of crest and claw
from
the nucleus of flight

The absolute act
of art
conformed
to continent sculpture
—bare as the brow of Osiris—
this breast of revelation

an incandescent curve
licked by chromatic flames
in labyrinths of reflections

This gong
of polished hyperaesthesia

shrills with brass
as the aggressive light
strikes
its significance

The immaculate
conception
of the inaudible bird
occurs
in gorgeous reticence. . .

Frances Gregg

To H.D.

You were all loveliness to me—
Sea-mist, the spring,
The blossoming of trees,
The wind,
Giver-of-Dreams.
Then—
A wistful silence guarded you about,
As in the spring
Iris and anemone are guarded.
And like a flame
Your beauty burned and wrought me
Into a bell,
Whose single note
Was echo of your silence.
Now—
You sing.
And I, muted,
Yet vibrate throughout,
Stirred by your hymn's immemorial burden;
"Spare us from loveliness!"

Hazel Hall

Seams

I was sewing a seam one day—
Just this way—
Flashing four silver stitches there
With thread, like this, fine as a hair,
And then four here, and there again,
When
The seam I sewed dropped out of sight. . .
I saw the sea come rustling in,
Big and grey, windy and bright. . .
Then my thread that was as thin
As hair, tangled up like smoke
And broke.
I threaded up my needle, then—
Four here, four there, and here again.

Two Sewing

The wind is sewing with needles of rain.
With shining needles of rain
It stitches into the thin
Cloth of earth. In,
In, in, in.
Oh, the wind has often sewed with me.
One, two, three.

Spring must have fine things
To wear like other springs.
Of silken green the grass must be
Embroidered. *One and two and three.*
Then every crocus must be made
So subtly as to seem afraid
Of lifting colour from the ground;
And after crocuses the round
Heads of tulips, and all the fair
Intricate garb that Spring will wear.
The wind must sew with needles of rain,
With shining needles of rain,
Stitching into the thin
Cloth of earth, in,
In, in, in,
For all the springs of futurity.
One, two, three.

The Listening Macaws

Many sewing days ago
I cross-stitched on a black satin bag
Two listening macaws.

They were perched on a stiff branch
With every stitch of their green tails,
Their blue wings, yellow breasts and sharply turned heads,
Alert and listening.

Now sometimes on the edge of relaxation
My thought is caught back,
Like gathers along a gathering thread,
To the listening macaws;
And I am amazed at the futile energy
That has kept them,
Alert to the last stitch,
Listening into their black satin night.

Footfalls

I

Life, be my pillow.
Forget, forget, forget
If I once asked for wandering
With never a thought of cold or wet.
Forget, forget, forget, forget
If I once asked for roads that fled
Before resisting tread.
Be nothing for my feet, life;
Be something under my head....

II

I have loved,
And having loved, walk well.
I move not as I once, a lover, moved,
For now no stammered gladness of the mind
Corrupts my step's tonality; a bell,
Well-rung, is not more finally resigned.
With all that once was love I feed my feet.
Hear in my tread assimilated need;
Hear reaching, yielding, tempered to the beat
Of tethered rhythm; hear my sounds succeed
Each other, dying away
Into the day....

III

Motion, motion;
Life is meaningless
Save in its motion.
I will move, blind; I will feel nothingness,

So that, itinerant, I may unwind
Meanings coiled in my feet. And though there be
Only the meaning of futility,
Yet, moving, I shall find
All that is ever found:
Motion, and echoed motion,
Sound....

IV

Away,
Look away from me, away.
Consider how the pools of sun
Glisten in paleness on the street, and know
That I deplore with you what is begun
Only to serve the purpose of decay.
Consider well the daylight's watery glow
Shed by a sun involved in its more slow
Manner of dissolution, so that I,
Unheeded, may pass by....

V

We live, we die,
Of course we die,
For we have lived and all
That pushes toward the sky
Must, after reaching, fall.
So if we live today
We may not live tomorrow,
Yet there's a better way
To die than to die of sorrow.
And whatever the dying be,
Companioned by winds that stalk
Beside us undyingly,
Let us walk, walk....

VI

Hear me, I am guilty,
I am guilty, guilty, guilty.
My foot is heavy with the crime
Of going; I am guilty, guilty.
Hear me, and deplore what Time,
As its accomplice, makes me be,
For Time has made a tool of me,
And I am guilty, guilty, guilty.
Hear me, I am compelled to move,
To inflict my dream, to spend my love
And all the essences of life
Furthering strife....

VII

Lost,
Lost, perhaps my way;
Perhaps the roads that crossed
Muddled my feet; perhaps a ray
Of light that I was meant to see
To make intelligible to me
The sense of something lost, is lost.
Lost, perhaps a wind-snatched word
Yet to be heard....

VIII

Flame might follow my feet
Were I one motion nearer fire.
I am so nebulous with heat,
So much a shaping of desire,
Flame might follow, might follow my feet.
A dripping wing of flame might fuse
With my shadow but for the street
Cooling my shoes....

IX

On and on;
I must go on and on
Through noon and night and dawn.
Only this is given me:
The going on and on and on
Through noon and dusk and night and dawn;
Never the interval to be
The contour of myself. With sound
Leaning like rain above the ground,
I must go on and on: a shape
Existent in escape....

X

The tip of a fir,
And it is colored green,
Over a shiny roof is seen.
And who needs more, even if there were
Something more than the tip of a fir?
And who would think, even if they could,
Of roots and trunks that have stood, have stood
Through—but who would care how many springs—
Even if there were such things?
Over a roof
The feathery green
Tip of a fir
Is seen,
Seen....

XI

Love me,
Love me; life am I,
And time is relentless lullaby.
Love me, touch me; my hands make
Your hands whole and keep you awake.

Touch me, lead me where high walls keep
Back the winds that might sing of sleep,
Yet never so far that slow desert sands
Swirl in our eyes and quiet our hands,
And never and never into the mist
Drowsy with sea. Hear the blood in my wrist
Evolving sound to chasten the tune
Time has sung to the moon....

XII

Listen,
Listen, listen, listen.
Spend your hearing listening
To the utterance of my feet—
Utterance of my feet, my feet.
Deafen yourself on the sounds I fling
Bountifully over your dismal street,
And make them do for a quieter day
When I may not pass this way.
Listen, though you break your ear;
Listen and you will hear
My feet, my feet, my feet....

XIII

I must not sound.
Softness be between me and the ground.
Caution, be my sandal, let me pass
Unchronicled like feet that fall on grass.
There has been much to chasten and to shame
Along the never-ending way I came;
There is so much of hush, of sleep in me
That once was wildness, I move quietly.
And yet for all my care I sound, I sound;
Like a panther through a tangled ground
I sound....

XIV

Nothing.
Hear no more than nothing.
Hear no less, for that am I.
I am all that and yet no more
Than shadow on a wall, a high
Flurry of sand that swirls because
The wind has moved it from a shore
To fling it back to quietness.
No more, no more than this: the pause
Of many silences, no more,
And yet no less,
No less....

Woman Death

Wash over her, wet light
Of this dissolving room.
Dusk smelling of night,
Lay on her placid gloom.
Wash over her; as waves push back the sands
Fold down her hands.

Many another rain
Of dusk has filled such walls;
Many a woman has lain
Submerged where the damp light falls,
Wanting her hands held down,
Finding it strange that they
Alone refuse to drown.

The mind after its day
Fills like an iron cup
With waters of the night.
The eyes wisely give up
The little they held of light.
Move over her, subdue her, Dark, until
Her hands are still.

Out of the east comes night;
From west, from north, from south,
Gathers the blackened light
To move against her mouth.
Many another has known
These four pressures of space,
Feeling her lips grow stone

And hollows curving her face,
And cared so little to feel.
Her light had never given
More than her dark might steal;
Then for this she had striven:
To feel the quiet moving on her hands
Like thin sea over sands.

Time gathers to break
In arrested thunder, gloom
Comes with thickness to make
Deep ocean of a room,
Comes to soothe and shape
The breathed-out breath.

Some who die escape
The rhythm of their death,
Some may die and know
Death as a broken song,
But a woman dies not so, not so;
A woman's death is long.

Riddle

Come, I would give you
A riddle to plague you.
What of the heaven
That spurs your sight—
That moves before you,
A shadow, moon-colored,
To blind and beckon,
A darkness, a light?

What of the heaven
Of which you know nothing
Save that it makes you
Timorous strength,
Save that it gives you
Silver for breathing,
Save that it leads you
Down the world's length?

The mind will not help you,
The mind's dry laughter
Will baffle and foil you;
Now will the heart know.
Better to leave it
A riddle, to name it
Mist or a sunbeam,
Or dazzle of snow.

The Unuttered

Griefs forsaken now and lonely
And hurt that is too proud for sound,
Cluster together and rhythm the darkness.
Never let their names be found,
Lest loose syllables be tightened
For utterance, lest they should form
In twisted meanings. Know them as blowing,
Know them for ungathered storm,
Their soft motion will be broken
To quiet, like the stir of a dove,
Like the dropped leaf. Let them move.
They will not elude your silence,
They will make good love.

H.D.

Sea Rose

Rose, harsh rose,
marred and with stint of petals,
meager flower, thin,
sparse of leaf,

more precious
than a wet rose
single on a stem—
you are caught in the drift.

Stunted, with small leaf,
you are flung on the sand,
you are lifted
in the crisp sand
that drives in the wind.

Can the spice-rose
drip such acrid fragrance
hardened in a leaf?

Sea Lily

Reed,
Slashed and torn
but doubly rich—
such great heads as yours
drift upon temple-steps,
but you are shattered
in the wind.

Myrtle-bark
is flecked from you,
scales are dashed
from your stem,
sand cuts your petal,
furrows it with hard edge,
like flint
on a bright stone.

Yet though the whole wind
slash at your bark,
you are lifted up,
aye—though it hiss
to cover you with froth.

Garden

I

You are clear
O rose, cut in rock,
hard as the descent of hail.

I could scrape the colour
from the petals
like spilt dye from a rock.

If I could break you
I could break a tree.

If I could stir
I could break a tree—
I could break you.

II

O wind, rend open the heat,
cut apart the heat,
rend it to tatters.

Fruit cannot drop
through this thick air—
fruit cannot fall into heat
that presses up and blunts
the points of pears
and rounds the grapes.

Cut the heat—
plough through it,
turning it on either side
of your path.

Sea Violet

The white violet
is scented on its stalk,
the sea-violet
fragile as agate,
lies fronting all the wind
among the torn shells
on the sand-bank.

The greater blue violets
flutter on the hill,
but who would change for these
who would change for these
one root of the white sort?

Violet
your grasp is frail
on the edge of the sand-hill,
but you catch the light—
frost, a star edges with its fire.

Orchard

I saw the first pear
as it fell—
the honey-seeking, golden-banded,
the yellow swarm
was not more fleet than I,
(spare us from loveliness)
and I fell prostrate
crying:
you have flayed us
with your blossoms,
spare us the beauty
of fruit-trees.

The honey-seeking
paused not,
the air thundered their song,
and I alone was prostrate.

O rough-hewn
god of the orchard,
I bring you an offering—
do you, alone unbeautiful,
son of the god,
spare us from loveliness:

these fallen hazel-nuts,
stripped late of their green sheaths,
grapes, red-purple,
their berries
dripping with wine,
pomegranates already broken,
and shrunken figs
and quinces untouched,
I bring you as offering.

Storm

You crash over the trees,
you crack the live branch—
the branch is white,
the green crushed,
each leaf is rent like split wood.

You burden the trees
with black drops,
you swirl and crash—
you have broken off a weighted leaf
in the wind,
it is hurled out,
whirls up and sinks,
a green stone.

Hermes of the Ways

I

The hard sand breaks,
and the grains of it
are clear as wine.

Far off over the leagues of it,
the wind,
playing on the wide shore,
piles little ridges,
and the great waves
break over it.

But more than the many-foamed ways
of the sea,
I know him
of the triple path-ways,
Hermes,
who awaits.

Dubious,
facing three ways,
welcoming wayfarers,
he whom the sea-orchard
shelters from the west,
from the east
weathers sea-wind;
fronts the great dunes.

Wind rushes
over the dunes,

and the coarse, salt-crusted grass
answers.

Heu,
it whips round my ankles!

II

Small is
this white stream,
flowing below ground
from the poplar-shaded hill,
but the water is sweet.

Apples on the small trees
are hard,
too small,
too late ripened
by a desperate sun
that struggles through sea-mist.

The boughs of the trees
are twisted
by many bafflings;
twisted are
the small-leafed boughs.

But the shadow of them
is not the shadow of the mast head
nor of the torn sails.

Hermes, Hermes,
the great sea foamed,
gnashed its teeth about me;
but you have waited,
where sea-grass tangles with
shore-grass.

For Bryher and Perdita

They said:
she is high and far and blind
in her high pride,
but now that my head is bowed
in sorrow, I find
she is most kind.

We have taken life, they said,
blithely, not groped in a mist
for things that are not—
are if you will, but bloodless—
why ask happiness of the dead?
and my heart bled.

Ah, could they know
how violets throw strange fire,
red and purple and gold,
how they glow
gold and purple and red
where her feet tread.

Hymen

As from a temple service, tall and dignified, with slow pace, each
a queen, the sixteen matrons from the temple of Hera pass before
the curtain—a dark purple hung between Ionic columns—of the porch
or open hall of a palace. Their hair is bound as the marble hair of
the temple Hera. Each wears a crown or diadem of gold.
 They sing—the music is temple music, deep, simple, chanting notes:

From the closed garden
Where our feet pace
Back and forth each day,
This gladiolus white,
This red, this purple spray —
Gladiolus tall with dignity
As yours, lady—we lay
Before your feet and pray:

Of all the blessings—
Youth, joy, ecstasy—
May one gift last
(As the tall gladiolus may
Outlast the wind-flower,
Winter-rose or rose),
One gift above,
Encompassing all those;

For her, for him,
For all within these palace walls,
Beyond the feast,
Beyond the cry of Hymen and the torch,

Beyond the night and music
Echoing through the porch till day.

*The music, with its deep chanting notes, dies away. The curtain
hangs motionless in rich, full folds. Then from this background of
darkness, dignity and solemn repose, a flute gradually detaches itself,
becomes clearer and clearer, pipes alone one shrill, simple little melody.
From the distance, four children's voices blend with the flute, and
four very little girls pass singly before the curtain, small maids or
attendants of the sixteen matrons. Their hair is short and curls at
the back of their heads like the hair of the chryselephantine Hermes.
They sing:*

Where the first crocus buds unfold
We found these petals near the cold
 Swift river-bed.

Beneath the rocks where ivy-frond
Puts forth new leaves to gleam beyond
 Those lately dead:

The very smallest two or three
Of gold (gold pale as ivory)
 We gatherèd.

*When the little girls have passed before the curtain, a wood-wind
weaves a richer note into the flute melody; then the two blend into one
song. But as the wood-wind grows in mellowness and richness, the
flute gradually dies away into a secondary theme and the wood-wind
alone evolves the melody of a new song.*

*Two by two—like two sets of medallions with twin profiles distinct,
one head slightly higher, bent forward a little—the four figures of four
slight, rather fragile taller children, are outlined with sharp white
contour against the curtain.*

The hair is smooth against the heads, falling to the shoulders, but slightly waved against the nape of the neck. They are looking down, each at a spray of winter-rose. The tunics fall to the knees in sharp marble folds. They sing:

Never more will the wind
Cherish you again,
Never more will the rain.

Never more
Shall we find you bright
In the snow and wind.

The snow is melted,
The snow is gone,
And you are flown:

Like a bird out of our hand,
Like a light out of our heart,
You are gone.

As the wistful notes of the wood-wind gradually die away, there comes a sudden, shrill, swift piping.

Free and wild, like the wood-maidens of Artemis, is this last group of four—very straight with heads tossed back. They sing in rich, free, swift notes. They move swiftly before the curtain in contrast to the slow, important pace of the first two groups. Their hair is loose and rayed out like that of the sun-god. They are boyish in shape and gesture. They carry hyacinths in baskets, strapped like quivers to their backs. They reach to draw the flower sprays from the baskets, as the Huntress her arrows.

As they dart swiftly to and fro before the curtain, they are youth, they are spring—they are the Chelidonia, their song is the swallow-song of joy:

Between the hollows
Of the little hills
The spring spills blue—
Turquoise, sapphire, lapis-lazuli—
On a brown cloth outspread.

Ah see,
How carefully we lay them now,
Each hyacinth spray,
Across the marble floor—
A pattern your bent eyes
May trace and follow
To the shut bridal door.

Lady, our love, our dear,
Our bride most fair,
They grew among the hollows
Of the hills;
As if the sea had spilled its blue,
As if the sea had risen
From its bed,
And sinking to the level of the shore,
Left hyacinths on the floor.

*There is a pause. Flute, pipe and wood-wind blend in a full, rich
movement. There is no definite melody but full, powerful rhythm like
soft but steady wind above forest trees. Into this, like rain, gradually
creeps the note of strings.*

*As the strings grow stronger and finally dominate the whole, the
bride-chorus passes before the curtain. There may be any number
in this chorus. The figures—tall young women, clothed in long white
tunics—follow one another closely, yet are all distinct like a procession
of a temple frieze.*

*The bride in the center is not at first distinguishable from her
maidens; but as they begin their song, the maidens draw apart into*

two groups, leaving the veiled symbolic figure standing alone in the center.

The two groups range themselves to right and left like officiating priestesses. The veiled figure stands with her back against the curtain, the others being in profile. Her head is swathed in folds of diaphanous white, through which the features are visible, like the veiled Tanagra.

When the song is finished, the group to the bride's left turns about; also the bride, so that all face in one direction. In processional form they pass out, the figure of the bride again merging, not distinguishable from the maidens.

STROPHE But of her
 Who can say if she is fair?
 Bound with fillet,
 Bound with myrtle
 Underneath her flowing veil,
 Only the soft length
 (Beneath her dress)
 Of saffron shoe is bright
 As a great lily-heart
 In its white loveliness.

ANTISTROPHE But of her
 We can say that she is fair.
 We bleached the fillet,
 Brought the myrtle;
 To us the task was set
 Of knotting the fine threads of silk:
 We fastened the veil,
 And over the white foot
 Drew on the painted shoe
 Steeped in Illyrian crocus.

STROPHE But of her,
 Who can say if she is fair?

For her head is covered over
With her mantle
White on white,
Snow on whiter amaranth,
Snow on hoar-frost,
Snow on snow,
Snow on whitest buds of myrrh.

ANTISTROPHE But of her,
We can say that she is fair;
For we know underneath
All the wanness,
All the heat
(In her blanched face)
Of desire
Is caught in her eyes as fire
In the dark center leaf
Of the white Syrian iris.

The rather hard, hieratic precision of the music—its stately pause and beat—is broken now into irregular lilt and rhythm of strings.
Four tall young women, very young matrons, enter in a group.
They stand clear and fair, but this little group entirely lacks the austere precision of the procession of maidens just preceding them. They pause in the center of the stage; turn, one three-quarter, two in profile and the fourth full face; they stand, turned as if confiding in each other like a Tanagra group.
They sing lightly, their flower trays under their arms.

Along the yellow sand
Above the rocks
The laurel-bushes stand.
Against the shimmering heat
Each separate leaf
Is bright and cold,

And through the bronze
Of shining bark and wood
Run the fine threads of gold.

Here in our wicker-trays,
We bring the first faint blossoming
Of fragrant bays:

Lady, their blushes shine
As faint in hue
As when through petals
Of a laurel-rose
The sun shines through,
And throws a purple shadow
On a marble vase.

(Ah, love,
So her fair breasts will shine
With the faint shadow above.)

The harp chords become again more regular in simple definite
rhythm. The music is not so intense as the bride-chorus; and quieter,
more sedate, than the notes preceding the entrance of the last group.
Five or six slightly older serene young women enter in processional
form; each holding before her, with precise bending of arms, coverlets
and linen, carefully folded, as if for the bride couch. The garments are
purple, scarlet and deep blue, with edge of gold.
They sing to blending of wood-wind and harp.

From citron-bower be her bed,
Cut from branch of a tree a-flower,
Fashioned for her maidenhead.

From Lydian apples, sweet of hue,
Cut the width of board and lathe.

Carve the feet from myrtle-wood.

Let the palings of her bed
Be quince and box-wood overlaid
With the scented bark of yew.

That all the wood in blossoming,
May calm her heart and cool her blood
For losing of her maidenhood.

The wood-winds become more rich and resonant. A tall youth crosses the stage as if seeking the bride door. The music becomes very rich, full of color.

The figure itself is a flame, an exaggerated symbol; the hair a flame; the wings, deep red or purple, stand out against the curtains in a contrasting or almost clashing shade of purple. The tunic, again a rich purple or crimson, falls almost to the knees. The knees are bare; the sandals elaborately strapped over and over. The curtain seems a rich purple cloud, the figure, still brighter, like a flamboyant bird, half emerged in the sunset.

Love pauses just outside the bride's door with his gift, a tuft of black-purple cyclamen. He sings to the accompaniment of wood-winds, in a rich, resonant voice:

The crimson cover of her bed
Is not so rich, nor so deeply bled
The purple-fish that dyed it red,
As when in a hot sheltered glen
There flowered these stalks of cyclamen:

(Purple with honey-points
Of horns for petals;
Sweet and dark and crisp,
As fragrant as her maiden kiss.)

There with his honey-seeking lips
the bee clings close and warmly sips,
And seeks with honey-thighs to sway
And drink the very flower away.

(Ah, stern the petals drawing back;
Ah rare, ah virginal her breath!)

Crimson, with honey-seeking lips,
The sun lies hot across his back,
The gold is flecked across his wings.
Quivering he sways and quivering clings
(Ah, rare her shoulders drawing back!)
One moment, then the plunderer slips
Between the purple flower-lips.

> *Love passes out with a crash of cymbals. There is a momentary
> pause and the music falls into its calm, wave-like rhythm.*
> *A band of boys passes before the curtain. They pass from side
> to side, crossing and recrossing; but their figures never confuse one
> another, the outlines are never blurred. They stand out against the
> curtain with symbolic gesture, stooping as if to gather up the wreaths,
> or swaying with long stiff branch as if to sweep the fallen petals from
> the floor.*
> *There is no marked melody from the instruments, but the boys'
> voices, humming lightly as they enter, gradually evolve a little dance
> song. There are no words but the lilt up and down of the boys' tenor
> voices.*
> *Then, as if they had finished the task of gathering up the wreaths
> and sweeping the petals, they stand in groups of two before the
> pillars where the torches have been placed. They lift the torches from
> the brackets. They hold them aloft between them, one torch to each
> two boys. Their figures are cut against the curtain like the simple,
> triangular design on the base of a vase or frieze—the boys' heads on
> a level, the torches above them.*

They sing in clear, half-subdued voices:

Where love is king,
Ah, there is little need
To dance and sing,
With bridal-torch to flare
Amber and scatter light
Across the purple air,
To sing and dance
To flute-note and to reed.

Where love is come
(Ah, love is come indeed!)
Our limbs are numb
Before his fiery need;
With all their glad
Rapture of speech unsaid,
Before his fiery lips
Our lips are mute and dumb.

Ah, sound of reed,
Ah, flute and trumpet wail,
Ah, joy decreed—
The fringes of her veil
Are seared and white;
Across the flare of light,
Blinded the torches fail.
(Ah, love is come indeed!)

*At the end of the song, the torches flicker out and the figures are no
longer distinguishable in the darkness. They pass out like shadows. The
purple curtain hangs black and heavy.*

*The music dies away and is finally cut short with a few deep, muted
chords.*

Song

You are as gold
as the half-ripe grain
that merges to gold again,
as white as the white rain
that beats through
the half-opened flowers
of the great flower tufts
thick on the black limbs
of an Illyrian apple bough.

Can honey distill such fragrance
as your bright hair—
for your face is as fair as rain,
yet as rain that lies clear
on white honey-comb,
lends radiance to the white wax,
so your hair on your brow
casts light for a shadow.

Helen

All Greece hates
the still eyes in the white face,
the luster as of olives
where she stands,
and the white hands.

All Greece reviles
the wan face when she smiles,
hating it deeper still
when it grows wan and white,
remembering past enchantments
and past ills.

Greece sees unmoved,
God's daughter, born of love,
the beauty of cool feet
and slenderest knees,
could love indeed the maid,
only if she were laid,
white ash amid funereal cypresses.

Fragment Forty

Love . . . bitter-sweet. —Sappho.

1

Keep love and he wings,
with his bow,
up, mocking us,
keep love and he taunts us
and escapes.

Keep love and he sways apart
in another world,
outdistancing us.

Keep love and he mocks,
ah, bitter and sweet,
your sweetness is more cruel
than your hurt.

Honey and salt,
fire burst from the rocks
to meet fire
spilt from Hesperus.

Fire darted aloft and met fire:
in that moment
love entered us.

2

Could Eros be kept?
he were prisoned long since
and sick with imprisonment;
could Eros be kept?
others would have broken
and crushed out his life.

Could Eros be kept?
we too sinning, by Kypris,
might have prisoned him outright.

Could Eros be kept?
nay, thank him and the bright goddess
that he left us.

3

Ah, love is bitter and sweet,
but which is more sweet,
the sweetness
or the bitterness?
none has spoken it.

Love is bitter,
but can salt taint sea-flowers,
grief, happiness?

Is it bitter to give back
love to your lover
if he crave it?

Is it bitter to give back
love to your lover

if he wish it
for a new favourite?
who can say,
or is it sweet?

Is it sweet
to possess utterly?
or is it bitter,
bitter as ash?

4

I had thought myself frail;
a petal,
with light equal
on leaf and under-leaf.

I had thought myself frail;
a lamp,
shell, ivory or crust of pearl,
about to fall shattered,
with flame spent.

I cried:
"I must perish,
I am deserted,
an outcast, desperate
in this darkness,"
(such fire rent me with Hesperus,)
then the day broke.

5

What need of a lamp
when day lightens us,

what need to bind love
when love stands
with such radiant wings
over us?

What need—
yet to sing love,
love must first shatter us.

Fragment Forty-one

. . . thou flittest to Andromeda. —Sappho.

1

Am I blind alas,
am I blind?
I too have followed
her path.
I too have been at her feet.
I too have wakened to pluck
amaranth in the straight shaft,
amaranth purple in the cup,
scorched at the edge to white.

Am I blind?
am I the less ready for her sacrifice?
am I the less eager to give
what she asks,
she the shameless and radiant?

Am I quite lost,
I towering above you and her glance,
walking with swifter pace,
with clearer sight,
with intensity
beside which you two
are as spent ash?

Nay, I give back to the goddess the gift
she tendered me in a moment
of great bounty.

I return it. I lay it again
on the white slab of her house,
the beauty she cast out
one moment, careless.

Nor do I cry out:
"why did I stoop?
why did I turn aside
one moment from the rocks
marking the sea-path?
Aphrodite, shameless and radiant,
have pity, turn, answer us."

Ah no—though I stumble toward
her altar-step,
though my flesh is scorched and rent,
shattered, cut apart,
slashed open;
though my heels press my own wet life
black, dark to purple,
on the smooth, rose-streaked
threshold of her pavement.

2

Am I blind alas, deaf too
that my ears lost all this?
nay, O my lover,
shameless and still radiant,
I tell you this:

I was not asleep,
I did not lie asleep on those hot rocks
while you waited.
I was not unaware when I glanced

out toward the sea
watching the purple ships.

I was not blind when I turned.
I was not indifferent when I strayed aside
or loitered as we three went
or seemed to turn a moment from the path
for that same amaranth.

I was not dull and dead when I fell
back on our couch at night.
I was not indifferent when I turned
and lay quiet.
I was not dead in my sleep.

3

Lady of all beauty,
I give you this:
say I have offered small sacrifice,
say I am unworthy your touch,
but say not:
"she turned to some cold, calm god,
silent, pitiful, in preference."

Lady of all beauty,
I give you this:
say not:
"she deserted my altar-step,
the fire on my white hearth
was too great,
she fell back at my first glance."

Lady, radiant and shameless,
I have brought small wreaths,

(they were a child's gift,)
I have offered myrrh-leaf,
crisp lentisk,
I have laid rose-petal
and white rock-rose from the beach.

But I give now a greater,
I give life and spirit with this.
I render a grace
no one has dared to speak,
lest men at your altar greet him
as slave, callous to your art;

I dare more than the singer
offering her lute,
the girl her stained veils,
the woman her swathes of birth,
or pencil and chalk,
mirror and unguent box.

I offer more than the lad
singing at your steps,
praise of himself,
his mirror his friend's face,
more than any girl,
I offer you this:
(grant only strength
that I withdraw not my gift,)
I give you my praise and this:
the love of my lover
for his mistress.

Fragment Sixty-eight

. . . even in the house of Hades. –Sappho.

1

I envy you your chance of death,
how I envy you this.
I am more covetous of him
even than of your glance,
I wish more from his presence
though he torture me in a grasp,
terrible, intense.

Though he clasp me in an embrace
that is set against my will
and rack me with his measure,
effortless yet full of strength,
and slay me
in that most horrible contest,
still, how I envy you your chance.

Though he pierce me—imperious—
iron—fever—dust—
though beauty is slain
when I perish,
I envy you death.

What is beauty to me?
has she not slain me enough,
have I not cried in agony of love,
birth, hate,
in pride crushed?

What is left after this?
what can death loose in me
after your embrace?
your touch,
your limbs are more terrible
to do me hurt.

What can death mar in me
that you have not?

2

What can death send me
that you have not?
you gathered violets,
you spoke:
"your hair is not less black,
nor less fragrant,
nor in your eyes is less light,
you hair is not less sweet
with purple in the lift of lock;"
why were those slight words
and the violets you gathered
of such worth?

How I envy you death;
what could death bring,
more black, more set with sparks
to slay, to affright,
than the memory of those first violets,
the chance lift of your voice,
the chance blinding frenzy
as you bent?

3

So the goddess has slain me
for your chance smile
and my scarf unfolding
as you stooped to it;
so she trapped me
with the upward sweep of your arm
as you lifted the veil,
and the swift smile and selfless.

Could I have known?
nay, spare pity,
though I break,
crushed under the goddess' hate,
though I fall beaten at last,
so high have I thrust my glance
up into her presence.

Do not pity me, spare that,
but how I envy you
your chance of death.

Lethe

Nor skin nor hide nor fleece
 Shall cover you,
Nor curtain of crimson nor fine
Shelter of cedar-wood be over you,
 Nor the fir-tree
 Nor the pine.

Nor sight of whin nor gorse
 Nor river-yew,
Nor fragrance of flowering bush,
Nor wailing of reed-bird to waken you,
 Nor of linnet,
 Nor of thrush.

Nor word nor touch nor sight
 Of lover, you
Shall long through the night but for this:
The roll of the full tide to cover you
 Without question,
 Without kiss.

Christmas 1944

I

The stratosphere was once where angels were;
if we are dizzy and a little mad,
forgive us, we have had
experience of a world beyond our sphere,
there—where no angels are;

the angle host and choir
is driven further, higher,
or (so it seems to me) descended to our level,
to share our destiny;

we do not see the fire,
we do not even hear
the whirr and distant roar,
we have gone hence before

the sound manifests;
are we here? or there?
we do not know,
waiting from hour to hour,

hoping for what? dispersal
of our poor bodies' frame?
what do we hope for?
name remembered? faults forgot?

or do we hope to rise upward?
no—no—not to those skies;

rather we question here,
what do I love?

what have I left un-loved?
what image would I choose
had I one thing, as gift,
redeemed from dust and ash?

I ask, what would I take?
which doll clutch to my breast?
should some small tender ghost,
descended from the host

of cherubim and choirs, speak:
'look, they are all here,
all, all your loveliest treasures,
look and then choose—but *one*—

we have our journey now,
poor child—come.'

II

A Dresden girl and boy
held up the painted dial,
but I had quite forgot
I had that little clock;

I'll take the clock—but how?
why, it was broken, lost,
dismantled long ago;

but there's another treasure,
that slice of amber-rock,

a traveller once brought
me from the Baltic coast,

and with it (these are small)
the little painted swallow—
where are they? one, I left,
I know at a friend's house;

and there's that little cat
that lapped milk from my tray
at breakfast-time—but where?

at some hotel perhaps?
or staying with a friend?
or was it in a dream?
a small cat with grey fur;
perhaps you may remember?

> it's true I lent or gave away the amber,
> the swallow's somewhere else in someone's house,
> the clock was long ago, dismantled, lost,
> the cat was dream or memory or both;
> but I'll take these—is it too much?

III

We are a little dizzy
and quite mad,
but we have had
strange visitations
from the stratosphere,
of angels drawn to earth
and nearer angels;

we think and feel and speak
like children lost,
for one Child too, was cast
at Christmas, from a house
of stone with wood for beam
and lintel and door-shaft;

go—go—there is no room
for you, in this our Inn:

to Him, the painted swallow,
to Him, the lump of amber,
to Him, the boy and girl
with roses and love-knots,
to Him, the little cat
to play beneath the Manger:

if we are dizzy
and a little mad,
forgive us, we have had
strange visitations
from the stratosphere.

The Walls Do Not Fall

To Bryher

for Karnak 1923
from London 1942

1

An incident here and there,
and rails gone (for guns)
from your (and my) old town square:

mist and mist-grey, no colour,
still the Luxor bee, chick and hare
pursue unalterable purpose

in green, rose-red, lapis;
they continue to prophesy
from the stone papyrus:

there, as here, ruin opens
the tomb, the temple; enter,
there as here, there are no doors:

the shrine lies open to the sky,
the rain falls, here, there
sand drifts; eternity endures:

ruin everywhere, yet as the fallen roof
leaves the sealed room
open to the air,

so, through our desolation,
thoughts stir, inspiration stalks us
through gloom:

unaware, Spirit announces the Presence;
shivering overtakes us,
as of old, Samuel:

trembling at a known street-corner,
we know not nor are known;
the Pythian pronounces—we pass on

to another cellar, to another sliced wall
where poor utensils show
like rare objects in a museum;

Pompeii has nothing to teach us,
we know crack of volcanic fissure,
slow flow of terrible lava,

pressure on heart, lungs, the brain
about to burst its brittle case
(what the skull can endure!):

over us, Apocryphal fire,
under us, the earth sway, dip of a floor,
slope of a pavement

where men roll, drunk
with a new bewilderment,
sorcery, bedevilment:

the bone-frame was made for
no such shock knit within terror,
yet the skeleton stood up to it:

the flesh? it was melted away,
the heart burnt out, dead ember,
tendons, muscles shattered, outer husk dismembered,

yet the frame held:
we passed the flame: we wonder
what saved us? what for?

2

Evil was active in the land,
Good was impoverished and sad;

Ill promised adventure,
Good was smug and fat;

Dev-ill was after us,
tricked up like Jehovah;

Good was the tasteless pod,
stripped from the manna-beans, pulse, lentils:

they were angry when we were so hungry
for the nourishment, God;

they snatched off our amulets,
charms are not, they said, grace;

but gods always face two-ways,
so let us search the old highways

for the true-rune, the right-spell,
recover old values;

nor listen if they shout out,
your beauty, Isis, Aset, or Astarte,

is a harlot; you are retrogressive,
zealot, hankering after old flesh-pots;

your heart, moreover,
is a dead canker,

they continue, and
your rhythm is the devil's hymn,

your stylus is dipped in corrosive sublimate,
how can you scratch out

indelible ink of the palimpsest
of past misadventure?

3

Let us, however, recover the Sceptre,
the rod of power:

it is crowned with the lily-head
or the lily-bud:

it is Caduceus; among the dying
it bears healing:

or evoking the dead,
it brings life to the living.

4

There is a spell, for instance,
in every sea-shell:

continuous, the sea thrust
is powerless against coral,

bone, stone, marble
hewn from within by that craftsman,

the shell-fish:
oyster, clam, mollusc

is master-mason planning
the stone marvel:

yet that flabby, amorphous hermit
within, like the planet

senses the finite,
it limits its orbit

of being, its house,
temple, fane, shrine:

it unlocks the portals
at stated intervals:

prompted by hunger,
it opens to the tide-flow:

but infinity? no,
of nothing-too-much:

I sense my own limit,
my shell-jaws snap shut

at invasion of the limitless,
ocean-weight; infinite water

can not crack me, egg in egg-shell;
closed in, complete, immortal

full-circle, I know the pull
of the tide, the lull

as well as the moon;
the octopus-darkness

is powerless against
her cold immortality;

so I in my own way know
that the whale

can not digest me:
be firm in your own small, static, limited

orbit and the shark-jaws
of outer circumstance

will spit you forth:
be indigestible, hard, ungiving,

so that, living within,
you beget, self-out-of-self,

selfless,
that pearl-of-great-price.

5

When in the company of the gods,
I loved and was loved,

never was my mind stirred
to such rapture,

my heart moved
to such pleasure,

as now, to discover
over Love, a new Master:

His, the track in the sand
from a plum-tree in flower

to a half-open hut-door,
(or track would have been

but wind blows sand-prints from the sand,
whether seen or unseen):

His, the Genius in the jar
which the Fisherman finds,

He is Mage,
bringing myrrh.

6

In me (the worm) clearly
is no righteousness, but this—

persistence; I escaped spider-snare,
bird-claw, scavenger bird-beak,

clung to grass-blade,
the back of a leaf

when storm-wind
tore it from its stem;

I escaped, I explored
rose-thorn forest,

was rain-swept
down the valley of a leaf;

was deposited on grass,
where mast by jeweled mast

bore separate ravellings
of encrusted gem-stuff

of the mist
from each banner-staff:

unintimidated by multiplicity
of magnified beauty,

such as your gorgon-great
dull eye can not focus

nor compass, I profit
by every calamity;

I eat my way out of it;
gorged on vine-leaf and mulberry,

parasite, I find nourishment:
when you cry in disgust,

a worm on the leaf,
a worm in the dust,

a worm on the ear-of-wheat,
I am yet unrepentant,

for I know how the Lord God
is about to manifest, when I,

the industrious worm,
spin my own shroud.

7

Gods, goddesses
wear the winged head-dress

of horns, as the butterfly
antennae,

or the erect king-cobra crest
to show how the worm turns.

8

So we reveal our status
with twin-horns, disk, erect serpent,

though these or the double-plume or lotus
are, you now tell us, trivial

intellectual adornment;
poets are useless,

more than that,
we, authentic relic,

bearers of the secret wisdom,
living remnant

of the inner band
of the sanctuaries' initiate,

are not only 'non-utilitarian',
we are 'pathetic':

this is the new heresy;
but if you do not even understand what words say,

how can you expect to pass judgement
on what words conceal?

yet the ancient rubrics reveal that
we are back at the beginning:

you have a long way to go,
walk carefully, speak politely

to those who have done their worm-cycle,
for gods have been smashed before

and idols and their secret is stored
in man's very speech,

in the trivial or
the real dream; insignia

in the heron's crest,
the asp's back,

enigmas, rubrics promise as before,
protection for the scribe;

he takes precedence of the priest,
stands second only to the Pharaoh.

9

Thoth, Hermes, the stylus,
the palette, the pen, the quill endure,

though our books are a floor
of smouldering ash under our feet;

though the burning of the books remains
the most perverse gesture

and the meanest
of man's mean nature,

yet give us, they still cry,
give us books,

folio, manuscript, old parchment
will do for cartridge cases;

irony is bitter truth
wrapped up in a little joke,

Hatshepsut's name is still circled
with what they call the *cartouche*.

10

But we fight for life,
we fight, they say, for breath,

so what good are your scribblings?
this—we take them with us

beyond death: Mercury, Hermes, Thoth
invented the script, letters, palette;

the indicated flute or lyre-notes
on papyrus or parchment

are magic, indelibly stamped
on the atmosphere somewhere,

forever; remember, O Sword,
you are the younger brother, the latter-born,

your Triumph, however exultant,
must one day be over,

in the beginning
was the Word.

11

Without thought, invention,
you would have remained

unmanifest in the dim dimension
where thought dwells,

and beyond thought and idea,
their begetter,

Dream,
Vision.

12

So, in our secretive, sly way,
we are proud and chary

of companionship with you others,
our betters, who seem to imply

that we will soon be swept aside,
crumpled rags, no good for banner-stuff,

no fit length for a bandage;
but when the shingles hissed

in the rain of incendiary,
other values were revealed to us,

other standards hallowed us;
strange texture, a wing covered us,

and though there was a whirr and roar in the high air,
there was a Voice louder,

though its speech was lower
than a whisper.

13

The Presence was spectrum-blue,
ultimate blue ray,

rare as radium, as healing;
my old self, wrapped around me,

was shroud (I speak of myself individually
but I was surrounded by my companions

in this mystery);
do you wonder we are proud,

aloof,
indifferent to your good and evil?

peril, strangely encountered, strangely endured,
marks us;

we know each other
by secret symbols,

though, remote, speechless,
we pass each other on the pavement,

at the turn of the stair;
though no word pass between us,

there is subtle appraisement;
even if we snarl a brief greeting

or do not speak at all,
we know our Name,

we nameless initiates,
born of one mother,

companions
of the flame.

14

Yet we, the latter-day, twice-born,
have our bad moments when

dragging the forlorn
husk of self after us,

we are forced to confess to
malaise and embarrassment;

we pull at this dead shell,
struggle but we must wait

till the new Sun dries off
the old-body humours;

awkwardly, we drag this stale
old will, old volition, old habit

about with us;
we are these people,

wistful, ironical, willful,
who have no part in

new-world reconstruction,
in the confederacy of labour,

the practical issues of art
and the cataloguing of utilities:

O do not look up
into the air,

you who are occupied
in the bewildering

sand-heap maze
of present-day endeavour;

you will be, not so much frightened
as paralysed with inaction,

and anyhow,
we have not crawled so very far

up our individual grass-blade
toward our individual star.

15

Too old to be useful
(whether in years or experience,

we are the same lot)
not old enough to be dead,

we are the keepers of the secret,
the carriers, the spinners

of the rare intangible thread
that binds all humanity

to ancient wisdom,
to antiquity;

our joy is unique, to us,
grape, knife, cup, wheat

are symbols in eternity,
and every concrete object

has abstract value, is timeless
in the dream parallel

whose relative sigil has not changed
since Nineveh and Babel.

16

Ra, Osiris, Amen appeared
in a spacious, bare meeting-house;

he is the world-father,
father of past aeons,

present and future equally;
beardless, not at all like Jehovah,

he was upright, slender,
impressive at the Memnon monolith,

yet he was not out of place
but perfectly at home

in that eighteenth-century
simplicity and grace;

then I woke with a start
of wonder and asked myself,

but whose eyes are those eyes?
for the eyes (in the cold,

I marvel to remember)
were all one texture,

as if without pupil
or all pupil, dark

yet very clear with amber
shining . . .

17

. . . coals for the world's burning,
for, we must go forward,

we are at the cross-roads,
the tide is turning;

it uncovers pebbles and shells,
beautiful yet static, empty

old thought, old convention;
let us go down to the sea,

gather dry sea-weed,
heap drift-wood,

let us light a new fire
and in the fragrance

of burnt salt and sea-incense
chant new paeans to the new Sun

of regeneration;
we have always worshipped Him,

we have always said,
forever and ever, Amen.

 18

The Christos-image
is most difficult to disentangle

from its art-craft junk-shop
paint-and-plaster medieval jumble

of pain-worship and death-symbol,
that is why, I suppose, the Dream

deftly stage-managed the bare, clean
early colonial interior,

without stained-glass, picture,
image or colour,

for now it appears obvious
that *Amen* is our Christos.

19

He might even be the authentic Jew
stepped out from Velasquez;

those eye-lids in the Velasquez
are lowered over eyes

that open, would daze, bewilder
and stun us with the old sense of guilt

and fear, but the terror of those eyes
veiled in their agony is over;

I assure you that the eyes
of Velasquez' crucified

now look straight at you,
and they are amber and they are fire.

20

Now it appears very clear
that the Holy Ghost,

childhood's mysterious enigma,
is the Dream;

that way of inspiration
is always open,

and open to everyone;
it acts as go-between, interpreter,

it explains symbols of the past
in to-day's imagery,

it merges the distant future
with most distant antiquity,

states economically
in a simple dream-equation

the most profound philosophy,
discloses the alchemist's secret

and follows the Mage
in the desert.

21

Splintered the crystal of identity,
shattered the vessel of integrity,

till the Lord *Amen,*
paw-er of the ground,

bearer of the curled horns,
bellows from the horizon:

here am I, Amen-Ra,
Amen, Aries, the Ram;

time, time for you to begin a new spiral,
see—I toss you into the star-whirlpool;

till pitying, pitying,
snuffing the ground,

here am I, Amen-Ra whispers,
Amen, Aries, the Ram,

be cocoon, smothered in wool,
be Lamb, mothered again.

22

Now my right hand,
now my left hand

clutch your curled fleece;
take me home, take me home,

my voice wails from the ground;
take me home, Father:

pale as the worm in the grass,
yet I am a spark

struck by your hoof from a rock:
Amen, you are so warm,

hide me in your fleece,
crop me up with the new-grass;

let your teeth devour me,
let me be warm in your belly,

the sun-disk,
the re-born Sun.

23

Take me home
where canals

flow
between iris-banks:

where the heron
has her nest:

where the mantis
prayed on the river-reed:

where the grasshopper says
Amen, Amen, Amen.

[...]

43

Still the walls do not fall,
I do not know why;

there is zrr-hiss,
lightning in a not-known,

unregistered dimension;
we are powerless,

dust and powder fill our lungs
our bodies blunder

through doors twisted on hinges,
and the lintels slant

cross-wise;
we walk continually

on thin air
that thickens to a blind fog,

then step swiftly aside,
for even the air

is independable,
thick where it should be fine

and tenuous
where wings separate and open,

and the ether
is heavier than the floor,

and the floor sags
like a ship floundering;

we know no rule
of procedure,

we are voyagers, discoverers
of the not-known,

the unrecorded;
we have no map;

possibly we will reach haven,
heaven.

Marianne Moore

The Past Is The Present

If external action is effete
 and rhyme is outmoded,
 I shall revert to you,
 Habakkuk, as when in a Bible class
 the teacher was speaking of unrhymed verse.
He said—and I think I repeat his exact words,
 "Hebrew poetry is prose
 with a sort of heightened consciousness." Ecstasy affords
 the occasion and expediency determines the form.

Those Various Scalpels,

those
various sounds consistently indistinct, like intermingled echoes
 struck from thin glasses successively at random—
 the inflection disguised: your hair, the tails of two
 fighting-cocks head to head in stone—
 like sculptured scimitars repeating the curve of your ears in
 reverse order:
 your eyes, flowers of ice and snow

sown by tearing winds on the cordage of disabled ships; your raised
 hand,
 an ambiguous signature: your cheeks, those rosettes
 of blood on the stone floors of French châteaux,
 with regard to which the guides are so affirmative—
 your other hand,

a bundle of lances all alike, partly hid by emeralds from Persia
 and the fractional magnificence of Florentine
 goldwork—a collection of little objects—
 sapphires set with emeralds, and pearls with a moonstone, made
 fine
 with enamel in gray, yellow, and dragon-fly blue;
 a lemon, a pear

and three bunches of grapes, tied with silver: your dress,
 a magnificent square
 cathedral tower of uniform
 and at the same time diverse appearance—a
 species of vertical vineyard rustling in the storm

of conventional opinion. Are they weapons or scalpels?
 Whetted to brilliance

by the hard majesty of that sophistication which is superior to
 opportunity,
 these things are rich instruments with which to experiment.
 But why dissect destiny with instruments
 more highly specialized than components of destiny itself?

The Fish

wade
through black jade.
 Of the crow-blue mussel-shells, one keeps
 adjusting the ash-heaps;
 opening and shutting itself like

an
injured fan.
 The barnacles which encrust the side
 of the wave, cannot hide
 there for the submerged shafts of the

sun,
split like spun
 glass, move themselves with spotlight swiftness
 into the crevices—
 in and out, illuminating

the
turquoise sea
 of bodies. The water drives a wedge
 of iron through the iron edge
 of the cliff; whereupon the stars,

pink
rice-grains, ink-
 bespattered jelly-fish, crabs like green
 lilies, and submarine
 toadstools, slide each on the other.

All
external
 marks of abuse are present on this
 defiant edifice—
 all the physical features of

ac-
cident—lack
 of cornice, dynamite grooves, burns, and
 hatchet strokes, these things stand
 out on it; the chasm-side is

dead.
Repeated
 evidence has proved that it can live
 on what can not revive
 its youth. The sea grows old in it.

Marriage

This institution,
perhaps one should say enterprise
out of respect for which
one says one need not change one's mind
about a thing one has believed in,
requiring public promises
of one's intention
to fulfil a private obligation:
I wonder what Adam and Eve
think of it by this time,
this fire-gilt steel
alive with goldenness;
how bright it shows—
"of circular traditions and impostures,
committing many spoils,"
requiring all one's criminal ingenuity
to avoid!
Psychology which explains everything
explains nothing,
and we are still in doubt.
Eve: beautiful woman—
I have seen her
when she was so handsome
she gave me a start,
able to write simultaneously
in three languages—
English, German and French—
and talk in the meantime;
equally positive in demanding a commotion
and in stipulating quiet:

"*I* should like to be alone";
to which the visitor replies,
"I should like to be alone;
why not be alone together?"
Below the incandescent stars
below the incandescent fruit,
the strange experience of beauty;
its existence is too much;
it tears one to pieces
and each fresh wave of consciousness
is poison.
"See her, see her in this common world,"
the central flaw
in that first crystal-fine experiment,
this amalgamation which can never be more
than an interesting impossibility,
describing it
as "that strange paradise
unlike flesh, stones,
gold or stately buildings,
the choicest piece of my life:
the heart rising
in its estate of peace
as a boat rises
with the rising of the water";
constrained in speaking of the serpent—
shed snakeskin in the history of politeness
not to be returned to again—
that invaluable accident
exonerating Adam.
And he has beauty also;
it's distressing—the O thou
to whom from whom,
without whom nothing—Adam;
"something feline,

something colubrine"—how true!
a crouching mythological monster
in that Persian miniature of emerald mines,
raw silk—ivory white, snow white,
oyster white and six others—
that paddock full of leopards and giraffes—
long lemon-yellow bodies
sown with trapezoids of blue.
Alive with words,
vibrating like a cymbal
touched before it has been struck,
he has prophesied correctly—
the industrious waterfall,
"the speedy stream
which violently bears all before it,
at one time silent as the air
and now as powerful as the wind."
"Treading chasms
on the uncertain footing of a spear,"
forgetting that there is in woman
a quality of mind
which as an instinctive manifestation
is unsafe,
he goes on speaking
in a formal customary strain,
of "past states, the present state,
seals, promises,
the evil one suffered,
the good one enjoys,
hell, heaven,
everything convenient
to promote one's joy."
In him a state of mind
perceives what it was not
intended that he should;

"he experiences a solemn joy
in seeing that he has become an idol."
Plagued by the nightingale
in the new leaves,
with its silence—
not its silence but its silences,
he says of it:
"It clothes me with a shirt of fire."
"He dares not clap his hands
to make it go on
lest it should fly off;
if he does nothing, it will sleep;
if he cries out, it will not understand."
Unnerved by the nightingale
and dazzled by the apple,
impelled by "the illusion of a fire
effectual to extinguish fire,"
compared with which
the shining of the earth
is but deformity—a fire
"as high as deep
as bright as broad
as long as life itself,"
he stumbles over marriage,
"a very trivial object indeed"
to have destroyed the attitude
in which he stood—
the ease of the philosopher
unfathered by a woman.
Unhelpful Hymen!
a kind of overgrown cupid
reduced to insignificance
by the mechanical advertising
parading as involuntary comment,
by that experiment of Adam's

with ways out but no way in—
the ritual of marriage,
augmenting all its lavishness;
its fiddle-head ferns,
lotus flowers, opuntias, white dromedaries,
its hippopotamus—
nose and mouth combined
in one magnificent hopper—
its snake and the potent apple.
He tells us
that "for love that will
gaze an eagle blind,
that is with Hercules
climbing the trees
in the garden of the Hesperides,
from forty-five to seventy
is the best age,"
commending it
as a fine art, as an experiment,
a duty or as merely recreation.
One must not call him ruffian
nor friction a calamity—
the fight to be affectionate:
"no truth can be fully known
until it has been tried
by the tooth of disputation."
The blue panther with black eyes,
the basalt panther with blue eyes,
entirely graceful—
one must give them the path—
the black obsidian Diana
who "darkeneth her countenance
as a bear doth,"
the spiked hand
that has an affection for one

and proves it to the bone,
impatient to assure you
that impatience is the mark of independence,
not of bondage.
"Married people often look that way"—
"seldom and cold, up and down,
mixed and malarial
with a good day and a bad."
We Occidentals are so unemotional,
self lost, the irony preserved
in "the Ahasuerus *tête-à-tête* banquet"
with its small orchids like snakes' tongues,
with its "good monster, lead the way,"
with little laughter
and munificence of humor
in that quixotic atmosphere of frankness
in which "four o'clock does not exist,
but at five o'clock
the ladies in their imperious humility
are ready to receive you";
in which experience attests
that men have power
and sometimes one is made to feel it.
He says, "What monarch would not blush
to have a wife
with hair like a shaving-brush?"
The fact of woman
is "not the sound of the flute
but very poison."
She says, "Men are monopolists
of 'stars, garters, buttons
and other shining baubles'—
unfit to be the guardians
of another person's happiness."
He says, "These mummies

must be handled carefully—
'the crumbs from a lion's meal,
a couple of shins and the bit of an ear';
turn to the letter M
and you will find
that 'a wife is a coffin,'
that severe object
with the pleasing geometry
stipulating space not people,
refusing to be buried
and uniquely disappointing,
revengefully wrought in the attitude
of an adoring child
to a distinguished parent."
She says, "This butterfly,
this waterfly, this nomad
that has 'proposed
to settle on my hand for life'—
What can one do with it?
There must have been more time
in Shakespeare's day
to sit and watch a play.
You know so many artists who are fools."
He says, "You know so many fools
who are not artists."
The fact forgot
that "some have merely rights
while some have obligations,"
he loves himself so much,
he can permit himself
no rival in that love.
She loves herself so much,
she cannot see herself enough—
a statuette of ivory on ivory,
the logical last touch

to an expansive splendor
earned as wages for work done:
one is not rich but poor
when one can always seem so right.
What can one do for them—
these savages
condemned to disaffect
all those who are not visionaries
alert to undertake the silly task
of making people noble?
This model of petrine fidelity
who "leaves her peaceful husband
only because she has seen enough of him"—
that orator reminding you,
"I am yours to command."
"Everything to do with love is mystery;
it is more than a day's work
to investigate this science."
One sees that it is rare—
that striking grasp of opposites
opposed each to the other, not to unity,
which in cycloid inclusiveness
has dwarfed the demonstration
of Columbus with the egg—
a triumph of simplicity—
that charitive Euroclydon
of frightening disinterestedness
which the world hates,
admitting:

 "I am such a cow,
 if I had a sorrow
 I should feel it a long time;
 I am not one of those
 who have a great sorrow

in the morning
and a great joy at noon";

which says: "I have encountered it
among those unpretentious
protégés of wisdom,
where seeming to parade
as the debater and the Roman,
the statesmanship
of an archaic Daniel Webster
persists to their simplicity of temper
as the essence of the matter:

'Liberty and union
now and forever';

the Book on the writing-table;
the hand in the breast-pocket."

An Octopus

of ice. Deceptively reserved and flat,
it lies "in grandeur and in mass"
beneath a sea of shifting snow-dunes;
dots of cyclamen-red and maroon on its clearly defined
pseudo-podia
made of glass that will bend—a much needed invention—
comprising twenty-eight ice-fields from fifty to five hundred feet
thick,
of unimagined delicacy.
"Picking periwinkles from the cracks"
or killing prey with the concentric crushing rigor of the python,
it hovers forward "spider fashion
on its arms" misleadingly like lace;
its "ghostly pallor changing
to the green metallic tinge of an anemone-starred pool."
The fir-trees, in "the magnitude of their root systems,"
rise aloof from these maneuvers "creepy to behold,"
austere specimens of our American royal families,
"each like the shadow of the one beside it.
The rock seems frail compared with their dark energy of life,"
its vermilion and onyx and manganese-blue interior expensiveness
left at the mercy of the weather;
"stained transversely by iron where the water drips down,"
recognized by its plants and its animals.
Completing a circle,
you have been deceived into thinking that you have progressed,
under the polite needles of the larches
"hung to filter, not to intercept the sunlight"—
met by tightly wattled spruce-twigs
"conformed to an edge like clipped cypress

as if no branch could penetrate the cold beyond its company";
and dumps of gold and silver ore enclosing The Goat's Mirror—
that lady-fingerlike depression in the shape of the left human foot,
which prejudices you in favor of itself
before you have had time to see the others;
its indigo, pea-green, blue-green, and turquoise,
from a hundred to two hundred feet deep,
"merging in irregular patches in the middle of the lake
where, like gusts of a storm
obliterating the shadows of the fir-trees, the wind makes lanes of
ripples."
What spot could have merits of equal importance
for bears, elk, deer, wolves, goats, and ducks?
Pre-empted by their ancestors,
this is the property of the exacting porcupine,
and of the rat "slipping along to its burrow in the swamp
or pausing on high ground to smell the heather";
of "thoughtful beavers
making drains which seem the work of careful men with shovels,"
and of the bears inspecting unexpectedly
ant-hills and berry-bushes.
Composed of calcium gems and alabaster pillars,
topaz, tourmaline crystals and amethyst quartz,
their den is somewhere else, concealed in the confusion
of "blue forests thrown together with marble and jasper and agate
as if whole quarries had been dynamited."
And farther up, in a stag-at-bay position
as a scintillating fragment of these terrible stalagmites,
stands the goat,
its eye fixed on the waterfall which never seems to fall—
as endless skein swayed by the wind,
immune to force of gravity in the perspective of the peaks.
A special antelope
acclimated to "grottoes from which issue penetrating draughts
which make you wonder why you came,"

it stands its ground
on cliffs the color of the clouds, of petrified white vapor—
black feet, eyes, nose, and horns, engraved on dazzling ice-fields,
the ermine body on the crystal peak;
the sun kindling its shoulders to maximum heat like acetylene,
 dyeing them white—
upon this antique pedestal,
"a mountain with those graceful lines which prove it a volcano,"
its top a complete cone like Fujiyama's
till an explosion blew it off.
Distinguished by a beauty
of which "the visitor dare never fully speak at home
for fear of being stoned as an impostor,"
Big Snow Mountain is the home of a diversity of creatures:
those who "have lived in hotels
but who now live in camps—who prefer to";
the mountain guide evolving from the trapper,
"in two pairs of trousers, the outer one older,
wearing slowly away from the feet to the knees";
"the nine-striped chipmunk
running with unmammal-like agility along a log";
the water ouzel
with "its passion for rapids and high-pressured falls,"
building under the arch of some tiny Niagara;
the white-tailed ptarmigan "in winter solid white,
feeding on heather-bells and alpine buckwheat";
and the eleven eagles of the west,
"fond of the spring fragrance and the winter colors,"
used to the unegoistic action of the glaciers
and "several hours of frost every midsummer night."
"They make a nice appearance, don't they,"
happy seeing nothing?
Perched on treacherous lava and pumice—
those unadjusted chimney-pots and cleavers
which stipulate "names and addresses of persons to notify

in case of disaster"—
they hear the roar of ice and supervise the water
winding slowly through the cliffs,
the road "climbing like the thread
which forms the groove around a snail-shell,
doubling back and forth until where snow begins, it ends."
No "deliberate wide-eyed wistfulness" is here
among the boulders sunk in ripples and white water
where "when you hear the best wild music of the forest
it is sure to be a marmot,"
the victim on some slight observatory,
of "a struggle between curiosity and caution,"
inquiring what has scared it:
a stone from the moraine descending in leaps,
another marmot, or the spotted ponies with glass eyes,
brought up on frosty grass and flowers
and rapid draughts of ice-water.
Instructed none knows how, to climb the mountain,
by business men who require for recreation
three hundred and sixty five holidays in the year,
these conspicuously spotted little horses are peculiar;
hard to discern among the birch-trees, ferns, and lily-pads,
avalanche lilies, Indian paint-brushes,
bear's ears and kittentails,
and miniature cavalcades of chlorophylless fungi
magnified in profile on the moss-beds like moonstones in the water;
the cavalcade of calico competing
with the original American "menagerie of styles"
among the white flowers of the rhododendron surmounting rigid
leaves
upon which moisture works its alchemy,
transmuting verdure into onyx.
Larkspur, blue pincushions, blue pease, and lupin;
white flowers with white, and red with red;
the blue ones "growing close together

so that patches of them look like blue water in the distance":
this arrangement of colors
as in Persian designs of hard stones with enamel,
forms a pleasing equation—
a diamond outside and inside, a white dot;
on the outside, a ruby; inside, a red dot;
black spots balanced with black
in the woodlands where fires have run over the ground—
separated by aspens, cats' paws, and wooly sunflowers,
fireweed, asters, and Goliath thistles
"flowering at all altitudes as multiplicitous as barley,"
like pink sapphires in the pavement of the glistening plateau.
Inimical to "bristling, puny, swearing men
equipped with saws and axes,"
this treacherous glass mountain
admires gentians, ladyslippers, harebells, mountain dryads,
and "Calypso, the goat flower—
that greenish orchid fond of snow"—
anomalously nourished upon shelving glacial ledges
where climbers have not gone or have gone timidly,
"the one resting his nerves while the other advanced,"
on this volcano with the blue jay, her principal companion.
"Hopping stiffly on sharp feet" like miniature icehacks
"secretive, with a look of wisdom and distinction, but a villain,
fond of human society or the crumbs that go with it,"
he knows no Greek,
"that pride producing language,"
in which "rashness is rendered innocuous and error exposed
by the collision of knowledge with knowledge."
"Like happy souls in Hell," enjoying mental difficulties,
the grasshoppers of Greece
amused themselves with delicate behavior
because it was "so noble and so fair";
not practiced in adapting their intelligence
to eagle-traps and snow-shoes,

to alpenstocks and other toys contrived by those
"alive to the advantage of invigorating pleasures."
Bows, arrows, oars, and paddles, for which trees provide the wood,
in new countries more eloquent than elsewhere—
augmenting the assertion that, essentially humane,
"the forest affords wood for dwellings and by its beauty
stimulates the moral vigor of its citizens."
The Greeks liked smoothness, distrusting what was back
of what could not be clearly seen,
resolving with benevolent conclusiveness,
"complexities which still will be complexities
as long as the world lasts";
ascribing what we clumsily call happiness,
to "an accident or a quality,
a spiritual substance or the soul itself,
as act, a disposition, or a habit,
or a habit infused, to which the soul has been persuaded,
or something distinct from a habit, a power"—
such power as Adam had and we are still devoid of.
"Emotionally sensitive, their hearts were hard";
their wisdom was remote
from that of these odd oracles of cool official sarcasm,
upon this game preserve
where "guns, nets, seines, traps, and explosives,
hired vehicles, gambling and intoxicants are prohibited;
disobedient persons being summarily removed
and not allowed to return without permission in writing."
It is self-evident
that it is frightful to have everything afraid of one;
that one must do as one is told
and eat rice, prunes, dates, raisins, hardtack, and tomatoes
if one would "conquer the main peak of Mount Tacoma,
this fossil flower concise without a shiver,
intact when it is cut,
damned for its sacrosanct remoteness—

like Henry James "damned by the public for decorum";
not decorum, but restraint;
it is the love of doing hard things
that rebuffed and wore them out—a public out of sympathy with
 neatness.
Neatness of finish! Neatness of finish!
Relentless accuracy is the nature of this octopus
with its capacity for fact.
"Creeping slowly as with meditated stealth,
its arms seeming to approach from all directions,"
it receives one under winds that "tear the snow to bits
and hurl it like a sandblast
shearing off twigs and loose bark from the trees."
Is "tree" the word for these things
"flat on the ground like vines"?
some "bent in a half circle with branches on one side
suggesting dust-brushes, not trees;
some finding strength in union, forming little stunted groves
their flattened mats of branches shrunk in trying to escape"
from the hard mountain "planed by ice and polished by the wind"—
the white volcano with no weather side;
the lightning flashing at its base,
rain falling in the valleys, and snow falling on the peak—
the glassy octopus symmetrically pointed,
its claw cut by the avalanche
"with a sound like the crack of a rifle,
in a curtain of powdered snow launched like a waterfall."

The Steeple-Jack

Dürer would have seen a reason for living
 in a town like this, with eight stranded whales
to look at; with the sweet sea air coming into your house
on a fine day, from water etched
 with waves as formal as the scales
on a fish.

One by one in two's and three's, the seagulls keep
 flying back and forth over the town clock,
or sailing around the lighthouse without moving their wings—
rising steadily with a slight
 quiver of the body—or flock
mewing where

a sea the purple of the peacock's neck is
 paled to greenish azure as Dürer changed
the pine green of the Tyrol to peacock blue and guinea
gray. You can see a twenty-five-
 pound lobster; and fish nets arranged
to dry. The

whirlwind fife-and-drum of the storm bends the salt
 marsh grass, disturbs stars in the sky and the
star on the steeple; it is a privilege to see so
much confusion. Disguised by what
 might seem the opposite, the sea-
side flowers and

trees are favored by the fog so that you have
 the tropics at first hand: the trumpet-vine,

fox-glove, giant snap-dragon, a salpiglossis that has
spots and stripes; morning-glories, gourds,
 or moon-vines trained on fishing-twine
at the back door;

cat-tails, flags, blueberries and spiderwort,
 striped grass, lichens, sunflowers, asters, daisies—
yellow and crab-claw ragged sailors with green bracts—toad-plant,
petunias, ferns; pink lilies, blue
 ones, tigers; poppies; black sweet-peas.
The climate

is not right for the banyan, frangipani, or
 jack-fruit trees; or for exotic serpent
life. Ring lizard and snake-skin for the foot, if you see fit;
but here they've cats, not cobras, to
 keep down the rats. The diffident
little newt

with white pin-dots on black horizontal spaced-
 out bands lives here; yet there is nothing that
ambition can buy or take away. The college student
named Ambrose sits on the hillside
 with his not-native books and hat
and sees boats

at sea progress white and rigid as if in
 a groove. Liking an elegance of which
the source is not bravado, he knows by heart the antique
sugar-bowl shaped summer-house of
 interlacing slats, and the pitch
of the church

spire, not true, from which a man in scarlet lets
 down a rope as a spider spins a thread;

he might be part of a novel, but on the sidewalk a
sign says C.J. Poole, Steeple-Jack,
 in black and white; and one in red
and white says

Danger. The church portico has four fluted
 columns, each a single piece of stone, made
modester by white-wash. This would be a fit haven for
waifs, children, animals, prisoners,
 and presidents who have repaid
sin-driven

senators by not thinking about them. The
 place has a school-house, a post-office in a
store, fish-houses, hen-houses, a three-masted
 schooner on
the stocks. The hero, the student,
 the steeple-jack, each in his way,
is at home.

It could not be dangerous to be living
 in a town like this, of simple people,
who have a steeple-jack placing danger-signs by the church
while he is gilding the solid-
 pointed star, which on a steeple
stands for hope.

In Distrust Of Merits

Strengthened to live, strengthened to die for
 medals and positioned victories?
They're fighting, fighting, fighting the blind
 man who thinks he sees,—
who cannot see that the enslaver is
enslaved; the hater, harmed. O shining O
 firm star, O tumultuous
 ocean lashed till small things go
 as they will, the mountainous
 wave makes us who look, know

depth. Lost at sea before they fought! O
 star of David, star of Bethlehem,
O black imperial lion
 of the Lord—emblem
of a risen world—be joined at last, be
joined. There is hate's crown beneath which all is
 death; there's love's without which none
 is king; the blessed deeds bless
 the halo. As contagion
 of sickness makes sickness,

contagion of trust can make trust. They're
 fighting in deserts and caves, one by
one, in battalions and squadrons;
 they're fighting that I
may yet recover from the disease, My
Self; some have it lightly; some will die. "Man's
 wolf to man" and we devour
 ourselves. The enemy could not

have made a greater breach in our
defenses. One pilot-

ing a blind man can escape him, but
Job disheartened by false comfort knew
that nothing can be so defeating
as a blind man who
can see. O alive who are dead, who are
proud not to see, O small dust of the earth
that walks so arrogantly,
trust begets power and faith is
an affectionate thing. We
vow, we make this promise

to the fighting—it's a promise—"We'll
never hate black, white, red, yellow, Jew,
Gentile, Untouchable." We are
not competent to
make our vows. With set jaw they are fighting,
fighting, fighting,—some we love whom we know,
some we love but know not—that
hearts may feel and not be numb.
It cures me; or am I what
I can't believe in? Some

in snow, some on crags, some in quicksands,
little by little, much by much, they
are fighting fighting fighting that where
there was death there may
be life. "When a man is prey to anger,
he is moved by outside things; when he holds
his ground in patience patience
patience, that is action or
beauty," the soldier's defense
and hardest armor for

the fight. The world's an orphans' home. Shall
 we never have peace without sorrow?
without pleas of the dying for
 help that won't come? O
quiet form upon the dust, I cannot
look and yet I must. If these great patient
 dyings—all these agonies
 and woundbearings and bloodshed—
 can teach us how to live, these
 dyings were not wasted.

Hate-hardened heart, O heart of iron,
 iron is iron till it is rust.
There never was a war that was
 not inward; I must
fight till I have conquered in myself what
causes war, but I would not believe it.
 I inwardly did nothing.
 O Iscariot-like crime!
 Beauty is everlasting
 and dust is for a time.

Djuna Barnes

Portrait of a Lady Walking

In the North birds feather a long wind.
She is beautiful.
The Fall lays ice on the lemon's rind.
Her slow ways are attendant on the dark mind.
The frost sets a brittle stillness on the pool.
Onto the cool short pile of the wet grass
Birds drop like a shower of glass.

The Walking-Mort

Call her walking-mort; say where she goes
She squalls her bush with blood. I slam a gate.
Report her axis bone it gigs the rose.
What say of mine? It turns a grinning grate.
Impugn her that she baits time with an awl.
What do my sessions then? They task a grave.
So, shall we stand, or shall we tread and wait
The mantled lumber of the buzzard's fall
(That maiden resurrection and the freight),
Or shall we freeze and wrangle by the wall?

Seen from the 'L'

So she stands—nude—stretching dully
Two amber combs loll through her hair
A vague molested carpet pitches
Down the dusty length of stair.
She does not see, she does not care
 It's always there.

The frail mosaic on her window
Facing starkly towards the street
Is scribbled there by tipsy sparrows—
Etched there with their rocking feet.
Is fashioned too, by every beat
 Of shirt and sheet.

Still her clothing is less risky
Than her body in its prime.
They are chain-stitched and so is she
Chain-stitched to her soul for time.
Raveling grandly into vice
Dropping crooked into rhyme.
Slipping through the stitch of virtue,
 Into crime.

Though her lips are vague and fancy
In her youth—
They bloom vivid and repulsive
As the truth.
Even vases in the making
 Are uncouth.

Suicide

Corpse A
 They brought her in, a shattered small
 Cocoon,
 With a little bruisèd body like
 A startled moon;
 And all the subtle symphonies of her
 A twilight rune.

Corpse B
 They gave her hurried shoves this way
 And that.
 Her body shock-abbreviated
 As a city cat.
 She lay out listlessly like some small mug
 Of beer gone flat.

Quarry

While I unwind duration from the tongue-tied tree,
Send carbon fourteen down for time's address.
The old revengeful without memory
Stand by:
I come, I come that path and there look in
And see the capsized eye of sleep and wrath
And hear the beaters' 'Gone to earth!'
Then do I sowl the soul and slap its face
That it fetch breath.

Dereliction

Does the inch-worm on the Atlas mourn
That last acre it's not inched upon?
As does the rascal, when to grass he's toed
Thunder in the basket, mowed to measure;
The four last things begun:
Leviathan
Thrashing on the banks of kingdomcome.

As Cried

And others ask, "What's it to be possessed
Of one you cannot keep, she being old?"
There is no robin in my eye to build a nest
For any bride who shakes against the cold,
Nor is there a claw that would arrest
I keep the hoof from stepping on her breath—
The ravelled clue that dangles crock by a thread,
Who hooked her to the underworld. I said in a breath
I keep a woman, as all do, feeding death.

Verse

Should any ask "what is it to be in love
With one you cannot slough, she being young?"
What should it be, we answer, who can prove
The falling of the milk-tooth on the tongue,
Is autumn in the mouth enough.

Hildegarde Flanner

Moment

I saw a young deer standing
Among the languid ferns.
Suddenly he ran—
And his going was absolute,
Like the shattering of icicles
In the wind.

Fern Song

Had I the use of thought equivalent
To moist hallucination of a flute
I could be saying how
A certain music in my woods has driven
A certain female fern to tear
In panic from her good black root.
But no transparency of clear intent
Assisting me,
I only guessed at what the singer meant
That hour I heard his intervals prolong
Beyond security of common song
Into a raving sweetness coming closer
While the lyric animal himself
Was still remote,
since thrush may have a mile of music
In one inch of throat.

True Western Summer

Corporeal summer, no marvel is lost
In your obsession to be real.
To love you has been my boast
In the bald days of cactus and hawk
Where never a brook in liquid shade rolls green,
Nor softly to my heart rambles the rain,
And to love you humbly under the feet of the quail,
By fallen acacia seed and brown bud,
And in the poor kingdom of the crowded toad,
Whose wealth is drought,
There to love you well,
Even where shadow that gives no shade
Lies dark as obsidian strewn
There to love you still,
And now to love in alarm and delight
Seeing the little stone in the field
Tremble and soar to your meaning alive
Alive in the top of the sky,
And to love you more as a ravish of light
Feasts on the literal and the revealed
Leaving only of truth the passionate skull
Small and perfect where it fell.

Laura Riding

Named

Dance it was and no one dancing,
Cool fire and full spirit,
Pure performing without pitying
Self of flaming feet,
Heart of heat.

Air imbibed it. It was air.
Yellow flushed when was sun.
No name bespoken, only fair
Played a light with light,
Both in fright.

Man on man went up to see,
Saying, woman must be here,
Such delight cannot be
Unlovable or needless of
Name and love.

Man on man went up to see.
Came but one woman down
Nighttime, breathing heavily
Love like a name in her,
Too dark to stir.

Summons

Come to me, man of my death—
Is it not death, what I am not,
The immanences not yet mine,
To be unbled with love?
I am a hollow without hunger.
Fate asks not to be fed but filled.
The end will be an end.
Stop up the narrow cyst
Most nothing when most provided.
The embrace imbibes us bodily.
Only the clasp and quiet stay
As death. Death must be something,
To have been made of us.

How impossible is abandoning;
Love is the lightest call,
But irresistible as death is.
The cruel internal I perceive
Under any mask. Beauty is a guise.
But destiny and the open flesh
Are more dire than beautiful.
I have a hound out that smells blood
In the whitest skin. I have a heart
Bleeding me hollow.
I can detect you as scent the dark,
With my eyes closed, truly.
Or, though my fingers turn in on me,
The thought of your thin face will be
Deep with the idea of your body.
Love is sure, life is more easily fled.

For life is only one in every one
And can escape itself without pursuit or heed.
Love is a place of numbers, where the conscience doubles.
It is the time, whenever it is the call.
Say no more it is not much,
No mystery unless we waste words on it,
Sob afterwards when we should be still,
Go on as ghosts when death is livelier,
Though strange, without a language,
And not unhappy, since there are no tongues.

Incarnations

Do not deny,
Do not deny, thing out of thing.
Do not deny in the new vanity
The old, original dust.

From what grave, what past of flesh and bone
Dreaming, dreaming I lie
Under the fortunate curse,
Bewitched, alive, forgetting the first stuff…
Death does not give a moment to remember in

Lest, like a statue's too transmuted stone,
I grain by grain recall the original dust
And, looking down a stair of memory, keep saying:
This was never I.

So Slight

It was as near invisible
As night in early dusk.
So slight it was,
It was as unbelievable
As day in early dawn.

The summer impulse of a leaf
To flutter separately
Gets death and autumn.
Such faint rebellion
Was lately love in me.

So slight, it had no hope or sorrow,
It could but choose
A passing flurry for its nuptial,
Drift off and fall
Like thistledown without a bruise.

Take Hands

Take hands.
There is no love now.
But there are hands.
There is no joining now,
But a joining has been
Of the fastening of fingers
And their opening.
More than the clasp even, the kiss
Speaks loneliness,
How we dwell apart,
And how love triumphs in this.

The Quids

The little quids, the monstrous quids,
The everywhere, everything, always quids,
The atoms of the Monoton,
Each turned an essence where it stood,
Ground a gisty dust from its neighbours' edges,
Until a powdery thoughtfall stormed in and out—
The cerebration of a slippery quid enterprise.

Each quid stirred.
The united quids
Waved through a sinuous decision.
The quids, that had never done anything before
But be, be, be, be, be—
The quids resolved to predicate,
To dissipate themselves in grammar.

Oh, the Monoton didn't care,
For whatever they did—
The Monoton's contributing quids—
The Monoton would always remain the same.

A quid here and there gyrated in place-position,
While many turned inside-out for the fun of it.
And a few refused to be anything but
Simple unpredicated copulatives.
Little by little, this commotion of quids,
By ones, by tens, by casual millions,
Squirming within the state of things,
The metaphysical acrobats,
The naked, immaterial quids,

Turned in on themselves
And came out all dressed—
Each similar quid of the inward same,
Each similar quid dressed in a different way,
The quids' idea of a holiday.

The quids could never tell what was happening.
But the Monoton felt itself differently the same
In its different parts.
The silly quids upon their learned exercise
Never knew, could never tell
What their wisdom was about,
What their carnival was like,
Being in, being in, being always in
Where they never could get out
Of the everywhere, everything, always in,
To derive themselves from the Monoton.

The Rugged Black of Anger

The rugged black of anger
Has an uncertain smile-border.
The transition from one kind to another
May be love between neighbour and neighbour;
Or natural death; or discontinuance
Because, so small is space,
The extent of kind must be expressed otherwise;
Or loss of kind when proof of no uniqueness
Confutes the broadening edge and discourages.

Therefore and therefore all things have experience
Of ending and of meeting,
And of ending that much more
As self grows faint of self dissolving
When more is the intenser self
That is another too, or nothing.
And therefore smiles come of least smiling—
The gift of nature to necessity
When relenting grows involuntary.

This is the account of peace,
Why the rugged black of anger
Has an uncertain smile-border,
Why crashing glass does not announce
The monstrous petal-advance of flowers,
Why singleness of heart endures
The mind coupled with other creatures.
Room for no more than love in such dim passages
Where between kinds lie only
Their own uncertain edges.

This such precise division of space
Leaves nothing for walls, nothing but
Weakening of place, gentleness.
The blacker anger, blacker the less
As anger greater, angrier grows;
And least where most,
Where anger and anger meet as two
And share one smile-border
To remain so.

The Map of Places

The map of places passes.
The reality of paper tears.
Land and water where they are
Are only where they were
When words read *here* and *here*
Before ships happened there.

Now on naked names feet stand,
No geographies in the hand,
And paper reads anciently,
And ships at sea
Turn round and round.
All is known, all is found.
Death meets itself everywhere.
Holes in maps look through to nowhere.

O Vocables of Love

O vocables of love,
O zones of dreamt responses
Where wing on wing folds in
The negro centuries of sleep
And the thick lips compress
Compendiums of silence—

Throats claw the mirror of blind triumph,
Eyes pursue sight into the heart of terror.
Call within call
Succumbs to the indistinguishable
Wall within wall
Embracing the last crushed vocable,
The spoken unity of efforts.

O vocables of love,
The end of an end is an echo,
A last cry follows a last cry.
Finality of finality
Is perfection's touch of folly.
Ruin unfolds from ruin.
A remnant breeds a universe of fragment.
Horizons spread intelligibility
And once more it is yesterday.

Come, Words, Away

Come, words, away from mouths,
Away from tongues in mouths
And reckless hearts in tongues
And mouths in cautious heads—

Come, words, away to where
The meaning is not thickened
With the voice's fretting substance,
Nor look of words is curious
As letters in books staring out
All that man ever thought strange
And laid to sleep on white
Like the archaic manuscript
Of dreams at morning blacked on wonder.

Come, words, away to miracle
More natural than written art.
You are surely somewhat devils,
But I know a way to soothe
The whirl of you when speech blasphemes
Against the silent half of language
And, labouring the blab of mouths,
You tempt prolixity to ruin.
It is to fly you home from where
Like stealthy angels you made off once
On errands of uncertain mercy:
To tell me with a story here
Of utmost mercy never squandered
On niggard prayers for eloquence—
The marveling on man by man.

I know a way, unwild we'll mercy
And spread the largest news
Where never a folded ear dare make
A deaf division of entirety.

That fluent half-a-story
Chatters against this silence
To which, words, come away now
In an all-merciful despite
Of early silvered treason
To the golden all of storying.

We'll begin fully at the noisy end
Where mortal halving tempered mercy
To the shorn utterance of man-sense;
Never more than savageries
Took they from your bounty-book.

Not out of stranger-mouths then
Shall words unwind but from the voice
That haunted there like dumb ghost haunting
Birth prematurely, anxious of death.
Not ours those mouths long-lipped
To falsity and repetition
Whose frenzy you mistook
For loyal prophetic heat
To be improved but in precision.

Come, words, away—
That was an alien vanity,
A rash startling and a preening
That from truth's wakeful sleep parted
When she within her first stirred story-wise,
Thinking what time it was or would be

When voiced illumination spread:
What time, what words, what she then.

Come, words, away,
And tell with me a story here,
Forgetting what's been said already:
That hell of hasty mouths removes
Into a cancelled heaven of mercies
By flight of words back to this plan
Whose grace goes out in utmost rings
To bounds of utmost storyhood.

But never shall truth circle so
Till words prove language is
How words come from far sound away
Through stages of immensity's small
Centering the utter telling
In truth's first soundlessness.

Come, words, away:
I am a conscience of you
Not to be held unanswered past
The perfect number of betrayal.
It is a smarting passion
By which I call—
Wherein the calling's loathsome as
Memory of man-flesh over-fondled
With words like over-gentle hands.
Then come, words, away,
Before lies claim the precedence of sin
And mouldered mouths writhe to outspeak us.

Afterword by Robert Hass

MODERNISTS: THE WOMEN

HERE'S A WAY TO think about the advent of modernism in American writing. Gertrude Stein's parents died when she was in her teens. Born in Pittsburgh, she moved to Oakland, California, in the suburban hills across the bay from San Francisco, in 1878. Her mother died in 1888 when Gertrude was fourteen. The family moved into the city the following year and her father died there in 1891. At the invitation of aunts in Baltimore, the two young girls in the family departed the West Coast. Stein says nothing about the trip in her various writings, but her older sister Bertha remarked that they traveled that summer, the summer of 1892, by stagecoach and arrived in Baltimore in July.

They could hardly have taken the entire trip by stage. The continental railroad, of course, was completed by 1876. Oakland must have been the end of the line, so perhaps there was in 1892 a stage-ferry from San Francisco to Oakland or a bargain price on a stage to San Jose or Reno to pick up the train to Baltimore. The family was used to taking the stagecoach to the Napa Valley for vacation outings in summer. Perhaps they took the Napa stage and picked up a train there. In any case, by 1914 Gertrude Stein was in France, had bought a Ford motor car and taught herself to drive (in the forward gears: by her own account she hadn't mastered reverse) and, as a volunteer, was hauling medical supplies for the French Army. In 1892 we have to imagine the future author of *Four Saints in Three Acts* as a seventeen-year-old girl in a Belle Époque traveling outfit dreaming, and no doubt reading, her way across the continent by stage and rail.

She began her studies at Radcliffe the following year. After three years she left Harvard for medical school at Johns Hopkins—in the

second class of students at the new school and the first to admit women to medical study. She left Hopkins in the spring of 1905 without a degree and began to write novels. The first, *QED*, was not published in her lifetime. After she moved to Paris to join her brother Leo, she began work on the second novel, *Three Lives*. By October of 1905, through her brother, she had also begun to look at and acquire paintings. She met Picasso and Matisse, saw what they were doing and in 1908, while her third novel—the account of a family in Oakland, California—was going off the rails of conventional fiction, began to experiment with cubist—or what one of her friends, Mabel Dodge Luhan, called "post-impressionist"—prose. By 1912 she had met her companion Alice B. Toklas and had set up housekeeping with her in the house Stein had shared with Leo in Paris a short walk from Saint-Sulpice and the Luxembourg Gardens. *Tender Buttons*, her first extended work of experimental prose or prose poetry, was written in 1912, the same year that some of her cubist word portraits appeared in New York in Alfred Stieglitz's magazine *Camera Work*. *Tender Buttons* was published in 1914. In May of 1915 Stein and Toklas took a trip to Spain, where Stein wrote a poem—probably the first cubist sonnet— about, or occasioned by, a Spanish dancer. The poem is called "Susie Asado," which was not the dancer's name. "Asado" in Spanish means "grilled" or "toasted," and the idea of toast seems to have suggested high tea. The poem may have been written as early as 1912, but let's say 1915: so it took about twenty-three years from one of the last stage-coaches out of San Francisco to the first cubist sonnet:

> Sweet sweet sweet sweet sweet tea.
> Susie Asado.
> Sweet sweet sweet sweet sweet tea.
> Susie Asado.
> Susie Asado which is a told tray sure.
> A lean on the shoe this means slips slips hers.
> When the ancient light grey is clean it is yellow, it is a silver
> seller.

This is a please this is a please there are the saids to jelly. These
are the wets these say the sets to leave a crown to Incy.
Incy is short for incubus.
A pot. A pot is a beginning of a rare bit of trees. Trees tremble,
the old vats are in bobbles, bobbles which shade and shove
and render clean, render clean must.
Drink pups.
Drink pups drink pups lease a sash hold, see it shine and a
bobolink has pins. It shows a nail.
What is a nail. A nail is unison.
Sweet sweet sweet sweet sweet tea.

It is striking that Stein's experiments with poetry came from her work
in prose. It's always difficult to pin down the source of a particular
technical innovation in an art form, but it seems likely that it was
during the early writing of her third novel, *The Making of Americans*,
that the formal play, particularly the patterns of repetition that gave
such distinct life to *Three Lives*, led her to new sounds and away from
certain ideas of sense. That, and the example of compositional daring
and humor and intellectual fierceness and associative play in the work
of her painter friends, led her into the experiments with prose in her
early "portraits," "Picasso," "Matisse," "Portrait of Mabel Dodge," and
to the verbal equivalent to still lifes in *Tender Buttons*. The opening
line of "Susie Asado" with its five strong beats (to my ear: four *sweet*s
and then *sweet tea*) seems to tease the idea of the iambic line, but aside
from that it's not written by a writer listening into the echo chamber
of traditional verse and making her own departure. There are lyric
moments in her work—this moment in *Lifting Belly*, for example:

Kiss my lips. She did.
Kiss my lips again she did.
Kiss my lips over and over again she did.
I have feathers.
Gentle fishes.

> Do you think about apricots. We find them very beautiful. It
> is not alone their
> color it is their seeds that charm us. We find it a change.
> Lifting belly is so strange.

But they don't feel like the vers libre, the experiments in free verse, of the young poets of these years. Their methods—repetition and non sequitur—are her own, have their own cadence. (And *Lifting Belly* was not, in any case, available as an example to her contemporaries. It did not find its way into print until the 1960s.)

So here is another way to think about the advent of modernism. Marianne Moore entered Bryn Mawr the same year Gertrude Stein moved to Paris, 1905. Moore was seventeen, about to be eighteen. When Stein was taking Toklas to Pablo Picasso's studio to see the large, strange canvas he was working on, *Les Demoiselles d'Avignon*, Moore would have been a junior taking a course in seventeenth-century English prose. She had begun to contribute poems—poems a literate young woman at the turn of the nineteenth century might write after spending her high school years in Carlisle, Pennsylvania—to the college literary magazine. After graduation, she began teaching at the Carlisle Indian Industrial School and sent poems to the Bryn Mawr alumna magazine, *The Lantern*. In 1909, twenty-one years old, she was writing poems in a turn-of-the-century style with authority and panache. Here, from 1910, is what I guess is a description of a Chinese screen. The fashionable Chinoiserie dates the poem. Think of the screens in John Singer Sargent's society portraits. It was a moment when, just as racist anti-Asian immigration laws were being implemented in the West, in the East, among people of advanced taste, everything Chinese was chic.

To A Screen-Maker

I.
Not of silver, nor of coral
But of weather-beaten laurel

Carve it out.

II.
Carve out here and there a face
And a dragon circling space
Coiled about.

III.
Represent a branching tree
Uniform like tapestry
And no sky.

IV.
And devise a rustic bower
And a pointed passion flower
Hanging high.

This is already the work of a fastidious craftsperson. And it comes very much from someone with an ear to contemporary poetry. The hammered-out rhythm of the couplets sounds like William Butler Yeats, and the abrupt final line—long, short, long; what a course in Greek or Latin poetry would have told her was a "cretic foot"—gives each stanza a neatly delicate and classical finish. But she was not through with the poem. Here is the reworked version published in *The Egoist* in 1916 when she was twenty-eight and had been writing poems for another half-decade:

He Made This Screen

Not of silver nor of coral,
but of weatherbeaten laurel.

Here, he introduced a sea
uniform like tapestry;

here, a fig-tree; there, a face;
there, a dragon circling space—

designating here, a bower;
there, a pointed passion-flower.

A lot could be said about every detail of this revision, but the first
thing to notice is that she has hit upon what would become one of
her signature techniques: using the title to begin the poem, so that
the first line is the continuation of a sentence already begun. It moves
the poem in a stroke from a late-Victorian arts-and-crafts sensibility
to modernist efficiency, gives the poem a sense of sleek, no-nonsense
design, and so does the decision to get rid of the final short lines. The
title of the poem now tells you absolutely what it is about: making. If
the stuff represented on the screen calls a viewer to a delicate world
of imagination, to what might seem an Orientalized version of the
escapist world of Romantic and symbolist poetry, Moore in 1910 was
already interested in getting some distance from it. The first draft of
the poem was addressed to the screen-maker, and the final version
goes further. It mimes and celebrates the power of making, so that the
poem is not about passion but about who gets to designate it.

All of the young poets of the early twentieth century were drenched
in Romantic and Victorian poetry and were trying to get past its sound,
which seems to be why they were, collectively, riveted by the example
of Moore, who was not in London or Paris but in a small Pennsylvania
town teaching commercial English at a school for Native Americans.
When Ezra Pound read Moore's "The Fish," he is supposed to have said
to H.D., "She's gotten there first." The story doesn't tell us whether he
read the 1918 version of the poem, published in *The Egoist* when T.S. Eliot
had assumed its readership, the beginning of which looked like this:

THE FISH

Wade through black jade.
Of the crow-blue mussel-shells, one

Keeps adjusting the ash-heaps;
Opening and shutting itself like

An injured fan.

Or the revised version, which became one of her best-known poems,
published in a New York anthology of new verse, *Others for 1919*:

THE FISH

wade
through black jade.
 Of the crow blue mussel shells one keeps
 adjusting the ash heaps;
 opening and shutting itself like

an
injured fan.

Here she had come to what became her characteristic idiom in the
1920s: syllabics, that is, stanzas based on syllable count, sentences that
feel like expository prose (that course in seventeenth-century English
prose writers!) enjambed in ways that seem quite arbitrary though
they are honoring the shape of the syllable count and stanza pattern
and are finished by the use of rhyme, oddly timed. It is very much
the work of a maker (and gives us the most expressive—though self-
protective—shellfish in American poetry). She hadn't yet arrived at
the remarkable work to come—"Marriage" and "An Octopus" and
"The Steeple-Jack"—but in 1920 whatever was meant by a modernist
idiom was firmly in place.
 Here is a third entry into modernism. The reason why Moore's "He
Made This Screen" appeared in a small London magazine is that her
Bryn Mawr classmate Hilda Doolittle was its acting poetry editor in
1916, and her story is the iconic one about the advent of modernism.
Doolittle's father was a professor of astronomy at the University of

Pennsylvania, where the young Ezra Pound and William Carlos Williams were classmates. She met them while she was still a high school girl, and in 1905, when she was entering Bryn Mawr, Pound was beginning graduate work in Romance languages at Penn. They became romantically involved, which seems to have involved reading to each other Greek and Latin poetry in translation and the poems of Swinburne, who was still alive in that year and whose last book of poems was published in 1904. That seems to have been the mix: the woods of the Philadelphia suburb, romance, classical poetry, and the very sexy and in 1905 still daring poems of Swinburne. "Pagan" was the cool style of the advanced young in the 1900s and 1910s. Her boyfriend called Hilda "Dryad." (What she called him goes unrecorded.) In the learned world classicism was being transformed by a new archaeological scholarship. Jane Harrison's great *Prolegomena to the Study of Greek Religion* was published in 1903, a pioneering study of the ancient fertility rituals that lay behind the pretty myths. James Frazer's *The Golden Bough* was also appearing in those years. There was a sense that the archaic world behind what had become in the European Renaissance a pageantry of old stories had come out of the shadows and had begun to live and move. The teenaged lovers—Pound was just twenty in the fall of 1905, Doolittle eighteen—had probably not yet read the new scholarship, but they would.

By the end of the fall term of 1906 Doolittle had dropped out of Bryn Mawr. She and Ezra became engaged and un-engaged. By the end of spring term 1907 Pound had worn out his welcome at Penn and left to take a job teaching Romance languages at Wabash College in Crawfordsville, Indiana, a nondenominational but strongly Presbyterian institution. It was not a good fit. By midyear he was let go and, severance pay in his pocket, returned to Philadelphia and from there sailed for Venice, where he would write later,

Gods float in the azure air,
Bright gods and Tuscan, back before dew was shed.

Doolittle, meanwhile, was living at home and beginning to write. She had met another young poet, Frances Gregg, in Philadelphia. Their friendship, similarly intense and romantic, also involved Swinburne and classical poetry. Doolittle was beginning to publish some prose in a local paper and in the journal of the local Presbyterian church. She and Gregg moved to New York and Doolittle found an apartment in Greenwich Village. Pound, meanwhile, had moved from Venice to London and had begun to make his way in the London literary world. He'd published (at his parents' expense) two books of poems, *A Lume Spento* and *Exultations* and had arranged to give a series of lectures on medieval literature at a workingmen's institute. They were the fruit of his graduate study—in effect, the Ph.D. dissertation he was never going to write—and contained the seed of much of the early Cantos to come, and they were published as a book, *The Spirit of Romance,* in 1910. He returned to New York in the summer of 1910, renewed his romantic relationship with Doolittle and started one—apparently— with Gregg. By February 1911 he was back in London. He had given Doolittle a volume of Theocritus in Greek and she had begun to translate some of the idylls.

Pound in London had arranged for the publication of a third book of his poems, *Canzoni.* In New York Doolittle was invited by Gregg and her mother to join them on a trip to Europe. She obtained her parents' permission, and by May, having spent a few weeks in Paris, they were in London. Pound showed them around his world, which was mostly Kensington. In one account he introduced Gregg as "the American poetess" and Doolittle as her friend. Doolittle liked what she saw. She had felt herself floundering in Philadelphia and New York and, when Gregg and her mother returned to New York in October, Doolittle, with her parents' reluctant permission, saw them off from the docks in Liverpool. She had met, through Pound, who was by then engaged to his future wife Dorothy Shakespear, a young English poet, Richard Aldington, who would become Doolittle's husband. In that October she took an apartment in a building at Church Walk in Kensington. She lived in Apartment #6, Aldington was in #8, and Pound in #10.

And this brings us to the often-told story among the legends of modernism, the moment of the emergence of H.D. and of the imagist movement, the idea among some of the young poets in Pound's milieu of writing short poems in free verse that contain strong visual images—an idea that combined experimenting with new verse technique (how do you shed the deep habit of iambic rhythm?) and a directness of presentation that was a corrective to Victorian fluency and symbolist vagueness. In the story Doolittle, Aldington, and Pound work in the British Museum during the day and one day in 1912 in the spring or summer, in the museum tea room, Doolittle shows Pound some of her poems. He reads them with some amazement and says— the report comes from Doolittle—"Why, Dryad, this is poetry!" Doolittle was twenty-five that spring and this is the first glimpse we get of her poems. Pound supposedly made a few proprietary corrections and signed them for her—"H.D. *imagiste*," a gesture that has been read as a friend's sensitivity (they were almost childhood friends; he knew she disliked her faintly comic last name) and as a typical gesture of male control. If she was going to be a poet, she was going to have sprung from Pound's head, like Athena from the head of Zeus.

Pound had just signed on—to finish the story—as the European editor of a new Chicago magazine dedicated to publishing poetry. The first issue had appeared in October 1912. Pound sent off Doolittle's poems and a short note on the London literary scene that told American readers that the latest thing in Europe was a new movement called "Imagism." The note and three of H.D.'s poems, "Hermes of the Ways," "Priapus" (later re-titled "Orchard") and "Epigram (*After the Greek*)," which purported to be a translation, appeared in the January 1913 issue of the magazine. The poems were published under a title—"Verses, Translations, and Reflections from 'The Anthology'"—that made their provenance obscure. It isn't clear whether Doolittle, Pound or the editor of *Poetry*, Harriet Weaver, gave them this super-title. "The Anthology" would have meant to *Poetry*'s readers *The Greek Anthology*, the collection of short poems, many of them epigrammatic, many of them anonymous, some of them erotic, from the classical and Byzantine

periods. The title would have made it slightly unclear to readers what they were reading, except that it contained—in a new form—a glimpse of the archaic world.

The story about the poems has been analyzed—it's my impression—much more intently than the poems. But a hundred years ago it was the poems that made their impression. They led Marianne Moore to write to her old classmate—which is how, a few years later, Moore's poem came to appear in *The Egoist*—and they moved the Boston poet Amy Lowell, who had published her own first book that year, to get a letter of introduction from *Poetry*'s editor Harriet Weaver with which she headed off to London to meet these new poets, which in turn led to her collaboration with Doolittle and others to get anthologies of the new poetry published over the next decade.

One of the things that were striking about the poems, surely, was their form. Hardly anyone had published free verse poems in the spring of 1912. And the habit of the iambic lilt went deep. Having announced that the imagists were going to "compose in sequence of the musical phrase and not in sequence of the metronome," Ezra Pound produced in the first line of "In a Station of the Metro" a string of six iambic feet:

The apparition of these faces in the crowd—

And in the lovely bit of Chinoiserie he called "Ts'ai Chi'h" a mix of iambs and skipping anapests:

The petals fall to the fountain
 The orange-colored rose-leaves,
Their ochre clings to the stone.

Doolittle in "Hermes of the Ways" must have sounded like the new thing. Even the absence of capitals at the beginnings of lines must have produced their mild shock:

The hard sand breaks
and the grains of it
are clear as wine.

Far off over the leagues of it,
the wind,
playing on the wide shore,
piles little ridges,
and the great waves
break over it.

But more than the many-foamed ways
of the sea,
I know him
of the triple path-ways,
Hermes
who awaits.

The first lines are an almost hallucinatory close-up, so it takes a moment to see that their subject is something—a dune—breaking and coming clear, with a clarity like intoxication. It might be thought of as an image of her own situation. Then there is the energy of wind and sea, also about breaking, also about energies of transformation. The reader is clearly invited into an intense psychic space, a mythic space, of change and renewal.

A few years later, when she had corresponded with Marianne Moore, and published her poem in *The Egoist*, the magazine previously called *The New Freewoman*, and before that *The Freewoman*, Doolittle wrote a brief appreciation of Moore's poem. Here is part of it: "Miss Moore turns her perfect craft as the perfect craftsman must inevitably do, to some direct presentation of beauty, clear, cut in flowing lines, but so delicately that the very screen she carves seems meant to stand only in that serene palace of her own world of inspiration—frail, yet as all beautiful things are, absolutely hard—."

Whether or not it is an apt characterization of Moore's work, it seems a quite accurate description of what Doolittle was after in "Hermes of the Ways" and it even borrows the key words—"hard," "clear"—from that poem. The phrase "direct presentation" echoes Pound's first principle for the new poetry: "Direct treatment of the 'thing,' whether subjective or objective." That was to be the new, anti-rhetorical emphasis of the new poetry. The phrase of Doolittle's that will seem to contemporary readers to belong to the nineteenth rather than the twentieth century is "that serene palace of her own world of inspiration." Every poem, of course, creates what we might call now its own interior landscape, but Doolittle's way of saying it in 1916—she was twenty-five when she wrote "Hermes," twenty-nine when she described Moore's poetry—sounds like turn-of-the-century aestheticism.

If we are transported to the author's "own world of inspiration" in this poem, it is a world anything but serene. The Greekness of it puts it in a psychic or dream space, but that space is alive with energies:

Wind rushes
over the dunes,
and the coarse salt-crusted grass
answers.

Heu,
it whips round my ankles!

Hermes in the poem seems to be a figure for art. He is the young male god, a bit androgynous, who stands for quickness of imagination, the messenger god with access to the heavens and the hells. And he seems also here—critics have troubled over "him / of the triple path-ways," which was not one of his traditional epithets—to be the tutelary spirit for the speaker of the poem standing wind-whipped on a verge, a place of violent energies but a place of arrival.

The poem is constructed as a pair of lyrics. In the second one we see the place more clearly:

Small is
this white stream,
flowing below ground
from the poplar-shaded hill,
but the water is sweet.

This is a version of the Pierian Spring, of the muses' pure water. Hard
not to read the lines biographically. Doolittle has uprooted herself
from her family where she was languishing, made a great journey,
gone through at least a pair of tumultuous love affairs, and is finding
herself, among a bewilderment of paths, as an artist. Not the easiest
place to be, but she has survived, is on firm ground:

The boughs of the trees
are twisted
by many bafflings;
twisted are
the small-leafed boughs.

But the shadow of them
is not the shadow of the mast head
nor of the torn sails.

The final stanza, invoking the young god, can almost be read as an
allegorical emblem of the place she had come to in order to make a
new art:

Hermes, Hermes,
the great sea foamed,
gnashed its teeth about me;
but you have waited,
where sea-grass tangles with
shore-grass.

The idealization of the Hermes figure is something she would work out in her poetry over many years. Thirty years after this moment, in the bombed-out ruins of London, Hermes would become the figure of Amen, the Egyptian god she had seen excavated from the ruins of the pyramids in Cairo in the 1920s. And in a dream in that poem she would see him radiant in a white clapboard church from her Pennsylvania childhood, a figure for renewal in the midst of terrible violence. Here then is a simpler emblem of the origins of modernism—a young woman artist on an enlivening verge, the wind whipping about her. Even the small technical innovation of ending a line where there is no natural pause—"with / shore grass"—must have made a new effect of hesitation and emphasis.

The young modernists did their work, with varying emphases, from what seems now to have been three impulses. The first was a feeling that the old culture, the Christian high culture of the West or at least American evangelical culture, needed entire renovation, that the old values had failed. It was a feeling that the senseless carnage of the First World War intensified. The second was the sense that the arts themselves needed to start all over, to find a new footing. And the third was a belief in the power of art and of the artist. One of the reasons it is interesting to isolate the women artists in the modernist generation, as this anthology does, is that this push toward newness, toward new territory as the work of the craftsman artist, was described, by Pound and Eliot particularly, in a highly gendered rhetoric. Part of their valorization of art was to insist that poetry was work. "No verse is free," Eliot would write, "for a man who wants to do a good job." Pound in 1913 would write of his insistence on "hardness" and his dislike of "emotional slither" in pronouncements that seem not so subtly gendered. "I believe in technique," he wrote, "as the test of a man's sincerity."

There are probably several reasons for this tone. Sometime in the eighteenth or nineteenth century poetry came to be the special realm of feeling rather than thinking. Romantic and symbolist poetry came to be conceived as a protest against, an alternative to, the busy world, what E.M. Forster called in this period "the world of anger

and telegrams." This was probably a context for asserting, somewhat defensively, that poetry was man's work. And there had begun to be, in the nineteenth century, a force of powerful women writers—George Eliot, George Sand (notice the names)—and a fairly large audience of women readers among the social classes who could read. Also American poets in those years grew up with popular poetry in local magazines and newspapers—both Pound and Doolittle published when they were young in the Presbyterian journals of suburban Philadelphia—that was often sentimental and didactic and written by women.

Thus the insistence on learning, professionalism, toughness, and a man's work in the rhetoric of the young modernists. It must have complicated the experience of the young women who were growing into poets among the men in those years. These were also the years in England and the United States of the women's suffrage movement. In England during the time that Doolittle was writing the poems in *Sea Garden* and rethinking traditional ideas of female beauty, the remarkable Emmeline Pankhurst, founder of the Women's Social and Political Union, was in prison for her part in pro-suffrage demonstrations, conducting a hunger strike to protest her imprisonment, and being force-fed by the authorities. In the United States the suffrage movement was associated with the Women's Christian Temperance Union and thus with a narrow evangelical Protestant culture from which the young were trying to escape. These women—not just Stein and Moore and Doolittle: Mina Loy in her manifestos on feminism and futurism, Lola Ridge in her Progressive-era social reportage, Elsa von Freytag-Loringhoven in her Dadaist experiments, the early women poets of what would be the Harlem Renaissance—were negotiating what it meant to be a woman and an artist when there was a powerful masculine rhetoric in the arts and a powerful feminism in the streets.

And, unlike their male counterparts, there were not many models available to them for how to be a woman artist. They were making it up, and they knew they were making it up. It's interesting, for example, that Stein, Moore, and Doolittle each wrote a major poem about marriage. Stein's "Lifting Belly" is a kind of epithalamion, a good-na-

tured celebration of sexuality and domesticity, of the life she was making with Alice B. Toklas. Moore's "Marriage" and H.D.'s "Hymen" are meditations on marriage by two young women educated in a feminist generation at Bryn Mawr in the years of the suffrage movement to not settle for the definition or the gender role it imposed. And marriage was a subject very much on the agenda of the magazine in which Hilda Doolittle first printed Marianne Moore. *The Egoist* began life as *The Freewoman*, a feminist weekly begun by Dora Marsden and Mary Gawthorpe in November 1911. It was in some ways a break with Pankhurst and the Women's Social and Political Union, which had, as a matter of strategy, stayed away from the radical cultural underpinnings of the feminist movement to focus on suffrage and avoid scaring off potential allies. Marsden wanted none of it. She wanted to write about women's wages, housework, marriage, prostitution, and sexuality. The most controversial aspect of *The Freewoman* was its support for free love. On 23rd November, 1911, Rebecca West wrote an article where she claimed: "Marriage had certain commercial advantages. By it the man secures the exclusive right to the woman's body and by it, the woman binds the man to support her during the rest of her life . . . a more disgraceful bargain was never struck."

On 28th December, 1911, Marsden began a five-part series on morality. She argued that in the past women had been encouraged to restrain their senses and passion for life while "dutifully keeping alive and reproducing the species." She criticized the suffrage movement for encouraging the image of "female purity" and the "chaste ideal." Marsden suggested that this had to be broken if women were to be free to lead an independent life. She made it clear that she was not demanding sexual promiscuity for, "to anyone who has ever got any meaning out of sexual passion the aggravated emphasis which is bestowed upon physical sexual intercourse is more absurd than wicked." She had this to say about marriage: "Monogamy was always based upon the intellectual apathy and insensitiveness of married women, who fulfilled their own ideal at the expense of the spinster and the prostitute." According to Marsden monogamy's four cornerstones were "men's hypocrisy, the spinster's dumb resignation, the

prostitute's unsightly degradation and the married woman's monopoly." "Indissoluble monogamy," she wrote, "is blunderingly stupid, and reacts immorally, producing deceit, sensuality, vice, promiscuity and an unfair monopoly."

The magazine lasted less than a year. It closed down in October 1912 (and can be read online at the website of the Modernist Journals Project) and reemerged in June 1913 as *The New Freewoman*, a biweekly, with a new financial backer, Harriet Shaw Weaver, who later became James Joyce's patron. Marsden's intention was to continue to write about the issues she addressed in *The Freewoman* and to broaden the cultural reach of the magazine. She and Weaver brought on Rebecca West, then twenty years old, as literary editor, and West brought on Ezra Pound, who brought on Richard Aldington. In October 1913 Aldington and Doolittle were married and Aldington became assistant editor of *The New Freewoman*, which in January 1914 became *The Egoist*, a monthly, Harriet Shaw Weaver editor, Aldington assistant editor. In 1916 Aldington enlisted in the army and Doolittle took his place as an editor of *The Egoist*. Doolittle's *Sea Garden* appeared that year. Early that year Marianne Moore had sent a small manuscript of poems to Doolittle at a cottage in Devon. T.S. Eliot became the poetry editor of *The Egoist* in June 1917 and began to print some of Moore's poems. And in 1921 Doolittle and her new life's companion Annie Ellerman (the novelist whose pen name was Bryher) handset and published at the Egoist Press—which had the previous year printed Doolittle's *Choruses from the Iphegeneia*—Moore's *Poems*. It was near the moment—*The Waste Land,* Mina Loy's *Lunar Baedeker,* and Wallace Stevens's *Harmonium* were still to come—when modernism, as a literary movement, was thoroughly launched.

Moore's "Marriage" first appeared in a New York pamphlet series, *Manikin,* in 1923. Doolittle worked on "Hymen," Barbara Guest writes, "all through 1918–19" and it was published in the volume of that name in 1921. Like the other young modernist women, they made their commitment to the new art, not the politics of gender, but it's clear that they were in their different ways, thinking through the work of *The New Freewoman*. In "Marriage" Moore had moved from syllabics to

free verse and had begun her habit of introducing into the diction of her poems slightly mind-bending quotation. She had found her way to the wry and fastidious tone of her middle years:

> I wonder what Adam and Eve
> Think of it by this time,
> This firegilt steel
> Alive with goldenness;
> How bright it shows—
> "of circular traditions and impostures,
> committing many spoils,"
> requiring all one's criminal ingenuity
> to avoid!

And Doolittle, like Pound and Eliot, in 1920 had begun to experiment with reintroducing rhyme and an iambic-lilt, traditional song form, to an untraditional take on the nuptial masque in "Hymen":

> Where love is king,
> Ah, there is little need
> To dance and sing.
> With bridal-torch to flare
> Amber and scatter light
> Across the purple air,
> To sing and dance
> To flute-note and to reed.

> Where love is come
> (Ah love is come indeed!)
> Our limbs are numb
> Before his fiery need;
> With all their glad
> Rapture of speech unsaid,
> Before his fiery lips
> Our lips are mute and dumb.

And one might add to this Mina Loy's strategic intervention in the Edwardian tradition of the gently erotic lyric, the "Songs to Joannes," which she began in 1915 and published in New York magazines like the short-lived *Rogue* and Alfred Kreymborg's *Others*:

Spawn of fantasies
Sifting the appraisable
Pig Cupid his rosy snout
Rooting erotic garbage
"Once upon a time"
Pulls a weed white star-topped
Among wild oats sown in mucous membrane

Stein's *Lifting Belly*, of course, could not be published in those years but it didn't stop her from getting the work done. The crossing of early twentieth-century modernism and feminism, where, as Doolittle said, "the great sea foamed, gnashed its teeth about me," was well under way.

Appendix

from MARIANNE MOORE: SELECTED LETTERS

Response to H.D.'s review of Moore's poetry in *The Egoist*:

To H.D.
August 9, 1916

Dear Mrs. Aldington:
Your letter with the proof has just come. I never expected to be among those writers whose chief recommendation is the introductory letter with which they are published. As I read your article, I wondered and was amazed anew as I proceeded. It is hard to be commended by those for whose opinion we are nothing but when commendation comes from those from whom it is everything, we scarcely dare take it. Why, when you have written "The Shrine" and "The Wind Sleepers," should you be willing to find worth in that which the ordinary reader finds worthless! There are two things that I have always been disappointed not to be able to put into my work—a sense of the sea and a fighting spirit, and it delights me that anything I have written should remind you of the sea or seem to you to set itself in opposition to mediocrity and the spirit of compromise.

Our hearts are lightened today by reports of the Allies' success.

Yours,
MM

To H.D.
Ogden Memorial Presbyterian Church, Chatham, N.J.
November 10, 1916

Dear H.D.:
I have your letter and the article. Everyone thinks the article beautiful. Mary Carolyn Davies says she thinks it is the most beautiful book review she has ever read. Your poem "The Contest" is a beautiful thing, also "Evening" though there is nothing in it to compare, I think, with the last half of "The Contest."

I enjoyed Mr. Cournos's *Not Vodka* and have heard several people speak of it; also Leigh Henry's "stag kinds, singing apples, and serpent women." W.L. Phelps has an article in the October *Yale Review* on new translations of Russian novels in which he says: "[Fyodor] Solobug is just beginning to be known in England and America largely through the efforts of Mr. Cournos, to whom we owe some admirable translations of the short stories of [Leonid] Andreyev."

I hope Mr. Aldington will be in England through the winter; then perhaps by spring the war will be over. Won't you tell me what the prospects are and please tell Mr. Aldington that I am delighted that he likes my "Talisman." I am encouraged by the fact that Miss [May] Sinclair is interested in my work; I hope your efforts on my behalf are not burdensome and that you are not feeling that there is something interminable about doing anything for anyone?

The part of New Jersey in which we are, is not at all like the coast. It makes me think of Canada. There are small downs or hills covered with long pale grass and dotted with cedar trees. I have never seen so many cedar trees anywhere as there are here or so much untouched woodland. There is a stretch of woods near us composed almost entirely of oaks and hemlocks so that you get a magnificent columnar effect and a uniform floor of leaves and moss and the beech woods are full of sage green stones, and little sprouts of birch and hickory to which a few yellow leaves are still clinging. An old canal runs through this part of the state with ducks and swans on it; there are tow paths at the side and occasional rows of green beehives surmounted by round

green stones. There are skating and iceboating on a freshet near here and there is a clubhouse nearby at which we can play tennis and bowl when we like.

If you know of or should hear of a publisher who wishes a translator to translate modern French, Old French, or Provençal, I wonder if you would be willing to let me know? Two friends of mine in Carlisle, a Mr. and Mrs. Lucas, are experts in working with French or any of the modern languages and I have wished for a long time that they might do some translating. Mrs. Lucas was at Bryn Mawr 1901; Mr. Lucas has lived in France till about six years ago; Mrs. Lucas lectures on Italian art; Mr. Lucas teaches French. They wish to do translating but feel that the demand for translations is so slight that there is no use in their conferring with publishers. Mr. Knopf has published some French translations but he is more interested in Russian than in French just now and I do not know of anyone else over here, who is publishing translations.

I enclose the article on [Francis] Bacon. If you do not care for it, do not hesitate to return it. Sometime I may have something that you might like better. I should like to try a comparison of George Moore and [Henry] Fielding; also one of Knut Hamsun and [Thomas] Carlyle and one of Wallace Stevens and Compton Mackenzie. I am very much interested also, in William [Carlos] Williams' work, but I am a little afraid to undertake a criticism of it. I feel that I have not seen enough of it to justify my writing one.

Yours,
MM

To William Carlos Williams
April 16, 1917

Dear Dr. Williams,
We are looking forward with pleasure to having a visit from you. My mother and brother are anxious to meet you and I should be writing now to appoint a day but that an old gentleman is with us who may be here a week or two. When his visit is over, I shall write to ask what day

it would be convenient for you to come. I have enjoyed *The Tempers* and was sorry not to get in a word about it the other night.

Yours,
Marianne Moore

P.S. Your compression makes one feel that the Japanese haven't the field to themselves. I went to a ball game with Alfred [Kreymborg] Saturday, he said he had been talking to Mr. [Skip] Cannell's Japanese friend and he said (apropos of I forget just what,) "red flowers, blue flowers, ashes—that is best."

To Harriet Monroe
May 10, 1918

Dear Miss Monroe,
Shortly after writing you, I allowed a dealer to have the copies of *Poetry* of which I spoke to you. So return the postage enclosed in your letter.

 Poetry's approach to art is different from my own; I feel it therefore to be very good of you to imply that I am not *ipso facto* an alien.

Yours sincerely,
Marianne Moore

from COMPLETE PROSE OF MARIANNE MOORE

COMMENT (from *The Dial*, 1925)

When writers of plays or of novels create plots which are similar, the possibility of imitation occurs to one—of what was in Poe's time called plagiarism. Reflection might easily persuade one that neither author has been aware of the work of the other and that neither piece of work is invaluably original. Similarly, in the work of poets, resemblances in performance sometimes lead one to attribute to an author, depen-

dence upon sources of which he knows nothing. It is apparent, however, that among poets, aesthetic consanguinity is frequent. The fire, the restraint, the devout paganism of H.D. are unequivocally Greek. Wallace Stevens' morosely ecstatic, trembling yet defiant, multifarious plumage of thought and word is to be found, also, in France. By no means a chameleon, Ezra Pound wears sometimes with splendor, the cloak of medieval romance. Employing diction which is not infrequently as decorous as it is instructed, E.E. Cummings shares with certain writers of the fourteenth and sixteenth centuries, a manner as courtly and decisive as it is sometimes shabby. T.S. Eliot often recalls to us, the verbal parquetry of Donne, exemplifying that wit which he defines as "a tough reasonableness under . . . lyric grace."

Amy Lowell most conspicuously provides an illustration of this genetic sharing of tradition. Unequivocally paying tribute to Keats in her first book, *A Dome of Many-Coloured Glass,* she has to some readers appeared to be now an imagist, now a vorticist, now a writer of polyphonic prose. Granting a various method, one discerns in all that she has written, pre-eminently a love for the author whom she commemorates in her last work. One cannot but find in her imagination, an analogy to the "violets," the "nightingale," the "tiger-moth," the "rich attire" of Keats. When she says:

> I have no broad and blowing plain to link
> And loop with aqueducts, no golden mine
> To crest my pillars, no bright twisted vine
> Which I can train about a fountain's brink . . . ;

when as a pointillist she says of trees after a storm:

> They are blue,
> And mauve,
> And emerald.
> They are amber,
> And jade,

And sardonyx.
They are silver fretted to flame
And startled to stillness . . .

one is in the world of "chimes," of "perfume," and of "falling leaves"—
Endymion's world of "poppies," of

. . . visions all about my sight
Of colors, wings, and bursts of spangly light.

Nor is the atmosphere of sentiment, of hospitality, and leisure, at vari-
ance with the character of this self-dependently American, sometimes
modern American writer. The death of Amy Lowell but emphasizes
the force of her personality. Cosmopolitan yet isolated, essentially dis-
tinct from "the imagist group," of which she has been called "the rec-
ognized spokesman," she has by a misleadingly armored self-reliance,
sometimes obscured a generosity, a love of romance, the luster of a
chivalry which was essentially hers.

<div align="right">

The Dial, 79 (July 1925), 87–88.

</div>

THE SPARE AMERICAN EMOTION (from *The Dial,* 1926)

Extraordinary interpretations of American life recur to one—*The
Finer Grain, In the American Grain, The Making of an American, The
Domestic Manners of the Americans.* We have, and in most cases it
amounts to not having them, novels about discontented youth, unad-
vantaged middle age, American materialism; in *The Making of Amer-
icans,* however, we have "not just an ordinary kind of novel with a
plot and conversation to amuse you, but a record of a decent family
progress respectably lived by us and our fathers and our mothers,
and our grand-fathers, and grand-mothers." One is not able to refrain
from saying, moreover, that its chiseled typography and an enticing
simplicity of construction are not those of ordinary book-making.

By this epic of ourselves, we are reminded of certain early German engravings in which Adam, Eve, Cain, and Abel stand with every known animal wild and domestic, under a large tree, by a river. *The Making of Americans* is a kind of living genealogy which is in its branching, unified and vivid.

We have here a truly psychological exposition of American living—an account of that happiness and of that unhappiness which is to those experiencing it, as fortuitous as it is to those who have an understanding of heredity and of environment natural and inevitable. Romantic, curious, and engrossing is this story of "the old people in a new world, the new people made out of the old." There are two kinds of men and women Miss Stein tells us, the attacking kind and the resisting kind, each of which is often modified by many complex influences. Mr. Dehning who as of the resisting kind, "never concerned himself very much with the management of the family's way of living and the social life of his wife and children. These things were all always arranged by Mrs. Dehning." Yet "they could each one make the other one do what they wanted the other one to be doing"—this "really very nice very rich good kind quite completely successful a little troubled american man and woman." The insufficiency of Alfred Hersland who married Julia Dehning, is shown to be largely a result of his mother's anonymity, of incompetent pedagogy, of spoiling, and of his father's impatient unconsidering willfulness. The Dehnings were happy; the Herslands were under the impression that they too, were happy. As Miss Stein says:

> And all around the whole fence that shut these joys in was a hedge of roses, not wild, they had been planted, but now they were very sweet and small and abundant and all the people from that part of Gossols came to pick the leaves to make sweet scented jars and pillows, and always all the Herslands were indignant and they would let loose the dogs to bark and scare them but still roses grew and always all the people came and took them. And altogether the Herslands always loved it there in their old home in Gossols.

In persons either of the resisting or of the attacking kind, contradictions between "the bottom nature and the other natures" result in hybrids; as in Napoleon—in Herbert Spencer—in various other kinds of nature. Disillusionment, sensitiveness, cowardice, courage, jealousy, stubbornness, curiosity, suspicion, hopefulness, anger, subtlety, pride, egotism, vanity, ambition—each phase of emotion as of behavior, is to Miss Stein full of meaning. "Someone gives to another one a stubborn feeling," she says, "when that one could be convincing that other one if that other one would then continue listening," and "it is very difficult in quarreling to be certain in either one what the other one is remembering," Of the assorting of phenomena in "an ordered system" she says, "Always I am learning, always it is interesting, often it is exciting."

There is great firmness in the method of this book. Phillip Redfern we are told, "was a man always on guard, with every one always able to pierce him." The living rooms of Julia Dehning's house "were a prevailing red, that certain shade of red like that certain shade of green, dull, without hope, the shade that so completely bodies forth the ethically aesthetic aspiration of the spare american emotion." Her mother's house was, on the other hand, of a different period. "A nervous restlessness of luxury was through it all…. a parlor full of ornate marbles placed on yellow onyx stands, chairs gold and white of various size and shape, a delicate blue silk brocaded covering on the walls and a ceiling painted pink with angels and cupids all about, a dining-room all dark and gold, a living room all rich and gold and red with built-in couches…. Marbles and bronzes and crystal chandeliers and gas logs finished out each room."

We "hasten slowly forward" by a curious backward kind of progress. "Sometimes I like it," Miss Stein says, "that different ways of emphasizing can make very different meanings in a phrase or sentence I have made and am rereading." To recall her summary of washing is to agree with her:

> It's a great question this question of washing. One never can find any one who can be satisfied with anybody else's wash-

ing. I knew a man once who never as far as any one could see ever did any washing, and yet he described another with contempt, why he is a dirty hog sir, he never does any washing. The French tell me it's the Italians who never do any washing, the French and the Italians both find the Spanish a little short in their washing, the English find all the world lax in this business of washing, and the East finds all the West a pig, which never is clean with just the little cold water washing. And so it goes.

Repeating has value then as "a way to wisdom." "Some children have it in them." "Always more and more it has completed history in it" and "irritation passes over into patient completed understanding."

Certain aspects of life are here emphasized—the gulf between youth and age, and the bond between these two; the fact of sentimental as of hereditary family indivisibility—such that when Julia Dehning was married, every one of the Dehnings had "feeling of married living in them."

The power of sex which is palpable throughout this novel, is handsomely implied in what is said of certain uncles and cousins in the Dehning family,

generous decent considerate fellows, frank and honest in their friendships, and simple in the fashion of the elder Dehning. With this kindred Julia had always lived as with the members of one family. These men did not supply for her the training and experience that helps to clear the way for an impetuous woman through a world of passions, they only made a sane and moral back-ground on which she in her later life could learn to lean.

The ineradicable morality of America is varyingly exposited, as in the statement that to Julia Dehning, "all men that could be counted as men by her and could be thought of as belonging ever to her, they must be, all, good strong gentle creatures, honest and honorable and

honoring." Contrary to "the french habit in thinking," "the ameri-
can mind accustomed to waste happiness and be reckless of joy finds
morality more important than ecstasy and the lonely extra of more
value than the happy two."

There is ever more present in this history, a sense of the dignity of
the middle class, "the one thing always human, vital, and worthy." Of
a co-educational college of the west, Miss Stein says:

> Mostly no one there was conscious of a grand-father unless
> as remembering one as an old man living in the house with
> them or as living in another place and being written to
> sometimes by them and then having died and that was the
> end of grand-fathers to them. No one among them was held
> responsible for the father they had unless by some particu-
> lar notoriety that had come to the father of some one. It was
> then a democratic western institution, this college where
> Redfern went to have his college education.

As Bunyan's Christian is English yet universal, this sober, tender-
hearted, very searching history of a family's progress, comprehends in
its picture of life which is distinctively American, a psychology which
is universal.

<div align="right">

The Dial, 80 (February 1926), 153–66.

</div>

PERSPICUOUS OPACITY

(from *The Nation*, 1936: Review of *The Geographical History
of America, or The Relation of Human Nature to the Human Mind*,
by Gertrude Stein, with an introduction by Thornton Wilder
(Random House).)

Gertrude Stein has a theory that the American has been influenced by
the expansiveness of the country and the circumstance that there are
great areas of flat land where one sees few birds, flowers, or animals.

There are no nightingales, she says, and the eagle is not the characteristic bird it once was; whereas "the mocking-birds . . . have spread . . . and perhaps they will be all over, the national bird of the United States"—one ambiguous significance which she makes unequivocal. We owe very much to Thornton Wilder for giving us the clue to the meanings in the book, since the mind resists a language it is not used to. Realizing the laziness of the ordinary reader, Mr. Wilder explains that Miss Stein, as a result of thinking about masterpieces of literature, found that in them the emergencies of the Human Mind were dependent upon the geographical situations in which the authors lived— flat land conducing to the ability to escape from identity, hilly land conducing to the specific and the insistent. The Human Mind and Human Nature, as she says, are here "invented terms" of a "private language,"—the Human Mind being selfless and without identity, Human Nature insisting on itself as personality; and "it cost pain to express and think these things." Therefore sadness and tears are mentioned as connected with Human Nature and the exterior trudging we do, as opposed to felicity and the operations of the Human Mind. When an author writes as if he were alone, without thought of an audience, "for an audience never does prove to you that you are you," it is this which makes a masterpiece. "Anyone who writes anything is talking to themselves," not conversing, "and that is what Shakespeare always has done, he makes them say what he wants said," and is "everlastingly interesting."

Miss Stein likes naturalness. "Nothing I like more," she says, "than when a dog barks in his sleep"; and in giving lectures here, her attitude to pretense was calculated to make those who overanalyze a piece of straight thinking seem like the milliner's assistant in *Punch* who asks a dull patron, "Would Modom entertain a feather?" She says, "I like to look about me," "I love writing and reading." In looking about her she has detected things; in science, "well they never are right about anything"; excitement "has to do with politics and propaganda and government and being here and there and society"; the electioneering politician "has no personality but a persistence of insistence in a narrow range of ideas" and is not exciting; whereas science is exciting

and so is writing. Miss Stein says, "I wish writing need not sound so like writing," and sometimes she has made it sound like writing that one does not see at first what is meant. Looking harder, one is abashed not to have understood instantly; as water may not seem transparent to the observer but has a perspicuous opacity in which the fish swims with ease. For example, "There is no doubt of what is a master-piece but is there any doubt what a master-piece is."

To like reading and writing is to like words. The root meaning, as contrasted with the meaning in use, is like the triple painting on projecting lamellae, which—according as one stands in front, at the right, or at the left—shows a different picture: "In china china is not china it is an earthen ware. In China there is no need of China because in china china is china." Definitions are pleasurable, and words can fall sweetly on the ear:

> I like a play of so and so.
> Loho Leho.
> Leho is the name of a Breton.

"Winning is a description of a charming person," and "the thing about numbers that is important is that any of them have a pretty name... Numbers have such pretty names in any language."

It is a feat of writing to make the rhythm of a sentence unmistakable without punctuation: for example, "When they said reading made easy reading with tears and someone sent me such a beautiful copy of that," or "No one knowing me knows me. And I am I I." In a real writer's experimenting there can be an effect of originality as one can achieve a kind of Venetian needlepoint by fitting into each other two pieces of a hackneyed pattern of pleasant edging.

The Geographical History of America is offered as a detective story—"a detective story of how to write," making use of the political situation in United States, with allusions to the two Roosevelts and the two Napoleons—and is not propaganda, which is platitude. A detective story is a conundrum, and this one has "content without form" and is "without a beginning and a middle and an end"—Chapter I following

Chapter II, and Chapter III following Chapter II. The repeatings and regressions are, as Thornton Wilder says, sometimes for emphasis, sometimes a method of connecting passages, sometimes a musical refrain, sometimes playful. And, one adds, sometimes a little inconsiderate and unaccommodating and in being willing to be so, partake of Human Nature rather than of the Human Mind. And "nobody need be triumphant about that." But the book is a triumph, and all of us, that is to say a great many of us, would do well to read it.

The Nation, 143 (October 1936), 484–85.

HILDA DOOLITTLE

from *The Egoist:* Review of Marianne Moore
August 1916
I HAVE before me a collection of poems. They have appeared for the most part in various American periodicals. And readers of THE EGOIST are familiar with certain of these curiously wrought patterns, these quaint turns of thought and concealed, half-playful ironies. They have puzzled over such poems as "To a Steam Roller" or "Diligence is to Magic as Progress is to Flight" and asked—what is this all about—"scarecrows of aesthetic procedure"—"weight-hardened creatures"—"prosaic necessities," etc. etc. They have read Miss Marianne Moore's poems again and again, and questioned, half in despair—is this a mere word-puzzle, or does it mean something?

Does it mean something?

FEED ME, ALSO, RIVER GOD

"Lest by diminished vitality and abated
Vigilance, I become food for crocodiles—for that quicksand
Of gluttony which is legion. It is there—close at hand—
 On either side
 Of me. You remember the Israelites who said in pride

"And stoutness of heart: 'The bricks are fallen down, we will
Build with hewn stone, the sycamores are cut down, we will
 change to
Cedars?' I am not ambitious to dress stones, to renew
 Forts, nor to match
 My value in action, against their ability to catch

"Up with arrested prosperity. I am not like
Them, indefatigable, but if you are a god you will
Not discriminate against me. Yet—if you may fulfill

None but prayers dressed
As gifts in return for your own gifts—disregard the request."

I think that it does mean something. And if Miss Moore is laughing at us, it is laughter that catches us, that holds, fascinates and half-paralyses us, as light flashed from a very fine steel blade, wielded playfully, ironically, with all the fine shades of thrust and counter-thrust, with absolute surety and with absolute disdain. Yet with all the assurance of the perfect swordsman, the perfect technician, I like to imagine that there is as well something of the despair of the perfect artist—"see, you cannot know what I mean—exactly what I mean," she seems to say, half-pitying that the adversary is so dull—that we are so dull—"and I do not intend that you shall know—my sword is very much keener than your sword, my hand surer than your hand—but you shall not know that I know you are beaten."

Yet we are not always baffled. Miss Moore turns her perfect craft as the perfect craftsman must inevitably do, to some direct presentation of beauty, clear, cut in flowing lines, but so delicately that the very screen she carves seems meant to stand only in that serene palace of her own world of inspiration—frail, yet as all beautiful things are, absolutely hard—and destined to endure longer, far longer than the toppling sky-scrapers, and the world of shrapnel and machine-guns in which we live.

The clear, flawless tones of Miss Moore's poetry come like bell-notes, like notes from some palace-bell carved beneath the sea. Indeed I seem to place this very screen in some mermaid's palace.

"HE MADE THIS SCREEN

"Not of silver nor of coral,
But of weatherbeaten laurel.

"Here, he introduced a sea
Uniform like tapestry;

"Here, a fig-tree; there, a face;
There, a dragon circling space—

"Designating here, a bower;
There, a pointed passion-flower."

As I say the rhythm and the tones of her words come as through
some "sea-change"—and surely there is "something rich and strange"
in this "Talisman"—

"Under a splintered mast,
Torn from the ship and cast
 Near her hull

"A stumbling shepherd found
Embedded in the ground,
 A sea-gull

"Of lapis lazuli,
A scarab of the sea,
 With wings spread—

"Curling its coral feet,
Parting its beak to greet
 Men long dead."

Miss Marianne Moore is an American. And I think in reading Miss
Moore's poems we in England should be strengthened. We are torn in
our ambitions, our desires are crushed, we hear from all sides that art
is destined to a long period of abeyance, and that the reconstruction
of Europe must take all the genius of the race. I do not believe that.
There are others here in England who do not for one moment believe
that beauty will be one whit bruised by all this turmoil and distress.
Miss Moore helps us. She is fighting in her country a battle against

squalor and commercialism. We are all fighting the same battle. And we must strengthen each other in this one absolute bond—our devotion to the beautiful English language.

Mina Loy: Feminist Manifesto

The feminist movement as at present instituted is

Inadequate

Women if you want to realise yourselves—you are on the eve of a devastating psychological upheaval—all your pet illusions must be unmasked—the lies of centuries have got to go—are you prepared for the Wrench—? There is no half-measure—NO scratching on the surface of the rubbish heap of tradition, will bring about Reform, the only method is Absolute Demolition

Cease to place your confidence in economic legislation, vice-crusades & uniform education—you are glossing over Reality. Professional & commercial careers are opening up for you— Is that all you want?

And if you honestly desire to find your level without prejudice— be Brave & deny at the outset—that pathetic clap-trap war cry Woman is the equal of man— for

She is NOT!

The man who lives a life in which his activities conform to a social code which is a protectorate of the feminine element— —is no longer masculine.

The women who adapt themselves to a theoretical valuation of their sex as a relative impersonality, are not yet Feminine. Leave off looking to men to find out what you are not—seek within yourselves to find out what you are

As conditions at present constituted—you have the choice between
Parasitism, & Prostitution—or Negation

Men & women are enemies, with the enmity of the exploited for the parasite, the parasite for the exploited—at present they are the mercy of the advantage that each can take of the other's sexual dependence—. The only point at which the interests of the sexes merge—is the sexual embrace.

The first illusion it is to your interest to demolish is the division of women into two classes the mistress, & the mother every well-balanced & developed woman knows that is not true, Nature has endowed the complete woman with a faculty for expressing herself through all her functions—there are no restrictions the woman who is so incompletely evolved as to be un-self-conscious in sex, will prove a restrictive influence on the temperamental expansion of the next generation; the woman who is a poor mistress will be an incompetent mother—an inferior mentality—& will enjoy an inadequate apprehension of Life.

To obtain results you must make sacrifices & the first & greatest sacrifice you have to make is of your "virtue."

The fictitious value of woman as identified with her physical purity— is too easy a stand-by—rendering her lethargic in the acquisition of intrinsic merits of character by which she could obtain a concrete value—therefore, the first self-enforced law for the female sex, as a protection against the man made of bogey of virtue—which is the principal instrument of her subjection, would be the unconditional surgical destruction of virginity through-out the female population at puberty—.

The value of man is assessed entirely according to his use or interest to the community, the value of woman, depends entirely on chance, her

success or insuccess in maneuvering a man into taking the life-long responsibility of her—

The advantages of marriage are too ridiculously ample— compared to all other trades—for under modern conditions a woman can accept preposterously luxurious support from a man (with-out return of any sort—even offspring)—as a thanks offering for her virginity.
The woman who has not succeeded in striking that advantageous bargain—is prohibited from any but surreptitious re-action to Life-stimuli—& entirely debarred maternity.

Every woman has a right to maternity—
Every woman of superior intelligence should realize her race-responsibility, in producing children in adequate proportion to the unfit or degenerate members of her sex—

Each child of a superior woman should be the result of a definite period of psychic development in her life—& not necessarily of a possible irk-some & outworn continuance of an alliance—spontaneously adapted for vital creation in the beginning but not necessarily harmoniously balanced as the parties to it—follow their individual lines of personal evolution—
For the harmony of the race, each individual should be the expression of an easy & ample interpenetration of the male & female tempera-ments—free of stress.
Woman must become more responsible for the child than man—
Women must destroy in themselves, the desire to be loved—
The feeling that it is a personal insult when a man transfers his atten-tions from her to another woman.
The desire for comfortable protection instead of an intelligent curi-osity & courage in meeting & resisting the pressure of life sex or so called love must be reduced to its initial element, honour, grief, sen-timentality, pride & consequently jealously must be detached from it.
Woman for her happiness must retain her deceptive fragility of

appearance, combined with indomitable will, irreducible courage, & abundant health the outcome of sound nerves—

Another great illusion that woman must use all her introspective clear-sightedness & unbiased bravery to destroy—for the sake of her self respect is the impurity of sex the realisation in defiance of superstition that there is nothing impure in sex—except in the mental attitude to it—will constitute an incalculable & wider social regeneration than it is possible for our generation to imagine.

MINA LOY: APHORISMS ON FUTURISM

DIE in the Past
Live in the Future.

THE velocity of velocities arrives in starting.

IN pressing the material to derive its essence, matter becomes deformed.

AND form hurtling against itself is thrown beyond the synopsis of vision.

THE straight line and the circle are the parents of design, form the basis of art; there is no limit to their coherent variability.

LOVE the hideous in order to find the sublime core of it.

OPEN your arms to the dilapidated, to rehabilitate them.

YOU prefer to observe the past on which your eyes are already opened.

BUT the Future is only dark from outside.
Leap into it—and it EXPLODES with *Light*.

FORGET that you live in houses, that you may live in yourself—

FOR the smallest people live in the greatest houses.

BUT the smallest person, potentially, is as great as the Universe.

WHAT can you know of expansion, that limit yourselves to compromise?

HITHERTO the great man has achieved greatness by keeping the people small.

BUT in the Future, by inspiring people to expand their fullest capacity, the great man proportionately must be tremendous—a God.

LOVE of others is the appreciation of oneself.

MAY your egotism be so gigantic that you compromise mankind in your self-sympathy.

THE Future is limitless—the past a trail of insidious reactions.

LIFE is only limited by our prejudices. Destroy them, and you cease to be at the mercy of yourself.

TIME is the dispersion of intensiveness.

THE Futurist can live a thousand years in one poem.

HE can compress every aesthetic principle in one line.

THE mind is a magician bound by assimilations; let him loose and the smallest idea conceived in freedom will suffice to negate the wisdom of all forefathers.

LOOKING on the past you arrive at 'Yes', but before you can act upon it you have already arrived at 'NO'.

THE Futurist must leap from affirmative to affirmative, ignoring intermittent negations—must spring from stepping-stone to stone of creative exploration; without slipping back into the turbid stream of accepted facts.

THERE are no excrescences on the absolute, to which man may pin his faith.

TODAY is the crisis in consciousness.

CONSCIOUSNESS cannot spontaneously accept or reject new forms, as offered by creative genius; it is the new form, for however great a period of time it may remain a mere irritant—that moulds consciousness to the necessary amplitude for holding it.

CONSCIOUSNESS has no climax.

LET the Universe flow into your consciousness, there is no limit to its capacity, nothing that it shall not recreate.

UNSCREW your capability of absorption and grasp the elements of Life—*whole*.

MISERY is the disintegration of Joy.
Intellect, of Intuition;
Acceptance, of Inspiration.

CEASE to build up your personality with the ejections of irrelevant minds.

NOT to be a cipher in your ambiente,
But to colour your ambiente with your preferences.

NOT to accept experience at its face value.

BUT to readjust activity to the peculiarity of your own will.

THESE are the primary tentatives towards independence.

MAN is a slave only to his own mental lethargy.

YOU cannot restrict the mind's capacity.

THEREFORE you stand not only in abject servitude to your perceptive consciousness—

BUT also to the mechanical re-actions of the subconsciousness, that the rubbish heap of race-tradition—

AND believing yourself free—your least conception is coloured by the pigment of retrograde superstitions.

HERE are the fallow-lands of mental spatiality that Futurism will clear.

MAKING place for whatever you are brave enough, beautiful enough to draw out of the realized self.

TO your blushing we shout the obscenities, we scream the blasphemies, that you, being weak, whisper alone in the dark.

THEY are empty except of your shame.

AND so these sounds shall dissolve back to their innate
senselessness.

THUS shall evolve the language of the Future.

THROUGH derision of Humanity as it appears—

TO arrive at respect for man as he shall be—

ACCEPT the tremendous truth of Futurism
Leaving all those
 —Knick-knacks.—

Amy Lowell:
Preface To Some Imagist Poets (1915)

In March, 1914, a volume appeared entitled "Des Imagistes." It was a collection of the work of various young poets, presented together as a school. This school has been widely discussed by those interested in new movements in the arts, and has already become a household word. Differences of taste and judgment, however, have arisen among the contributors to that book; growing tendencies are forcing them along different paths. Those of us whose work appears in this volume have therefore decided to publish our collection under a new title, and we have been joined by two or three poets who did not contribute to the first volume, our wider scope making this possible.

In this new book we have followed a slightly different arrangement to that of our former Anthology. Instead of an arbitrary selection by an editor, each poet has been permitted to represent himself by the work he considers his best, the only stipulation being that it should not yet have appeared in book form. A sort of informal committee—consisting of more than half the authors here represented—have arranged the book and decided what should be printed and what omitted, but, as a general rule, the poets have been allowed absolute freedom in this direction, limitations of space only being imposed upon them. Also, to avoid any appearance of precedence, they have been put in alphabetical order.

As it has been suggested that much of the misunderstanding of the former volume was due to the fact that we did not explain ourselves in a preface, we have thought it wise to tell the public what our aims are, and why we are banded together between one set of covers.

The poets in this volume do not represent a clique. Several of them are personally unknown to the others, but they are united by certain common principles, arrived at independently. These principles are not new; they have fallen into desuetude. They are the essentials of all great poetry, indeed of all great literature, and they are simply these:—

1. To use the language of common speech, but to employ always the *exact* word, not the nearly-exact, nor merely the decorative word.
2. To create new rhythms—as the expression of new moods—and not to copy old rhythms, which merely echo old moods. We do not insist on "free-verse" as the only method of writing poetry. We fight for it as for a principle of liberty. We believe that the individual of a poet may often be better expressed in free-verse than in conventional forms. In poetry, a new cadence means a new idea.
3. To allow absolute freedom in the choice of subject. It is not good art to write badly about aeroplanes and automobiles; nor is it necessarily bad art to write well about the past. We believe passionately in the artistic value of modern life, but we wish to point out that there is nothing so uninspiring nor so old-fashioned as an aeroplane of the year 1911.
4. To present an image (hence the name: "Imagist). We are not a school of painters, but we believe that poetry should render particulars exactly and not deal in vague generalities, however magnificent and sonorous. It is for this reason that we oppose the cosmic poet, who seems to us to shirk the real difficulties of art.
5. To produce poetry that is hard and clear, never blurred nor indefinite.
6. Finally, most of us believe that concentration is the very essence of poetry.

The subject of free-verse is too complicated to be discussed here. We may say briefly, that we attach the term to all that increasing amount of writing whose cadence is more marked, more definite, and closer knit than that of prose, but which is not so violently nor so obviously accented as the so-called "regular verse." We refer those interested in the question to the Greek Melic poets, and to the many excellent French studies on the subject by such distinguished and well-equipped

authors as Remy de Gourmont, Gustave Hahn, Georges Duhamel, Carles Vildrac, Henri Ghéon, Robert de Souze, André Spire, etc.

We wish it to be clearly understood that we do not represent an exclusive artistic sect; we publish our work together because of a mutual artistic sympathy, and we propose to bring out our cooperative volume each year for a short term of years, until we have made a place for ourselves and our principles such as we desire.

Acknowledgments

Lola Ridge

"The Ghetto," "Flotsam," "Death Ray," "The Fifth-Floor Window," "Appulse": Copyright the Estate of Lola Ridge. Reprinted by permission of Elaine Sprout.

Gertrude Stein

"Yet Dish," "Susie Asado," "Tender Buttons," "Idem the Same: A Valentine to Sherwood Anderson," "Lifting Belly," "If I Told Him: A Completed Portrait of Picasso," "Stanzas in Meditation": Copyright the Estate of Gertrude Stein. Reprinted by permission of Georgia Glover.

Amy Lowell

"New Heavens for Old" and "Dissonance" from Ballads for Sale by Amy Lowell. Copyright 1927 by Houghton Mifflin Harcourt Publishing Company, renewed 1955 by Harvey H. Bundy and G. d'Andelot Belin, Jr., Trustees of the Estate of Amy Lowell. Reprinted by permission of Houghton Mifflin Harcourt Publishing Company. All rights reserved.

Elsa Von Freytag-Loringhoven

"Analytical History of Progeny," "A Dozen Cocktails Please," "Subjoyride," "Ostentatious," "Ohio—Indiansummer," "All's Well," "Ultramundanity," "Constitution," "Game Legend": Copyright Massachusetts Institute of Technology. Reprinted by permission of MIT Press from Body Sweats: The Uncensored Writings of Elsa von Freytag-Loringhoven, edited by Irene Gammel and Suzanne Zelazo.

ANGELINA WELD GRIMKE

"Grass Fingers," "Tenebris," "A Mona Lisa," "The Black Finger," "Under The Days": Copyright Angelina Weld Grimke. Reprinted by permission of the Moorland-Springarn Research Center, Howard University.

ANNE SPENCER

"At the Carnival," "Lines to a Nasturtium," "Translation,": Reprinted by permission of Anne Spencer House and Garden Museum, Inc. on behalf of the Spencer Family.

MINA LOY

"Songs to Joannes," "Poe," "Lunar Baedeker," "Der Blinde Junge," "Brancusi's Golden Bird": from *The Lost Lunar Baedeker* by Mina Loy. *Works of Mina Loy* copyright 1996 by the Estate of Mina Loy. Introduction and edition copyright 1996 by Roger Conover. Reprinted by permission of Farrar, Straus and Giroux, LLC.

H.D. (HILDA DOOLITTLE)

"Sea Rose," "Sea Lily," "Garden," "Sea Violet," "Orchard," "Storm," "Hermes of the Ways," "For Bryher and Perdita," "Hymen," "Song," "Helen," "Fragment Forty," "Fragment Forty-one," "Fragment Sixty-eight," "Lethe," "Christmas 1944," "The Walls Do Not Fall": by H.D. (Hilda Doolittle), from *Collected Poems, 1912–1944*, copyright 1982 by the Estate of Hilda Doolittle. Reprinted by permission of New Directions Publishing Corp.

MARIANNE MOORE

"The Steeple-Jack": Copyright Viking Penguin. Reprinted by permission of Viking Penguin. "The Fish," "These Various Scalpels," "Marriage," "An Octopus," and "The Past Is the Present": Reprinted with the permission of Scribner Publishing Group from *The Collected Poems of Marianne Moore* by Marianne Moore. Copyright © 1935 by Marianne Moore, renewed 1963 by Marianne Moore and T.S. Eliot. All rights reserved. "In Distrust of Merits": Reprinted with the permission of Scribner Publishing Group from *The Collected Poems of Marianne*

DJUNA BARNES

"Portrait of a Lady Walking," "The Walking-Mort," "Seen from the 'L,'" "Suicide," "Quarry," "Dereliction," "As Cried," "Verse": Copyright the Authors League Fund and St. Bride's Church, as joint literary executors of the Estate of Djuna Barnes. Reprinted by permission.

LAURA RIDING

"The Quids" first published in *The Close Chaplet* (Hogarth Press, 1926); "O Vocables of Love," "The Rugged Black of Anger," "The Map of Places" first published in *Love as Love, Death as Death* (Seizin Press, 1928); "Take Hands," "Incarnation," "So Slight" first published in *Poems: A Joking Word* (Alden Press, 1930); "Come, Words, Away" first published in *Poet: A Lying Word* (Arthur Barker Ltd.). In conformity with the late author's wish, we wish to record that, in 1941, Laura (Riding) Jackson renounced, on grounds of linguistic principle, the writing of poetry: She had come to hold that "poetry obstructs general attainment to something better in our linguistic way-of-life than we have."

Notes

Lola Ridge was born in Dublin in December 1873. She grew up in New Zealand and Australia, studied art at Trinity College, New South Wales, and moved to San Francisco in 1907. She published her first poems in *Overland Monthly* and then moved to New York. In April 1909 her poems were published in Emma Goldman's journal *Mother Earth*. Ridge's book, *The Ghetto and Other Poems*, was published in 1918. She published four more books of poems, *Sunup* in 1920, *Red Flag* in 1927, *Firehead* in 1929, and *Dance of Fire* in 1935. She died in Brooklyn in 1941. Her 1921 lecture "Woman and the Creative Will" was reissued in 1982 by the Michigan Occasional Papers in Women's Studies, no. 18.

Note on Lola Ridge: Marianne Moore on how she came to be associated with *The Dial*: "Lola Ridge had a party—she had a large apartment on a ground floor somewhere—and John Reed and Marsden Hartley, who was very confident with the brush, and Scott Thayer, editor of *The Dial*, was there. And much to my disgust we were induced each to read something we had written . . . "

Gertrude Stein was born in Allegheny, Pennsylvania, in February 1874, grew up in Oakland, California, and attended Radcliffe from 1893 to 1897, where she studied with William James. She then attended Johns Hopkins Medical School from 1897 to 1901. She moved to Paris in 1903 and in that year finished her first novel, *QED*, a book that was not published in her lifetime. She worked on *Three Lives* from 1905 to 1906. She came to know Matisse and Picasso and acquired some of their paintings, also work by Cézanne and Bonnard. When she met Alice B. Toklas upon her arrival in Paris from San Francisco in 1907, they visited Picasso's studio, where he was working on *Les Demoiselles d'Avignon*. Stein was also working on her third novel, *The Making of Americans*. The book and the exposure to fauvism and cubism took her off the tracks of the conventional novel entirely. *Three Lives* was published in 1909, and from around 1908 Stein began to experiment with the methods of cubism in both verse and prose. The word portraits of Matisse and Picasso, published in Alfred Stieglitz's *Camera Work*, were written in 1910–11, *Tender Buttons* in 1912, "Susie Asado" and "Yet Dish" in 1913, "Lifting Belly" from 1915 to 1917, and "Idem the Same: A Valentine to

Sherwood Anderson" in 1922. *Tender Buttons* was published in 1914, and "Susie Asado" and a few of the other experimental pieces appeared in *Geography and Plays* in 1922. She wrote "Patriarchal Poetry" and *Four Saints in Three Acts* in 1927 and *Stanzas in Meditation,* her most sustained experiment in verse abstraction, from 1929 to 1933. *The Autobiography of Alice B. Toklas,* her slant autobiography, was published that year, became a best-seller in the United States, and made her famous for expatriate eccentricity and for her influential—to the general public famously unintelligible—experimental prose and verse. She and Toklas survived the war and German occupation in the French countryside under some protection from the collaborationist Vichy government. *Wars I Have Seen* and *Reflections on the Atom Bomb* appeared in 1946. She died of cancer in the summer of that year at Neuilly-sur-Seine.

Notes on Stein:

1913: Mabel Dodge Luhan in a magazine article described Stein as "a post-impressionist in prose."

1926: Marianne Moore to Gertrude Stein re: "Composition as Explanation": Reading it had been "one of the most eager and enriching experiences I have ever had."

Amy Lowell was born in Brookline, Massachusetts, in February 1874. Her first published work appeared in *Atlantic Monthly* in 1910. Her first volume of poems, *A Dome of Many-Coloured Glass,* appeared in 1912. Her discovery of H.D.'s poems in *Poetry* in 1913 led her to the methods of imagism. In 1914 in an introduction to her second book, *Sword Blades and Poppy Seeds,* she described her own idea of free verse. The three volumes, *Some Imagist Poets,* appeared between 1915 and 1917, *Pictures of the Floating World* in 1919, and *Fir-Flower Tablets: Some Poems from the Chinese* in 1921. She died in 1928.

Elsa von Freytag-Loringhoven was born Else Ploetz in Swinoujscie in 1874, a Baltic seaport town that was then a part of Pomerania and lies now in the extreme northwest of Poland. She grew up in Berlin and studied art briefly in a school in the medieval city of Dachau, near Munich. She returned to Berlin, was active in theater, married there, moved to New York in 1910 and, after a failed attempt at farming with a lover, her husband's friend, in Sparta, Kentucky, she made her way to New York and there in 1913 married the Baron von Freytag-Loringhoven and moved into the Ritz. At the outbreak of war her husband returned to Germany, where he committed suicide. Von Freytag-Loringhoven moved to Greenwich Village, worked as an artist's model and met

Marcel Duchamp, and began to write poetry. Her work appeared in *New York Dada* in 1921 and *The Little Review* in 1918–22. One biographer, Amelia Jones, describes her as "mov[ing] throughout the city with shaved and painted scalp, headdress made of birdcages and wastepaper baskets, celluloid curtain rings as bracelets, assorted tea balls attached to her bust, spoons to her hat, a taillight to her bustle." Von Freytag-Loringhoven returned to Berlin in 1923 where she suffered a breakdown and spent time in a mental hospital. Friends, including Djuna Barnes, arranged for her to move to Paris. She died there of asphyxiation in 1927 when the gas in her apartment, perhaps accidentally, was left on overnight. A volume of her work, *Body Sweats: The Uncensored Writings of Elsa von Freytag-Loringhoven*, was published in 2011.

Florence Wheelock Ayscough was born in Shanghai in 1875 to a Canadian father and an American mother. Educated in New England, she became one of the foremost Sinologists of her generation. In addition to collaborating with Amy Lowell on *Fir-Flower Tablets* (1921), she is the author of *A Chinese Mirror* (1925), *Tu Fu: Autobiography of a Chinese Poet* (1928), and *Chinese Women Yesterday and Today* (1937). She married an English scholar, Francis Ayscough, in Shanghai, was widowed in 1933, and married another Sinologist, Harley McNair, in 1935. She lectured on Chinese literature at the University of Chicago from 1938 until her death in 1942.

Adelaide Crapsey was born in Brooklyn Heights, New York, in September 1878. She grew up in Rochester, New York, and entered Vassar in 1897. After graduation, she studied at School of Archaeology in Rome from 1904 to 1905, after which she taught high school history and literature and in 1911 began to teach poetics at Smith College. She died of chronic tuberculosis in 1914. Two books, *Verse* (1915), which includes her work in the cinquain form, and *A Study in English Metrics* (1918), were published posthumously.

Angelina Weld Grimke was born in February 1880 in Boston, Massachusetts. Her father, descended from South Carolina slaves and slaveholders, took a law degree from Harvard in 1874 and married the white daughter of a Boston clergyman in 1879. The marriage didn't last, and Angelina was raised by her father. She took a degree in physical education from Boston Normal School of Gymnastics in 1902 and moved, with her father to Washington, D.C., where she taught physical education and English in high schools, including M Street High, then called Preparatory High School for Colored Youth, from 1916 to 1926. Her poems, written mostly in the 1920s, were published in the prominent black magazines of the period, *The Crisis* and *Opportunity*. They also appeared in the anthologies *Negro Poets and their Poems* (1923) and Countee Cullen's *Caroling*

Dusk (1926). In 1926 she moved to New York and settled in Brooklyn. Her play, *Rachel*, was produced in 1916 and published in 1920. One of the first plays publicly performed by an African American writer, it was written partly in response to a call by the NAACP for artistic rejoinder to the racism in D.W. Griffith's *The Birth of a Nation* (1915). She died in Brooklyn in 1958.

Anne Spencer was born Annie Bethel Bannister, the child of former slaves, in April 1882 in Henry County, Virginia. She was raised in foster care in Bramwell, West Virginia, educated at Virginia Seminary near Lynchburg, and taught elementary school in Bramwell. She married a classmate, Edward Spencer, in 1901. Her first poems were published in *The Crisis* in 1920. James Weldon Johnson anthologized her work in *The Book of American Negro Poetry* in 1922. She worked as a school librarian in Lynchburg from 1924 to 1946 and published only about thirty poems in her lifetime. She died in 1975.

Mina Loy was born in London in December 1882. Her mother was English, her father a Hungarian Jew. She left school at seventeen and moved to Munich, where she studied painting for two years and then returned to London. She moved to Paris and was married by 1903. She met Stein in Paris in 1914 and wrote two prose pieces, "Aphorisms on Futurism" and "Feminist Manifesto," in that year. She began "Songs to Joannes" in 1915. During the war she served as a nurse in a surgical hospital. In 1916 she moved to New York, where she worked as a fashion model and a designer. "Songs to Joannes" was printed in *Others* in 1917. The following year she married Arthur Cravan, a poet and prizefighter, in Mexico City. Cravan disappeared during a sailing expedition, his fate unknown. Loy, pregnant with their child, moved to Buenos Aires, where her daughter was born in 1919, and then to New York. Her first book, *Lunar Baedeker*, was published in 1923. During the 1930s she became an art dealer, became friends with Joseph Cornell, and worked at painting and sculpture. Her selected poems were published in 1958. She died in Aspen, Colorado, in 1966.

Frances Gregg was born in the Midwest in 1888 and described her early life this way: "I was born into the world in America at a moment when the odd phenomenon of a social conscience was shaping to confound and startle the naiveté of that continent. My grandmother was a lecturer on 'Woman's rights' and 'Temperance'. I marched in a parade with banners inscribed with 'Votes for Women' before I was six. I signed the pledge when I was eight; and trailed up the sawdusty steps of a Camp Meeting platform to avow myself 'a child of God' in skirts too short and wisps of hair flicking against my burning cheeks, when I was ten. . . . Ladies with 'Movements' declaimed at me and predicted a great future for me. I played up to them all with the cynicism common to the young, and as

they were all extremely hideous ladies I shunned their 'Movements' and became an atheist on my own, but I had learned that 'women were wronged' and man 'the great enemy'." She met Hilda Doolittle in Philadelphia, and the two young women traveled to Europe together in 1911. Gregg met John Cowper Powys, with whom she had an intense lifelong relationship, and in 1912 married Cowper's friend Louis Wilkinson. They were subsequently divorced. Gregg returned to the United States and then moved back to England. She and her daughter settled on the west coast in Plymouth, where they were killed in an air raid in April 1941. Her autobiography, *A Mystic Leeway*, edited by Powys, was published posthumously, as were *Letters of John Cowper Powys to Frances Gregg* (1994).

Hazel Hall was born in February 1886 in St. Paul, Minnesota, and grew up in Portland, Oregon. She was paralyzed at the age of twelve by an attack of scarlet fever and confined to a wheelchair for the rest of her life. She lived with her mother and sister, got the news of the new poetry from magazines, and supported herself as a seamstress. Her poems appeared in *The Dial, Poetry,* and *The Literary Review* and were collected in *Curtains* (1921), *Walkers* (1923), and the posthumous *Cry of Time* (1928).

Hilda Doolittle was born in September 1886 in Bethlehem, Pennsylvania, and grew up in a Moravian community, the German pietist sect to which her mother's family belonged. Her father, of English and New England descent, became a professor of astronomy at the University of Pennsylvania, and the family moved to a suburb of Philadelphia, where as a high school girl she met two Penn students and future poets, Ezra Pound and William Carlos Williams. She also entered Bryn Mawr in 1905, in the same class as Marianne Moore, though, since Moore was a boarding student and Hilda a "non-resident," they did not know each other very closely. Doolittle withdrew from college after a year and in 1906 became engaged to Pound, who was on his way to Europe. She enrolled in a college course for teachers at Penn in 1908 and began to contribute prose to Presbyterian papers in 1910, when she moved to New York City and began to write poems modeled on the writings of Theocritus. She sailed with Gregg and her mother to Europe in 1911, visited Pound, and found that he had become engaged to Dorothy Shakespear. Through Pound she met Richard Aldington. In October 1914 she and Aldington were married. Living in London, she developed friendships with D.H. Lawrence and Amy Lowell. *Des Imagistes: An Anthology,* edited by Pound, appeared in 1914, H.D.'s *Sea Garden* in 1916. In 1915 she reconnected with Marianne Moore, who had submitted poems to *The Egoist,* which Doolittle was editing with Aldington. She also assisted Amy Lowell in editing the 1915, 1916, and 1917 volumes of *Some Imagist Poets: An Anthology.* In 1918, her marriage failing, Doolittle traveled to Zennor in Cornwall with Cecil Gray, a

Scotch composer and music critic, by whom she became pregnant. Her daughter Perdita was born in 1919, and in the interim Doolittle met Bryher (Annie Winifred Ellerman), a wealthy young novelist with whom she began a lifelong relationship. *Hymen* was published in 1921, *Heliodora* in 1924, and *Collected Poems* in 1925. *Red Roses for Bronze* (1931) is thought to have completed the first phase of her poetry. Bryher and Doolittle were in London during the intensive German bombing in World War II and her trilogy—*The Walls Do Not Fall, Tribute to the Angels,* and *The Flowering of the Rod*—was published from 1944 to 1946. Her long poem, *Helen in Egypt,* was written between 1952 and 1954 and published in 1961. Her last collection of poems, *Hermetic Definition,* was published posthumously in 1972. Her work in prose includes two memoirs, *An End to Torment,* an account of her relationship with Pound, and *Tribute to Freud,* an account of her analysis with Freud, and several novels, including *Palimpsest* (1926) and *Bid Me to Live* (1960). She died in Switzerland in 1961.

Notes on Doolittle:

Hilda reviewing Marianne: "If Moore is laughing at us, it is laughter that catches us, that holds, fascinates, and half-paralyzes us, as light flashed from a very fine steel blade . . . "

Marianne Moore was born in November 1887 and grew up in a suburb of St. Louis. Her parents separated before she was born. She, her brother, and her mother lived with her mother's father, a Presbyterian minister and colleague of T.S. Eliot's grandfather, a Unitarian minister. When the grandfather died in 1894, the small family moved to Carlisle, Pennsylvania, where her mother took a position as a teacher at Carlisle School, the famous boarding school for Native Americans. Moore entered Bryn Mawr in 1905 and graduated in 1909. She studied business and stenography in 1909–10 in Carlisle. In 1911 the Moores traveled to England and France, and upon their return Moore taught commercial English and coached sports at Carlisle. She had published poems in the college literary magazine beginning in 1909 and, after she graduated, continued to publish in *The Lantern,* Bryn Mawr's alumna magazine. From about 1915 Moore was sending poems to *The Egoist, Others,* and *Poetry.* In 1916 Moore and her mother moved to New Jersey to keep house for her brother, who had become a Presbyterian minister. Visiting Greenwich Village, she came to know Alfred Kreymborg and the group around *Others,* which included William Carlos Williams, and Lola Ridge. In 1918 when her brother left his ministry to join the Navy, Moore and her mother moved to New York, where Moore worked as a librarian. Her first book, *Poems,* was published (without her knowledge) by her former Bryn Mawr classmate Hilda Doolittle for the Egoist Press. Moore published her own

selection of her work, *Observations*, in 1924. In 1925 she became editor of *The Dial*, one of the most important modernist magazines of the period. She published *Selected Poems* in 1935, *The Pangolin* in 1936, *What Are Years* in 1941, a *Collected Poems* in 1951, and *Predilections*, a collection of essays and reviews, in 1955. She lived in her later years in Brooklyn and died there in 1972.

Djuna Barnes was born in Cornwell-on-the-Hudson, New York, in June 1892. Her first poems were published in *Harper's Weekly* in 1911. From 1912 to 1921 she worked as a journalist in New York, where she covered the suffrage movement and became active with the Provincetown Players, which produced three of her short plays in 1919 and 1920. A book of poems and drawings, *The Book of Repulsive Women*, appeared in 1915 when she was living in Greenwich Village. She moved to Paris in 1921. Her novel *Nightwood* was published in 1936. She died in New York in 1982.

Hildegarde Flanner was born in June 1899 in Indianapolis, Indiana. She attended Sweetbriar College in Virginia before transferring to the University of California at Berkeley in 1919. At Berkeley she studied poetry with Witter Bynner, recently arrived from Harvard, where he had been a classmate of Wallace Stevens. Flanner married in 1926 and moved to Southern California, where she raised her family and wrote poems, essays, and plays. In later years she lived in the Napa Valley, where she died in 1987. Her books of poems include *Young Girl* (1920), *This Morning* (1921), *Time's Profile* (1929), and *If There is Time* (1942).

Laura Riding was born Laura Reichenthal in January 1901 in New York City. She attended Cornell University and began writing and publishing poetry under the influence of Allen Tate and the Southern Fugitives. Her first poems were published in *The Fugitive* in 1922. Her first collection of poems, *The Close Chaplet*, was published in 1926. When her first marriage ended in 1925, she moved to England at the invitation of Robert Graves and his wife, which created a crisis in that marriage. From 1927 to 1936 Graves and (then) Riding lived in Majorca, where they established the Seizin Press. She published *Collected Poems* in 1938, and in 1939 she and Graves moved to the United States, where they parted. Riding remarried in 1941 and moved to Florida, where she ceased to write poetry and produced a number of prose books under the name Laura (Riding) Jackson and raised oranges. She died in 1991.

Textual note

WE SHOULD NOTE that, for reasons of length and economy, we have excerpted Hilda Doolittle's "The Walls Do Not Fall" by printing the first 23 sections and the final section. Readers will want to consult for themselves sections 34-42, the second part of the poem's argument for art in the midst of ruin. The version of Marianne Moore's remarkable "An Octopus," printed here, is the version printed in her *Observations* (1924). The editors would have liked to include several more poems by Marianne Moore; however her publishers charge such high fees for Moore's poems that to print everything we would have wished would have cost more than all the other permissions in this book combined (though Moore left no personal estate and though many of the poems were published first almost a century ago.) Publishers deserve to earn back what they invest in publishing poetry and more. But we believe that unreasonable fees have begun to distort anthologies and therefore the study of poetry.

—Robert Hass

Editor's note

IT IS ALWAYS a gift to work with good poems, and when the objective is to make those poems accessible to new readers by publishing a book—that strange memory-device through whose prism texts are diffused into a readership whose collective potential for their perception is unlimited—the gift of that work, and my gratitude toward it, is of course made much greater.

Selecting texts for such a project is very pleasurable, and hopefully contagious: Modernist works of art, their approximately "free" modularity anticipating cybernetics and other informational praxis/theories, are often pretty amenable to excerption and combination. To set thetic selections of any writers' works in a certain sequence (in our case, by birthdates) and then, so to speak, see what happens is an editor's principal pleasure, one that I strongly recommend other writers and readers give themselves, whether through a publisher or a copy shop; either way it's a pleasure always awesomely deferred, as it is the reader—one likely to be "new" to these works, and hence reading in that precious space of first encounter—whose pleasure an editor labors for, yet whose reception of these poems will follow contours of intellect that no editor can predict. It's to them—those joyously entropic tendrils of the future of poetry, including many of my friends—that my work is devoted.

—Paul Ebenkamp